creative
NATURE
PHOTOGRAPHY

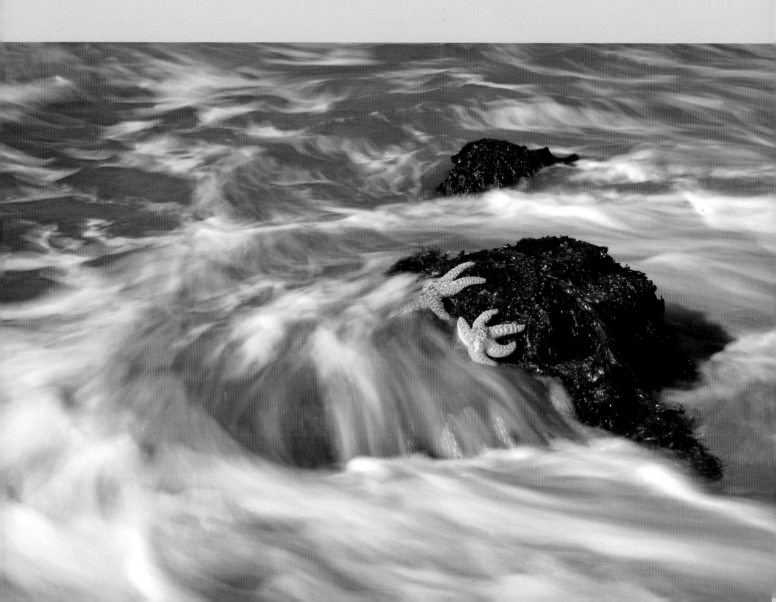

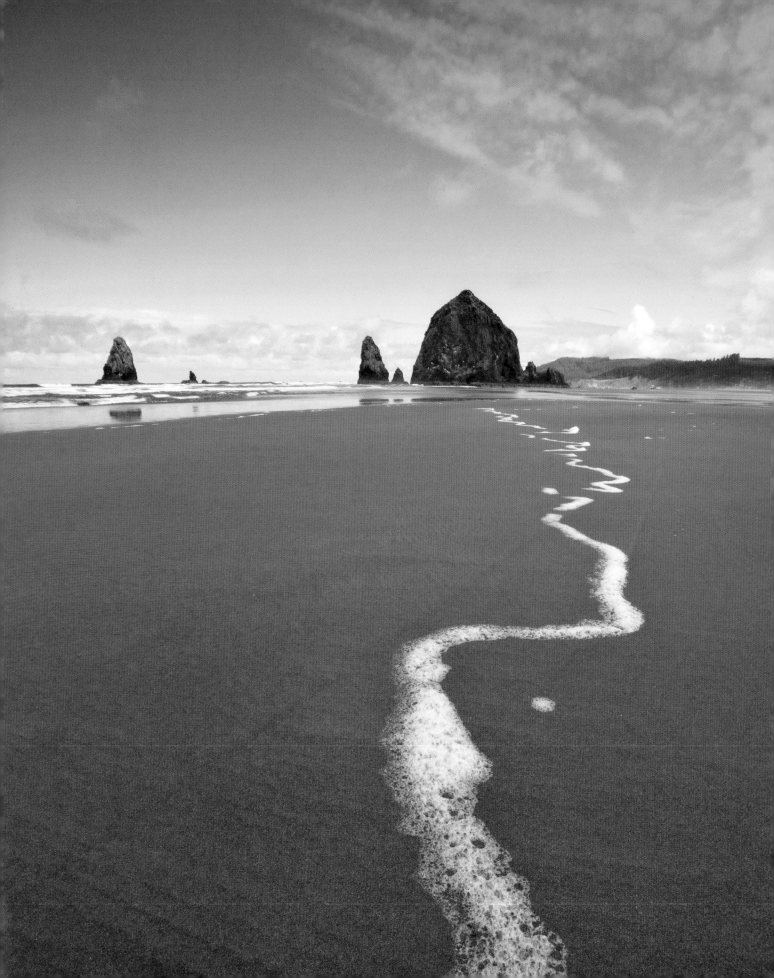

BILL COSTER

creative
NATURE
PHOTOGRAPHY

Essential Tips and Techniques

GREYSTONE BOOKS
D&M Publishers Inc.
Vancouver/Toronto/Berkeley

Text and photographs copyright © 2011 by Bill Coster

11 12 13 14 15 5 4 3 2 1

Greystone Books
An imprint of D&M Publishers Inc.
2323 Quebec Street, Suite 201
Vancouver BC Canada V5T 4S7
www.greystonebooks.com

First published in Great Britain by New Holland Publishers (UK) Ltd.

Cataloguing data available from Library and Archives Canada
ISBN 978-1-55365-847-4 (pbk.)
ISBN 978-1-55365-848-1 (ebook)

Cover and interior photographs by Bill Coster
Printed and bound in Singapore by Tien Wah Press
Text printed on acid-free paper
Distributed in the U.S. by Publishers Group West

CONTENTS

Introduction

I have been interested in natural history from an early age, so when I bought my first camera it was inevitable that animals would be my first photography subjects. I became keen to record the exotic species and locations I saw in my travels. Over time the photography became increasingly important, until I was planning trips based primarily on photographic potential. In tandem with the improvement in my photography, I began to have my work published in magazines and joined a major picture library specializing in nature. I remained a semi-professional nature photographer for a number of years, and at the same time established a successful career in IT with a large company. Although I enjoyed the work, I never felt really comfortable with corporate culture, and eventually made the decision to give up the day job and concentrate on photography.

Since then I have never looked back. I have travelled extensively to quickly increase my stock of images to generate more income. Throughout my new career I have always had the enthusiastic support of my wife Diana, who accompanies me whenever possible. Having that extra pair of eyes when photographing wildlife has proved very useful. Travelling together also enables us to spend more time at locations and explore their photographic possibilities more fully than could be done in short visits.

Nature photography is a very broad subject, ranging from the all-encompassing landscapes of the world's wild places to the minute detail revealed in a close-up of a small insect. The relationship between the landscape and the plants and animals that live in it is a very close one. It is the adaptations of living things to enable them to meet the challenges of thriving in each unique environment that have resulted in the huge variety of species on our planet.

The chapters in this book are arranged according to the challenges they pose to the photographer, rather than in any rigorously scientific way. The first chapter describes the photographic equipment required for nature photography, based largely on my own experience, and includes straightforward

advice on choosing cameras, lenses and other pieces of kit. The following chapters form the core of the book. Using a similar approach, each chapter begins by capturing the entire landscape of a specific environment, then gradually works down to details of the plants and animals that inhabit it. I have focused on the best photographic opportunities in each environment, so the balance of the subjects in each chapter varies – you do not find many insects in the icy polar regions, for example, so there are none in that chapter.

Digital cameras were used to create most of the images in the book, except in cases where a film image better illustrated a point or environment. Images captured with digital technology come with a wealth of data that includes details of the camera settings employed when the pictures were taken; this has been used to provide technical information on these pictures. Such data is not available for the film images, and this is reflected in the exposure details provided for these pictures.

Camera equipment

The scope of nature photography is very broad, and almost every piece of photographic equipment ever made could be useful at some time when photographing the natural world. The aim of this chapter is to highlight the most useful equipment.

I ALSO EXPLAIN why I personally find the equipment useful. Although images shot on film have been used for some of the examples in this book because they best suited a particular situation, film is for all practical purposes dead, so all the equipment advice is based on digital cameras.

CAMERAS

It is possible to take landscape pictures using digital compact cameras, but these are not practical for wildlife photography due to their fixed lenses of limited focal length. Most compacts only produce images in the jpeg format, which severely limits the post-capture control you have over your images. There are some compacts that can produce RAW files, and I use one of these myself – the Canon G9. The great advantage of using a compact is that you never have a problem with dust. This is because the lens is fixed to the camera body, so the dust just cannot get inside it. On the negative side, because these cameras have very small sensors they tend to suffer considerably with sensor noise. I found that the pictures from my G9 were unusable above 80 ISO.

At the other end of the scale are digital medium-format cameras. However, these are incredibly expensive at the moment, and with digital technology evolving so rapidly I do not feel they are a good investment. They are also bulky, and although great for landscapes are not very practical for a wide range of wildlife photography.

The best overall cameras for nature photography are the 35mm-equivalent digital SLRs (Single Lens Reflex) cameras with interchangeable lenses. The two big players are Canon and Nikon, who tend to lead the way in the constant improvements that are being made as digital technology continues to evolve. I have been a Canon user for many years, and great rivalry seems to exist between users of Canon and Nikon. In reality both systems are excellent, and the choice of lenses and other accessories for them far exceeds that of any other manufacturer. There are other systems, of course, but if you are just starting out I suggest you choose one of the two leading brands.

There are a number of factors to consider when choosing a digital camera body. I have attempted to avoid the technical detail as much as possible and to keep the advice very practical.

Sensor Size | In the days of film, every camera produced the same-size image on 35mm film, which was 36 x 24mm. When it comes to digital cameras, the image size is determined by the size of the sensor that records the picture. When this approximates the size of a single 35mm film image, it is known as 'full frame'. Nikon and Canon produce 35mm-like digital cameras with smaller sensors that effectively crop the centre out of the full-frame image, giving the impression that the subject has been magnified.

Cameras with full-frame sensors are generally relatively expensive, but they are the most useful for landscape photography because they do not crop images and therefore retain the full effect of wide-angle lenses.

Cameras with smaller sensors are useful for wildlife photography, because they effectively magnify the subject as they crop the full-frame image. Problems can occur with

small sensors when manufacturers try to squeeze too many megapixels on them, resulting in excessive noise that can seriously degrade the image at even moderate ISO settings (see under Megapixels, below).

Burst Rate | This is the number of frames that can be taken continuously before the buffer fills up and the camera can no longer take pictures, until the buffer clears itself by transferring the image data to the flashcard. This is rarely an issue with relatively static subjects, but can be restrictive when photographing wildlife in action. My full-frame Canon 1Ds Mark II has a burst rate of 10 frames, while the Canon 1D Mark II has a burst rate of 22 frames, making the 1D Mark II my camera of choice when photographing (for example) birds in flight.

Frame Rate | This relates to the number of frames per second that can be taken by the camera body. Like the burst rate, it is not relevant to static subjects, but being able to shoot at eight frames a second or more is very useful for photographing wildlife in action.

Megapixels | In simple terms, this is the number of pixels used to create a picture, and it directly relates to the size of the final digital image. Many people take the view that the more megapixels the camera produces, the better the quality of the image, but this is not necessarily the case. The camera sensor is actually an array of millions of tiny sensors, and when too many are crammed into a small space the resulting image can suffer from noise. This has a very similar effect to the grain found in film, and increases with ISO speed. In the relatively short time since digital cameras became widespread, the control of noise has improved enormously. Future developments are bound to produce further advances.

In summary, I would recommend a body with a full-frame sensor for landscape photography, and a body with a smaller sensor for wildlife photography.

TYPES OF LENS

Zoom Versus Fixed Lenses | Zoom lenses have improved so much in quality that I now use them for much of my nature photography. Individual zoom lenses are usually heavier that their fixed-length counterparts, but they combine a wide range of focal lengths in one lens. This enables you to carry far less equipment than you would need if you had a range of fixed-length optics. Zoom lenses also have the advantage of enabling you to use focal lengths that are just not possible with fixed lenses (whoever heard of a 33mm lens?). In addition, they permit you to make adjustments to your composition without having to move backwards and forwards. On the negative side, zoom lenses have smaller apertures for their weight and size than lenses with fixed focal lengths. For many subjects this is not a concern, and with ever-higher ISOs available on digital cameras it is even less of an issue.

Despite the improvements in zoom lens technology, I would recommend buying the best zoom lens that you can afford. I use Canon professional 'L' lenses whenever I can because I know they are of the highest quality.

A cheap zoom lens is not going to be a good investment, although there are a number of independent lens manufacturers who do produce good-quality optics. If you are on a budget, these can be an option worth considering.

Super telephoto lenses nearly always have a fixed focal length, because the prime requirement of these large and heavy lenses is to have as large a maximum aperture as possible, which is best achieved using a fixed lens. Other specialist lenses, such as macro and tilt and shift lenses, are also only available with a fixed focal length.

Image-stabilized Lenses | Many lenses now have Image Stabilization technology, known as IS on Canon cameras and VR (Vibration Reduction) on Nikons. As their names suggest, these lenses reduce the effect of camera shake when taking photographs. The technology comes into play particularly well when hand-holding lenses of all sizes, and I often take advantage of it when using a tripod is unsuitable or inconvenient. IS can get confused when a camera is used on a tripod, so because it is not required in this situation I turn it off.

USED ON A FULL-FRAME CAMERA, A STANDARD ZOOM LENS IS VERY VERSATILE, AND PERFECT FOR LANDSCAPE PHOTOGRAPHY. IT CAN EASILY BE HAND-HELD, AS IT WAS FOR THIS PICTURE OF SNOW-COVERED MOUNTAINS AND SEA ICE TAKEN FROM A MOVING SHIP.

Canon EOS 1Ds Mark II, 24-105mm lens, 1/500th sec @ f9, digital ISO 400

Svalbard, Norway

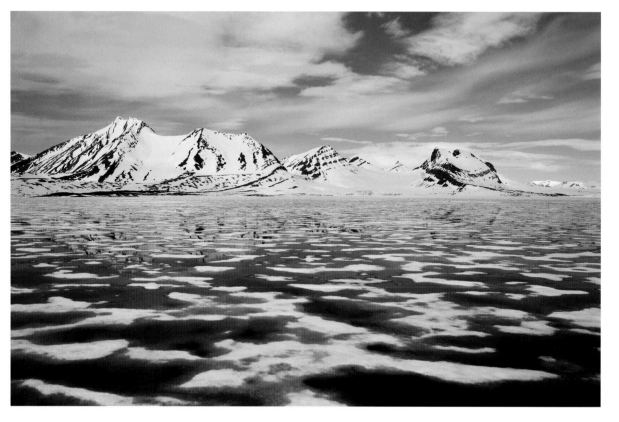

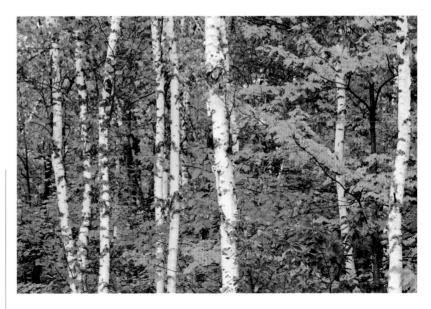

THE THREE BASIC LENSES

From the technical details with the pictures in this book, you will note that I have used a wide range of lenses over the years. However, if you are just starting out you can easily get by with just three key lenses to cover the majority of situations in nature photography. These are the standard zoom, telephoto zoom and super telephoto.

Standard Zooms | The range of focal lengths that the so-called standard zooms can cover seems to be increasing all the time. My standard lens at the moment is the Canon 24-105mm f4L IS, which at the 24mm end provides me with a very wide angle, and at the other end a short telephoto. I use this primarily for landscape and plant photography, and never go anywhere without it.

Telephoto Zooms | These cover longer focal lengths and are useful for all types of nature photography. My favourite in this category is the Canon 100-400mm f4.5-5.6L IS. It has an awful push/pull zoom mechanism instead of the normal rotating zoom found in most lenses, but I love the flexibility of use the range of focal lengths provides. It is handy for landscapes, particularly when working in forests, and ideal for places like Antarctica, where you often have to shoot landscapes from far away on a ship. It is also the lens I use more than any other for photographing wildlife in the Antarctic, where the animals are approachable and a big telephoto is unnecessary. Being so much lighter than a super telephoto lens, it gives me the freedom to wander around looking for pictures.

There have been reports from some quarters that this lens is 'not sharp', but I have taken many thousands of pictures with it and the results have never been less than superb. It also has the advantage of having a 77mm filter thread, so it will take a standard-sized polariser filter, which comes into play when photographing landscapes. Although it will physically accept a teleconverter, I would advise against using one because in my experience doing so results in a significant degradation of image quality. Nikon produce an excellent 200-400mm zoom lens, but although the f4 aperture is useful, it is well over twice the weight of the Canon optic, so far less convenient to carry around, especially if you also regularly use a super telephoto.

An alternative telephoto zoom is a 70-200mm lens, several versions of which are made by both Canon and Nikon. It does not have the reach of the 100-400mm lens, but works well with a teleconverter, which provides that extra reach. I have the f2.8 version of this lens, which is very fast and still gives you f5.6 if used with the 2x converter. This works well with this lens, although I still prefer the flexibility of the 100-400mm for general work.

Super Telephoto Lenses | A big telephoto lens is pretty much essential for wildlife photography, and the

A TELEPHOTO ZOOM IS VERY USEFUL FOR PICKING OUT DETAILS IN A LANDSCAPE, AS IN THIS COMBINATION OF BIRCH AND MAPLE TREES IN AUTUMN.

Canon EOS 1Ds Mark II, 100-400mm zoom lens @ 275mm, 0.5 sec @ f22, digital ISO 100

Michigan, USA

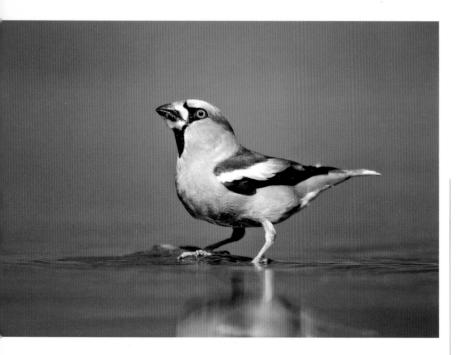

Canon EOS 1Ds
Mark II, 500mm lens,
1/800th sec @ f4,
digital ISO 400

Hungary

500mm f4L IS has now become the main workhorse in this field. The Canon lens weighs 4kg, and I nearly always use it on a tripod with a Wimberley head. The maximum aperture of f4 enables fast focusing, even when a 1.4x converter is used, since the effective aperture is then f5.6. Below f5.6, autofocus slows down considerably, and in some lower end cameras will no longer function at all. The IS feature is useful when working at slower shutter speeds on these long lenses, especially when using teleconverters, because the long focal length magnifies not only the subject, but also any camera movement or vibration, and IS helps to combat this.

OTHER LENSES

Having covered the main three lenses that no nature photographer should be without, here are descriptions of several other more specialized lenses.

Macro Lenses | These are specialist lenses that enable much closer focusing than is possible with normal lenses.

True macro lenses enable 1:1 or actual life-size images to be produced on a full-frame camera, and are perfect for photographing small insects and plants. Two focal lengths are most suited to nature photography, 100mm and 180mm (Nikon have 105mm and 200mm). For relatively static subjects, such as moths at rest and flowers, the 100mm lens is sufficient. The extra reach of the 180mm (or 200mm Nikon) is of great benefit for photographing more nervous subjects that are difficult to approach, such as dragonflies and butterflies, although these larger lenses are considerably more expensive.

For macro work, a camera with a small sensor, such as the Canon EOS 50D, is useful. With this, your 100mm macro becomes an effective 160mm macro at no extra cost.

Mid-range Super Telephoto | I would define this as either a 300mm f2.8 or a 400mm f4. Both these lenses come within the range of the 100-400mm zoom lens, and if you also have a 500mm f4 lens, why would you want one of these as well? The answer is: because of their combination of weight and brightness. For many years I owned a 300mm f2.8, but I sold this and bought the Canon f4 IS DO. The DO stands for Diffractive Optical, the use of which enables the lens to be smaller and lighter than a normal lens. This superb-quality lens weighs in at just under 2 kilograms, which is half the weight of the 500mm f4. When used with a 1.3x body and a 1.4x converter, it gives me the equivalent of a 728mm lens, which I can easily hand-hold. This makes it a perfect lens for photographing birds in flight, especially when you are attempting to capture small and fast-flying species. In such

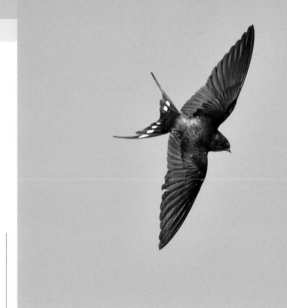

cases, hand-holding gives you the freedom of movement and ability to react quickly and track the often erratic bird flight. I have also used this lens when photographing from moving boats, situations where a tripod would be impossible to use. In addition, its relatively light weight makes it valuable in locations where you are wandering around a lot, but need a longer focal length than your long zoom can provide. It allows you to work without a tripod – and in this case the IS facility is very useful.

Ultra Wide-angle Lens |

I would define ultra wide angle as any focal length smaller that 24mm, and lenses of this length are of value mainly in landscape photography. The difference of a few millimetres in focal length is very significant when working with wide-angle lenses. I use the

Canon 17-40mm f4L, which overlaps quite a lot with my 24-105mm, but the difference between 17mm and 24mm is astonishing, with the angle of view increasing from around 73 degrees at 24mm to about 92 degrees at 17 mm. That is around 26 per cent more coverage for just a 7mm decrease in focal length. There are wider lenses than 17mm, but they have a limited use for nature photography and are costly.

Tilt and Shift Lens |

Although these are specialist items, they can be of value to nature photographers in

MY CANON 400MM F4 DO LENS AND 1.4X CONVERTER, WHEN COMBINED WITH MY 8 FRAMES PER SECOND EOS 1D BODY THAT HAS A BURST RATE OF 22, IS IDEAL FOR HAND-HELD IMAGES OF SMALL BIRDS IN FLIGHT, LIKE THIS SWALLOW (*HIRUNDO RUSTICA*).

A VERY WIDE-ANGLE LENS WAS REQUIRED TO INCLUDE THE FOREGROUND ROCKS AND DISTANT MOUNTAIN IN THIS IMAGE OF KICKING HORSE RIVER, YOHO NATIONAL PARK, DISAPPEARING THROUGH A NATURAL BRIDGE LIKE A GIANT WHIRLPOOL.

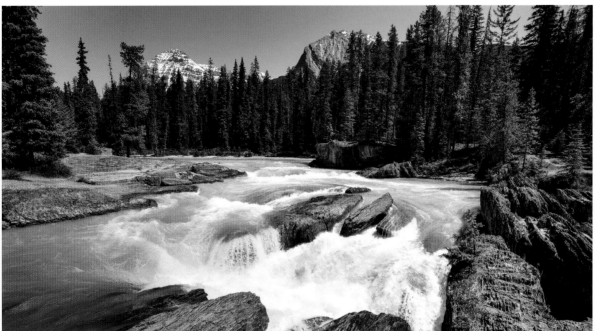

certain circumstances. Without going into great technical detail, the tilt control allows you to 'tilt' the angle of focus from the normal vertical to place it more horizontally. This is useful when photographing large and flat subjects such as fields of flowers. With a normal lens it can be difficult – and sometimes impossible – to achieve a sufficient depth of field to get both the foreground and background in focus, especially if you are using a telephoto lens and have the foreground flowers very close. This is because the plane of focus is vertical and the subject is horizontal.

To obtain the biggest possible depth of field, the subject needs to be parallel to the camera sensor. If you wanted to photograph a field of flowers, you would have to hover above the field and point your camera straight down to achieve this – a nice trick if you can do it. Using the tilt mechanism on the tilt and shift lens, you can tilt the plane of focus towards the horizontal and capture the scene in sharp focus, while keeping your feet firmly on the ground.

Even if you manage to get everything in focus by using a very small aperture on a normal lens, you will need to use a very slow shutter speed to obtain the correct exposure. If there is the slightest wind, the flowers will move around and will not come out sharp. With the tilt mechanism, you can use a much wider aperture and faster shutter speed. Although there are a number of focal lengths available with tilt and shift mechanisms, depth of field is much less of a problem with wide-angle lenses, so I find the Canon 90mm T/S lens the most useful.

The shift mechanism can be used to correct the tendency of a vertical lens to converge towards the centre when you point it upwards, which is especially the case with a wide-angle lens. It is often used for photographing buildings, but I have not found much of a use for it in nature photography, and much the same effect can now be achieved using software such as Photoshop.

Teleconverters | These are extremely useful, small, lightweight lenses. They fit between the main lens and camera body, and increase the effective focal length of the lens. They come in two sizes, 1.4x and 2x. The numbers refer to how much the focal length is increased when they are used. Thus a 500mm lens becomes a 700mm lens when used with a 1.4x converter, and a 1,000mm lens when used with a 2x converter. You do not, however, get something for nothing, and the downside is a reduction in quality and a loss of light. When using the 1.4x converter you loose one stop of light (so the 500mm f4 becomes a 700mm f5.6); with the 2x the loss is two stops (the 500mm becomes a 1,000mm f8). I only ever use Canon converters (if you are a Nikon user use only Nikon converters). There are less costly independent converters available, but these are unlikely to match the quality of the two prime brands.

In my experience, it is difficult to detect any loss in quality when using the 1.4x converter with most lenses (although as mentioned previously I would not use it with the Canon 100-400mm zoom). I use the 2x less frequently – although the image is good, the slight loss of quality is detectable. The quality of the image edge suffers more than that of the centre. Cameras with smaller sensors can thus give better results with the 2x converter than full-frame cameras, since in the case of the former the edges are cropped out when the picture is taken.

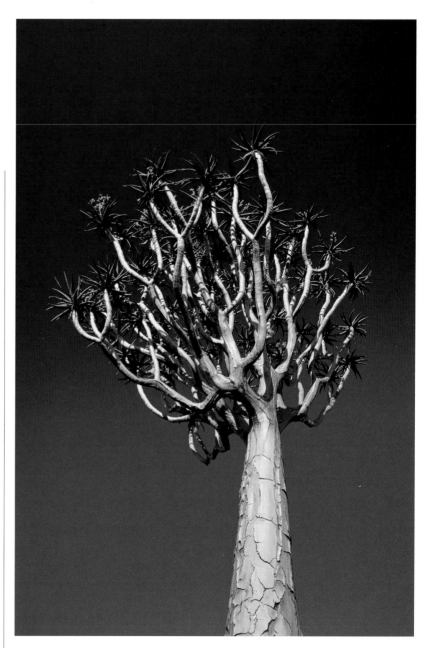

Canon EOS 1n, 24-85m
lens, polarising filter,
exposure unrecorded,
Fuji Velvia film, ISO 50

Namibia

EXTENSION TUBES

These are hollow rings that fit between the camera body
and lens, and reduce the minimum focusing distance
of the lens. They can be of value when used with shorter
lenses as an alternative to a macro lens, and if you only do
macro work occasionally they are good for making large
images of small subjects such as insects. Extension
tubes are also useful when photographing small creatures
such as hummingbirds with a long telephoto lens – on
their own, most of these lenses will not focus close
enough to enable you to produce a good-sized image
of your subject.

FILTERS

The only filter I use is a polarising filter, which I find
beneficial for several reasons. Its best-known effect is
produced on a sunny day, when it darkens the blue sky
and can bring out the detail in any white clouds present.
I also use it when photographing forests whatever the
weather, because it reduces the reflections from the
leaves, in doing so making the colour far more intense.

The filter can be used for reducing the shutter
speed when making long exposures of subjects such as
waterfalls, because it results in the loss of around two
stops of light. You could, of course, use a neutral-density
filter to reduce the light reaching the sensor, which is
what it is designed for, but I prefer the convenience of a
polarising filter because it is usually on the lens anyway.

TRIPODS

Although I enjoy the freedom of hand-holding my camera,
particularly when photographing wildlife, I still consider
a tripod to be an essential piece of equipment and would
not leave home without one. I have used a Manfrotto 055
tripod for many years. It is very sturdy, yet of a reasonably

A POLARISING FILTER
DARKENS A BLUE SKY AND
PRODUCES A RATHER
DRAMATIC IMAGE, AS IN
THIS SHOT OF A QUIVER
TREE (*ALOE DICHOTOMA*).

15

TO PRODUCE THIS RATHER ETHEREAL EFFECT WHEN PHOTOGRAPHING WATERFALLS, A VERY SLOW SHUTTER SPEED IS NEEDED, SO A TRIPOD IS ABSOLUTELY ESSENTIAL.

> Canon EOS 1Ds
> Mark II, 24-105mm
> zoom lens @ 45mm,
> 5 sec @ f16,
> digital ISO 50
>
> *Michigan, USA*

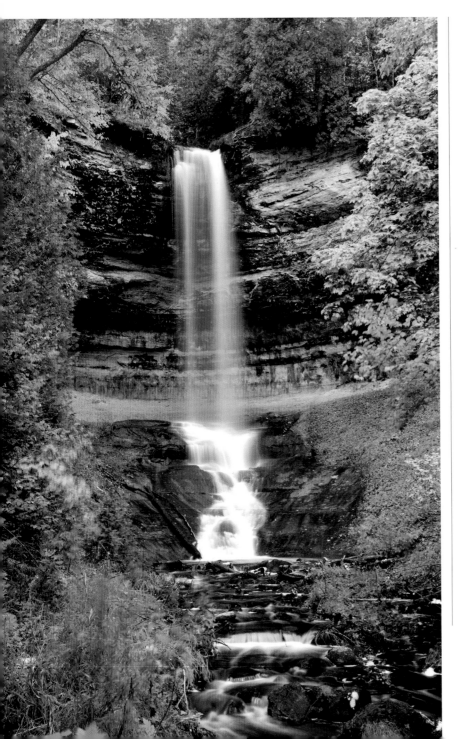

light weight, and has quick-release legs, something I would not be without. I cannot get on with tripods that have twist-lock legs and avoid them, and do not use carbon-fibre tripods. In my view the high cost of these tripods cannot be justified for the small weight savings to be gained. Of course, many people are happy with twist-lock legs and carbon-fibre tripods, so it comes down to personal taste and how deep your pockets are.

Why is a tripod essential for nature photography? There are perhaps more reasons for using a tripod than you might think.

Preventing Camera Shake | The most obvious reason for using a tripod is to prevent camera shake during the exposure. This facility is clearly most useful when making long exposures due to either low light conditions or using small apertures to increase the depth of field.

Long Waits | Nature seldom does what you want it to do, and when taking photographs of nature you will frequently spend a great deal of time hanging around waiting for something to happen. You may have to wait for the sun to appear from behind the clouds for a landscape, for a bird to return to its nest, or for a mammal to appear and carry out a specific action. Even if you are using a normal lens, it is far easier to have your camera set up on a tripod ready to use, than to hold it for a long time.

Taking the Weight | Unless you are built like Arnold Schwarzenegger, some of the super telephoto lenses are just too heavy to hand-hold and really do need a tripod

just to support them. The Canon 500mm f4 weighs about 4 kilograms, and I very rarely use it without a tripod.

Remote Control | There may be occasions when you want to operate your camera remotely, and in such cases a tripod is usually required to support the camera close to your subject.

Aligning Images | If you want to produce HDR images (discussed in later chapters), you will need to take several different exposures of exactly the same scene. A tripod is essential to ensure that the camera remains in the same place for each exposure, so that each image in the sequence is precisely aligned.

Composition | A powerful creative reason for using a tripod relates to composition. Once you have your camera set up on the tripod and in position, you can take your time and carefully consider the shot, making small adjustments by moving the camera around or by zooming in and out. Obviously, the luxury of having the time to do this only really applies to rather static subjects, and is particularly relevant when photographing landscapes.

TRIPOD HEADS

There is a vast array of tripod heads to choose from. I have tried a few over the years, but have now settled for two. When employing long and heavy telephoto lenses for wildlife photography, I use a Wimberley head. This is a very specialized gimbal-type head, which rotates the lens around its centre of gravity, instead of the whole thing being balanced on top, as is the case with other types of head. The lens is attached using its tripod collar via an Arca Swiss-type mount. This can be adjusted backwards and forwards until the lens and camera combination you are using is perfectly balanced. Once this has been accomplished (which only takes a minute or so), the entire weight is taken by the tripod and the camera simply hangs in place ready to be moved around with ease. If you have a large telephoto lens such as a 500mm or 600mm f4, you really must get a Wimberley head.

For all other tripod work I use a small and lightweight ball-and-socket head made by a US-based company called Really Right Stuff. This also comes with an Arca Swiss-type clamp, and the same company additionally supplies specially designed plates for a wide range of camera bodies that fit into the clamp. The plates are well worth buying, because they are designed to prevent the camera body from twisting once it is on the head – a problem with quite a few 'one size fits all' tripod-mount systems, many of which are more trouble than they are worth.

FLASHGUNS

I am not a great user of flash for much of my nature photography, although I do use it quite a lot for macro work, especially when photographing invertebrates. I often use fill flash when photographing static insects such as moths at rest. During the day many moths are inactive

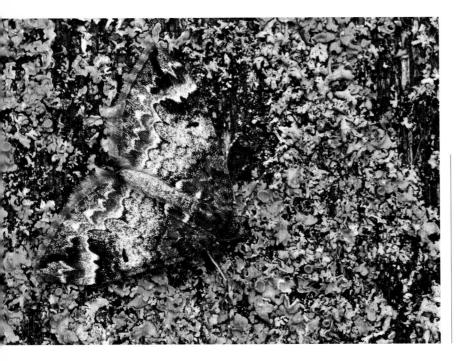

Canon EOS 1Ds Mark II,
100mm macro lens,
Canon 580Z flashgun,
1/3rd sec @ f22, flash
compensation at -1 1/3rd
stops, digital ISO 100.

Essex, UK

and can be found sleeping on a variety of surfaces, although they tend to always be in relatively cool shade because they dislike bright sunlight. Photographing them in these rather dull conditions does not bring out their subtle colours and textures, so I use a standard flashgun to provide additional light in the form of fill flash, setting the flash compensation at between -1 and -1.5 stops to prevent the flash from overpowering the ambient light.

This approach works well for static subjects that allow you time to set up the camera on a tripod, but I tend to

ABOVE FILL FLASH IS USEFUL FOR BRINGING OUT THE INTRICATE DETAILS OF INSECTS LIKE THIS MARBLED CARPET MOTH (*CHLOROCLYSTA TRUNCATE*) AT REST DURING THE DAY.

RIGHT A RING FLASH IS IDEAL FOR PHOTOGRAPHING SMALL INSECTS LIKE THIS MARMALADE HOVER-FLY (*EPISYRPHUS BALTEATUS*) FEEDING ON A GAZANIA FLOWER IN MY GARDEN.

Canon EOS 50D,
100mm macro lens,
ring flash,
1/250th sec @ f16,
digital ISO 100

Essex, UK

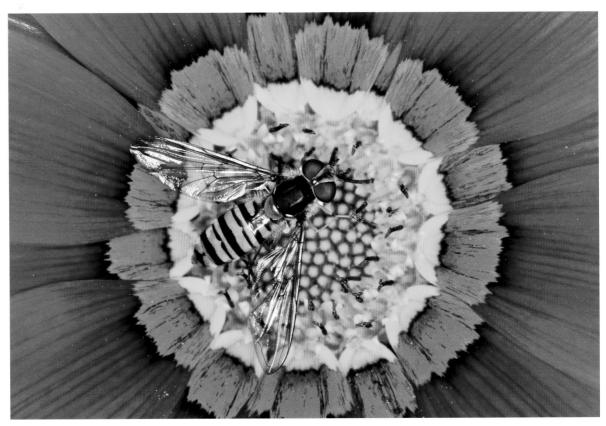

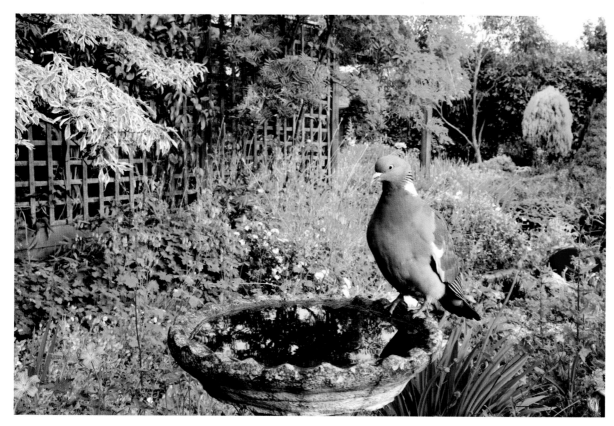

Canon EOS 1Ds
Mark II, 24-105mm
zoom lens @ 38mm,
1/40th sec @ f14,
digital ISO 400

Essex, UK

USING A REMOTE RELEASE
ENABLED ME TO GET UP
CLOSE AND USE A WIDE-
ANGLE LENS TO TAKE THIS
PICTURE OF A WOODPIGEON
(*COLUMBA PALUMBUS*) AT
A GARDEN BIRD BATH.

use full flash when photographing more active insects, such as bees and hover-flies. The depth of field in macro photography is minimal, so a small aperture is required to increase this as much as possible. This in turn requires a slower shutter speed, so ambient light will not be strong enough to allow a fast enough shutter speed for a hand-held shot. I find this technique particularly beneficial when using a ring flash, which fits around the end of the lens on the filter ring. Ring flash is of value when photographing small insects, because the flash is concentrated directly on the subject and gives a very even light with few shadows.

REMOTE RELEASE

A remote release enables you to fire the camera shutter from a distance, which can be useful when photographing wildlife. Clearly you need to predict exactly where your subject will appear, and I have used it to photograph birds visiting a bird bath in my own garden, as shown in the image of a Woodpigeon above.

It is easy enough to photograph birds from a distance with a long telephoto lens, but in this particular instance I wanted to get in close and use a wide-angle lens for a more intimate view that showed the garden as well. The camera needed to be less than a metre away from the subjects, so a hide would almost certainly have put them off. I therefore set up the camera on a tripod with a remote wireless trigger, and went indoors.

The birds ignored the camera and came down to the bird bath almost immediately, enabling me to use the remote to trigger the camera through the window and get some nice images of a familiar scene.

Coasts

Coasts provide unique habitats in the natural world and are excellent locations for an enormous variety of nature photography, from broad, uninterrupted landscapes to unique creatures that occur only at this intersection of sea and land.

● TROPICAL BEACH

Canon EOS 1V,
24-85mm lens,
exposure unrecorded,
Fuji Velvia film

*Midway Island,
Pacific Ocean*

COASTS HAVE A SPECIAL ATTRACTION for many people, and the resulting disturbance has spoiled numerous fine habitats. Nonetheless, it is surprising how resilient life along coasts is. Even on the most crowded holiday beaches, creatures of the littoral zone can be found in abundance. They include sponges, sea-anemones, bristle worms, molluscs, crustaceans, and spiny-skinned animals like starfish and sea urchins. What small child has not been fascinated by finding a crab while playing along the shoreline or among the rocks revealed at low tide?

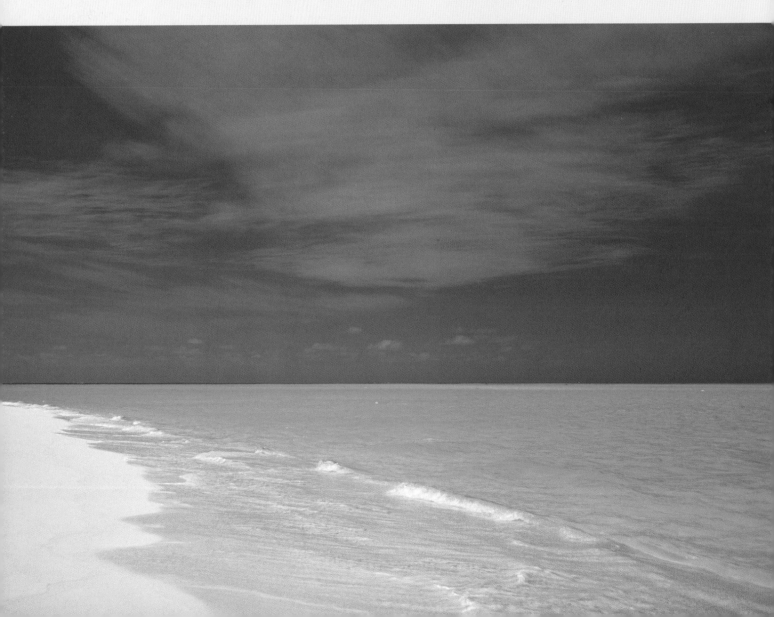

HIT THE BEACH

The shot opposite is a classic tropical-beach three 's' image: sea, sand and sky. It is the very simplest of compositions, in which the basic natural elements make a graphic image, devoid of clutter. The boundary between the land and sea is unclear as the water laps up the gently rising shoreline. The turquoise-blue sea is an important element, and is caused by the sea being very shallow and the sea bottom very pale.

I was visiting Midway Island, a small atoll in the middle of the Pacific Ocean, to photograph the many breeding seabirds found there. On a lovely sunny day I could not resist this scene, and used a polarising filter to bring out the best in the limited colour palette that was available. Whenever you are taking a picture that includes the horizon, it is essential to make sure it is straight. This is most easily accomplished by using a good tripod and a bubble level to get it right. You can crop a digital or scanned image afterwards if it is not straight, but will lose part of the original image when you do this, so getting it right in the first place is a good idea.

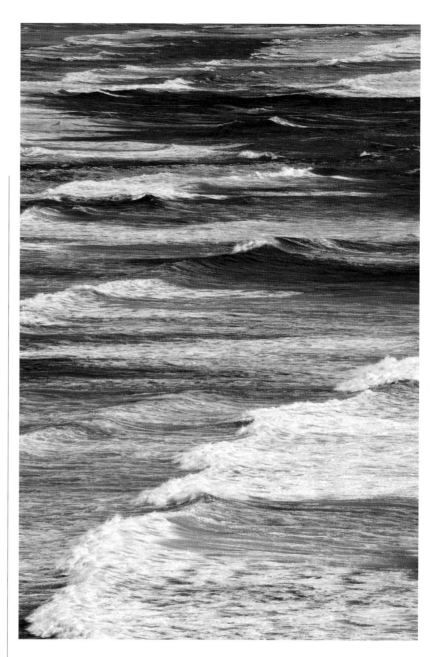

WAVES

The sea itself can provide interesting images, and waves breaking along the shoreline, with their constantly changing forms, can make good photographic subjects. I have included two images of waves taken on either side of the North American continent. Both are just pictures of the sea as it reaches the coast, but they are each completely different in the effect they have on the viewer.

The first image (above), taken in Oregon, is almost an abstract, with the subtle shades of blue and white combining to create a mood of calmness and reflection. Although the waves are of no great height, the sea is not calm at all and it is only the strong waves that give any

⬤ WAVES
Canon EOS 1Ds Mark II, 100-400mm zoom lens, 1/64oth sec @ f16, digital ISO 400
Oregon, USA

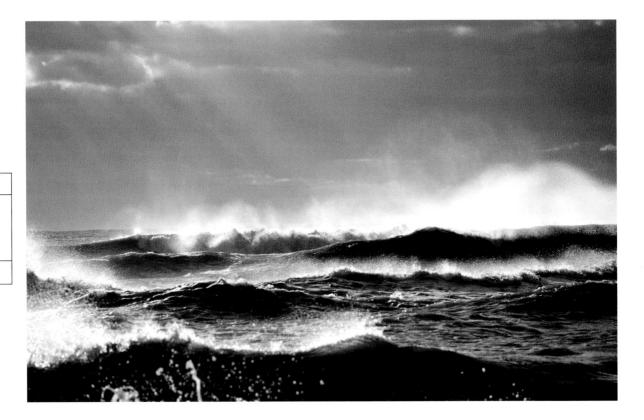

● COASTAL STORM

Canon EOS 1V,
70-200mm lens,
exposure unrecorded,
Fuji Sensia film

Virginia, USA

structure to the picture. The image was taken from high on a cliff at the side of a bay. I had taken a few general shots of the area from my vantage point, but was drawn to the sea itself. The most interesting patterns in the surf were close to the shore where the water was forced into the shallower depths, which made it foam. To make the most of this, I turned the camera on its side and shot in portrait mode to include as much of the coastal strip as possible. I wanted to make the subject quite abstract, so the shot does not include any reference points, such as the beach itself or any rocks offshore. To flatten the image, I chose a telephoto lens and shot the distant part of the bay below.

The second image of waves (above) was taken in stormy conditions, with high waves and dramatic lighting, in Virginia on the east coast of the USA. My wife and I were photographing Snow Geese in the late autumn along this stretch of the east coast, when a storm hit during the late afternoon. The winds were incredibly strong and we took

shelter in a nearby motel, although we did not get much sleep because anything not nailed down was blown noisily around outside. The winds had eased a little by the morning, so we drove out to have a look around. The roads along the shore were difficult to navigate because they were partly covered in wind-blown sand from the beach, and the car park resembled a small dune system. I climbed the bank to view the sea, and was nearly blown over on reaching the top. Then the sun broke through the dark clouds and sent shafts of light towards the sea, producing back light on the spray as the wind blew the tops off the waves. I raised my hand-held camera (a tripod would have blown over in an instant) and grabbed a couple of shots.

Considering this was a bit of a grab shot, the result was a really atmospheric picture that has sold again and again. It is not technically perfect – the foreground waves are out of focus – but it captures the moment and is full of energy. This is what makes it such a successful image.

FOCAL POINTS

The previous images worked because they created a mood or atmosphere, but they did not have a single strong point of interest. This is often difficult to achieve on a coast, because much of the environment is pretty featureless, especially when shooting towards the sea. Offshore stacks like the ones in this image are a real gift to a nature photographer, providing very strong anchor points when creating coastal landscapes. The shot is of Cannon Beach in Oregon, and was taken in the early evening when the sun was low in the sky. I had been hoping for a strong sunset, but due to the heavy cloud on the western horizon this was just not going to happen. At first glance the scene looked quite drab, but the clouds looked reasonably interesting, and I liked the reflections in the wet sand.

⊙ OFFSHORE STACKS

Canon EOS 1Ds
Mark II, 17-40mm lens
@ 17mm, 1/30th sec
@ f11, digital ISO 100

Oregon, USA

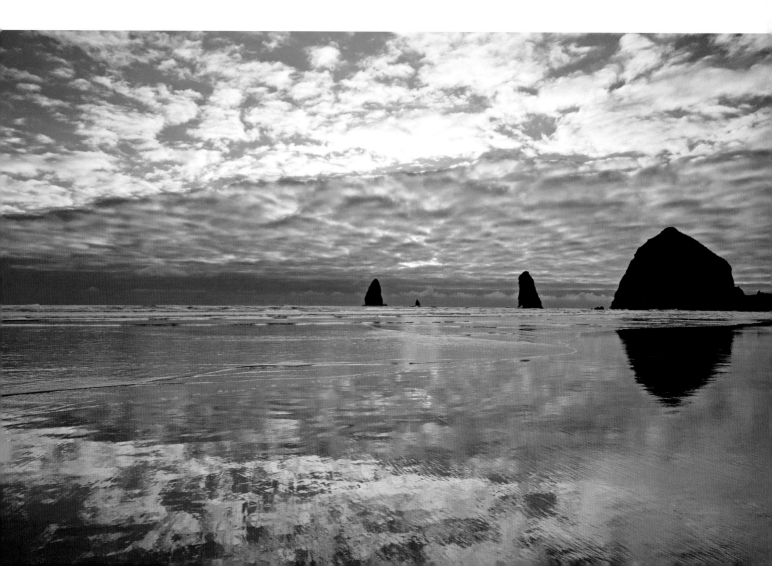

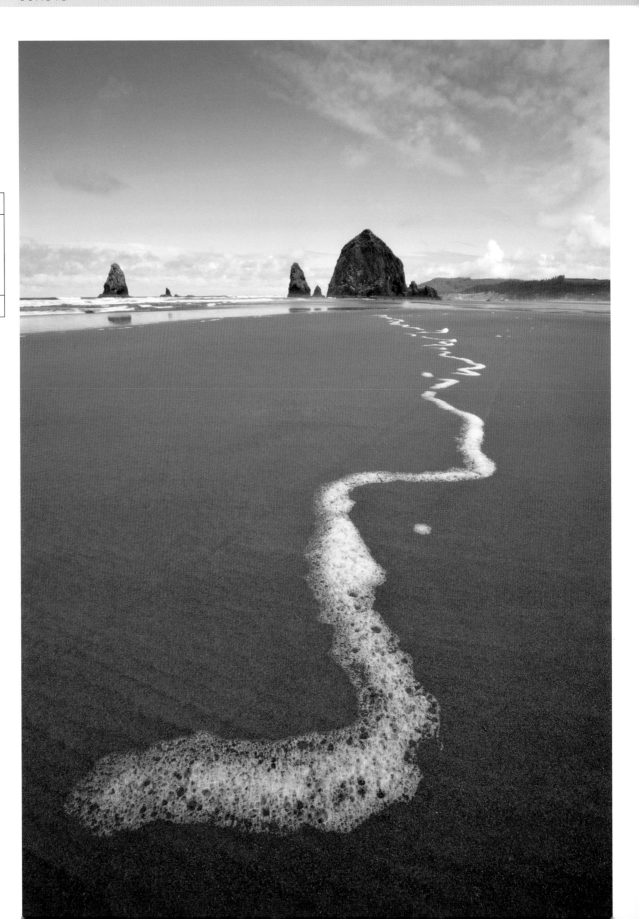

● OFFSHORE STACKS

Canon EOS 1Ds
Mark II, 17-40mm
zoom lens @17mm,
1/8th sec @ f22,
digital ISO 100

Oregon, USA

I played around with the scene with a 24-105mm lens, but this did not work because I could not capture enough of the sky. It was only when I switched to a wide-angle zoom, and looked through the viewfinder with the lens set to 17mm, that I found the shot I was after.

LEAD-IN

When photographing a relatively empty scene, it is useful to use something to draw the eye of the viewer towards one particular element that forms the focal point of the image. In the shot opposite the white foam 'pointer' does not actually go anywhere near the large offshore stack that is the focal point, but falls hundreds of metres short of it. A very wide-angle lens was used to emphasize the foreground, which appears to foreshorten the background, so in the picture the 'lead-in' or 'pointer' seems to go to almost the base of the rock. This is a deliberate optical illusion created by the appropriate lens choice for the desired effect.

Even though the early morning light was behind me, I was struggling to make an interesting image of the offshore stacks on Cannon Beach. The sky was not particularly inspiring, and the rock shapes looked less dramatic when lit from the front. As I wandered along the beach towards the rock, I came across a line of frothy bubbles that had been left in a place where a wave had retreated. I set up the tripod low to the ground, and positioned myself so that the meandering line led the eye to the giant haystack rock. Using a very wide-angle lens, the start of the line

of bubbles was emphasized by being placed just a few centimetres from the lens. This wide-angle lens has a large depth of field, but because the foreground was so close I stopped down to f22 to ensure that everything in the frame was sharp. One of the great things about photographing landscapes is that, unlike wildlife, they do not move around very much. In most cases the shutter speed is irrelevant, so you can use low ISO speeds for maximum quality, and small apertures to create a maximum depth of field.

COASTAL FLOWERS

Coasts have their own special flora. One of my favourite seaside plants is Thrift, which produces masses of pale pink flowers in May and June around the British Isles, including Shetland, where the next two images were taken. The pictures were shot at the same place using the same lens, but they are very different.

Both of the images featured overleaf show the plant growing in its environment. It exists on virtually bare rock, so it is hard to see where it gets its nutrients, and because it grows so close to the sea it gets covered with salt water at regular intervals, particularly during winter storms. Being able to adapt to such a harsh environment has its advantages. Many plants cannot survive in such conditions so competition from other species is very low. Thrift is certainly a success story, and it is a very common plant found in many coastal locations.

While wandering around the coast of Mousa looking for images, I was attracted to a particular rock. Not only

Above:

● THRIFT-
COVERED ROCK

Canon EOS 1Ds
Mark II, 28-135mm
zoom lens @28mm,
1/160th sec @ f11,
digital ISO 200

Shetland Isles, UK

Right:

● THRIFT
(*Armeria maritima*)
AND LICHEN

Canon EOS 1Ds
Mark II, 28-135mm
zoom lens @130mm,
1/250th sec @ f11,
digital ISO 400

Shetland Isles, UK

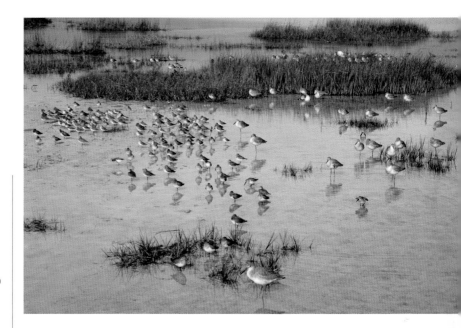

were there many Thrift plants on it in full bloom, but also due to the clean air of the Shetlands lichens thrived on it. The combination of the bright yellow lichen and pink flowers was irresistible. The dark sky in the background added drama to the scene, and contrasted nicely with the much paler rock in the foreground. The resulting image (top left) puts the prettiness of the flowers within the context of the constant struggle for life in the coastal environment.

The second image (bottom left), taken not far away, shows a much closer view of a Thrift plant growing among the same yellow lichens. By concentrating on a single plant and framing the image to exclude much of the surrounding environment, a very different picture emerges. The details of the Thrift, lichens and texture of the rock dominate the frame. I used the strong sloping lines in the rocks to give the image structure, positioning the camera angle so that the lines started in the bottom left-hand corner. In this type of image, with no reference points to the horizon, you have considerable freedom to move your camera around for the angle that best suits the composition you have in mind.

BIRDS AND COASTS

A number of bird species are typical of coastal habitats. The most obvious of these are seabirds, although many only visit the coast to breed during the summer months. The waders, on the other hand, tend towards the reverse, with large flocks spending the winter on coastal mudflats, which they are dependent on for food. Of course, these are not the only bird species to be associated with coastal

living, and many sea ducks and some geese are also reliant on this habitat for food and shelter during winter.

In my experience, the hardest pictures to take are those that show a bird actually with its coastal environment. It was easy to create the preceding images of Thrift using a wide-angle lens; plants, unlike birds, tend not to run away when you approach them. However, a location in Florida, where I found birds remarkably indifferent to human presence, provided an exception to this behaviour. I know of no other place on Earth where I could have taken the above picture of a group of mixed wading birds (or shorebirds as they are known in America).

The image was taken at Fort De Soto Park, on the Gulf coast of Florida near the city of St Petersburg. Being close to such a large city, the beach can be heaving with people, especially at weekends. Despite this, many waders winter here in large numbers – I guess they have become used to having people around. As the tide comes in and covers their feeding grounds, the waders gather together on the slightly higher ground, which remains dry or with only a shallow covering of water.

I noticed that a couple of people had walked quite close to a gathering of birds and had not disturbed them,

● MIXED WADERS AT HIGH TIDE

Canon EOS 1D Mark II, 24-85mm zoom lens @56mm, 1/250th sec @ f16, digital ISO 400

Florida, USA

so I thought I would try my luck. I decided against using a tripod because it might disturb the birds, and edged slowly forwards. None of the birds seemed worried by me, and I took several shots before retreating, still moving slowly so as to avoid disturbance. (Do not try this in Europe – if you do, you will send every bird within kilometres into a panic.)

The second image of a bird in its coastal environment, shown on these two pages, was taken at Olympic National Park using a more typical lens for wildlife photography – a long telephoto. The magnification factor of a telephoto lens is often essential for photographing birds because (apart from in Florida) they rarely allow a close approach.

The downside of using a long focal length is that the depth of field available is strictly limited, so getting both bird and background into focus is very difficult. In this image of a Brown Pelican diving into the sea between

● DIVING BROWN PELICAN (*Pelecanus occidentalis*) AND SEA STACKS

Canon EOS 1Ds Mark II, 100-400mm zoom lens @400mm, 1/400th sec @ f8, digital ISO 400

Washington State, USA

offshore stacks, the bird and the background are in focus, even though the picture was taken at f8, which is quite a wide aperture. This works because both the bird and the background are a long way from the camera. At a distance the available depth of field was at its greatest and encompassed both elements in the picture, even though the bird was much closer to the camera than the stacks. I would have liked to stop down to f16, but this would have

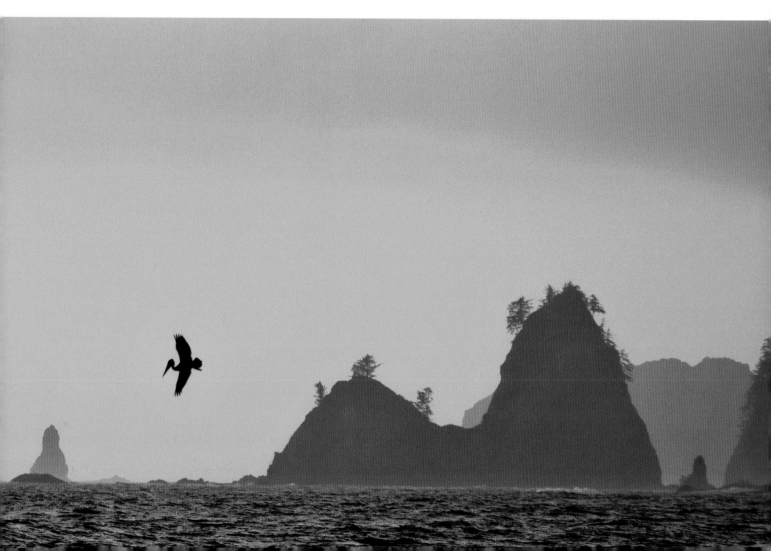

resulted in a 1/100th second shutter speed, which would not have been enough to freeze the pelican.

The final panoramic image was cropped from the original, which had far too much uninteresting sky in it. When taking the shot I wanted to frame the bird in between the two sets of stacks, so this determined the width of the composition. A few pelicans were present offshore and I had taken some pictures of them flying in between the stacks, but when this one prepared to dive I knew this was going to be the best shot of the session.

As I prepared to take the shot I was very much aware of a couple of seagulls that were hanging around hoping to benefit from any spare food should the pelican make a successful dive and come up with a fish. I did not want them in the picture, but could not do anything about it when the picture was taken. Later, while processing the image, I cloned out the gulls to create the image I had in my mind's eye when I pressed the shutter. The original RAW file also looked rather dull (as RAW files tend to do), so I increased the colour temperature during conversion. Finally I had created the picture I wanted through a combination of digital capture and post processing of the digital image.

I have included a small picture that shows roughly what the RAW file looked like straight out of the camera. There are some who would disapprove of any digital manipulation of this sort, but I take the view that as the creator of the image I am free to realize my artistic vision by removing distracting elements that I have no control over during the digital capture. As for the change in colour temperature, I could easily have set this when I took the

picture and nobody would have been any the wiser. I shoot in RAW, so am fully aware that the colour temperature can be adjusted after the event, which gives me much more control, and indeed artistic input, than settling on whatever the software in the camera comes up with. I am sure any artist using paints who witnessed the scene would not have included the distracting gulls in their painting. The beauty of digital is that photographers now enjoy similar freedom to control the final appearance of their own work. More artistic control is surely one of the big positives of the digital age.

INDIVIDUAL BIRDS

Apart from images that show birds in coastal habitats, coasts are great places for taking more typical bird pictures such as the shot opposite featuring a Sanderling running along the edge of the shore.

Sanderlings breed in the tundra of the far north, but spend their winters much further south. They are the archetypical shoreline waders, feeding right on the edge of the sea, where they run about like clockwork mice, up and down the beach following the waves as they break, then retreat back to the sea. I had always wanted to photograph one at full tilt, and on the tourist beach at Fort Myers early one morning I set up close to the shoreline and waited. There were several groups of these small waders scattered along the shore, but I saw little point in chasing them around. After a while one group approached from my left and I prepared myself for the shot. I kept as low as

SANDERLING
(*Calidris alba*)

Canon EOS 1D Mark II,
500mm lens + 1.4x
converter, 1/500th sec
@ f8, digital ISO 400

Florida, USA

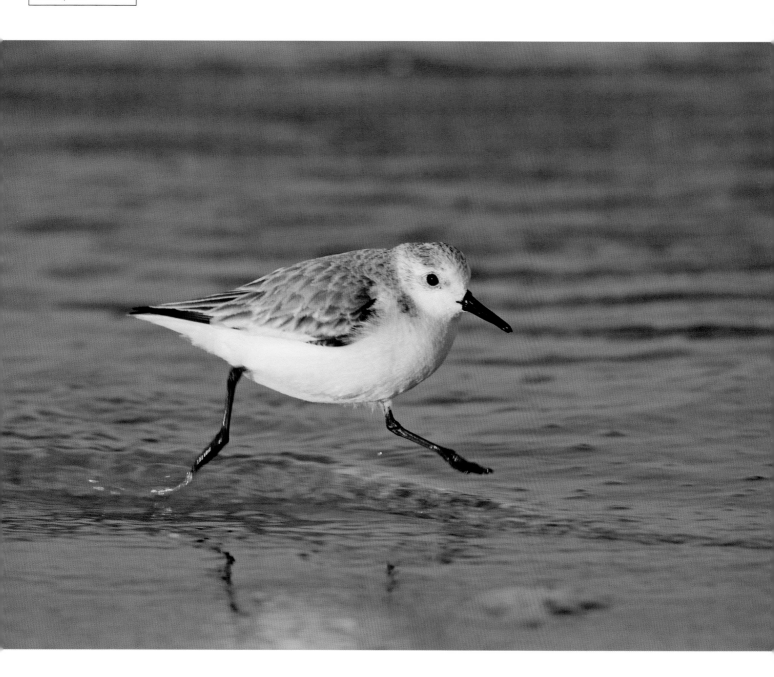

<table>
<tr><td>

● PUFFIN
(*Fratercula arctica*)

Canon EOS 1D Mark II,
400mm lens + 1.4x
converter, 1/400th sec
@ f8, digital ISO 400

Shetland Isles, UK

</td></tr>
</table>

possible, both to create a good photographic angle and to keep a low profile so as not to scare the birds away. Some distance behind the birds, a jogger was running right along the shoreline. Once the birds became aware of him, rather than fly off they simply ran along the edge of the sea, just in front of me. I tracked one bird in the viewfinder and got the shot I was after. It was only later, when I examined the results closely, that I noticed that both the bird's feet were completely off the ground.

No mention of coastal birds would be complete without that most popular of seabirds, the Puffin. It is hard to take a bad picture of these cracking little birds, with their colourful bills and upright gait. Moreover, like many seabirds that spend most of their life at sea, they seem to be far less wary of humans than their landlubber cousins, which is great news for photographers.

When photographing seemingly 'tame' birds, it is nonetheless important to treat your subject with respect and move carefully and slowly when making an approach. In this way you avoid frightening the bird, which is good both for the bird and for you because it will not fly away. Once you have taken your prize-winning shot, do not be tempted to suddenly stand up and whoop in triumph. You should show just as much care in backing away from your subject as you did getting close to it. If it remains in the same place after you have backed away you have done a good job.

This particular Puffin photograph was taken on the sea cliffs on the island of Noss in the Shetlands. The footpath on Noss runs all around the coast of the island. I had taken my 400mm lens, which is half the weight of the 500mm

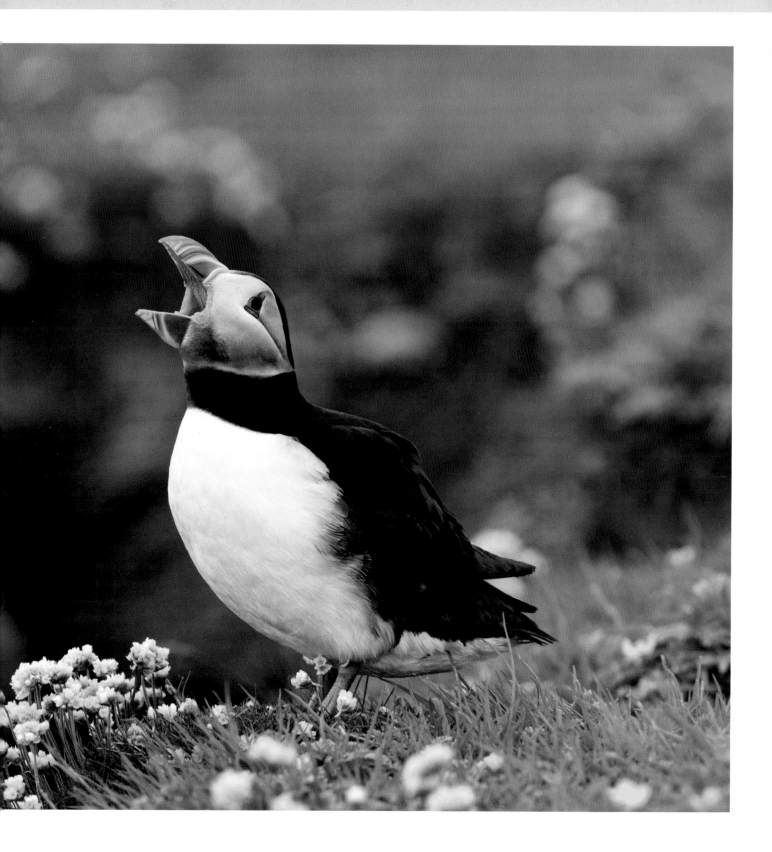

lens, and I could hand-hold it. IS is very helpful when you are hand-holding long lenses, and because I used it in this instance I did not have to take my tripod on the long walk either, so saving even more weight.

I have to confess that I am not exactly sure what the Puffin is doing. I spotted the bird standing among some Thrift and it briefly put its head up and opened its mouth. I focused on the bird and waited. Sure enough it did it again and I got the shot. It looks as if it is calling, but no sound was produced.

● COMMON SEAL
(*Phoca vitulina vitulina*)

Canon EOS 1D Mark II, 500mm lens + 1.4x converter, 1/650th sec @ f5.6, digital ISO 400

Shetland Isles, UK

MAMMALS

Seals are probably the mammal I most associate with coasts, and although they can be quite nervous of people when they are on land, once in the sea they become far more confident and will often come over to investigate you.

This was certainly the case with the Common Seal shown below, photographed on the island of Yell in the Shetland Isles. At high tide these seals would often visit a small harbour close to where we were staying on the

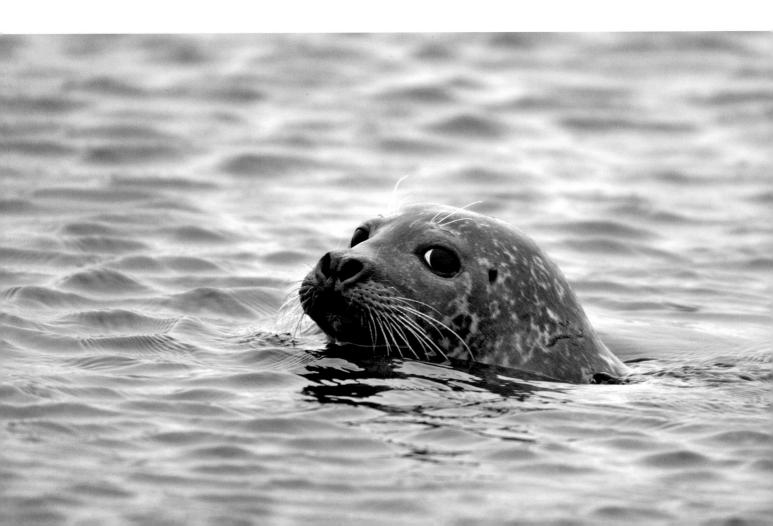

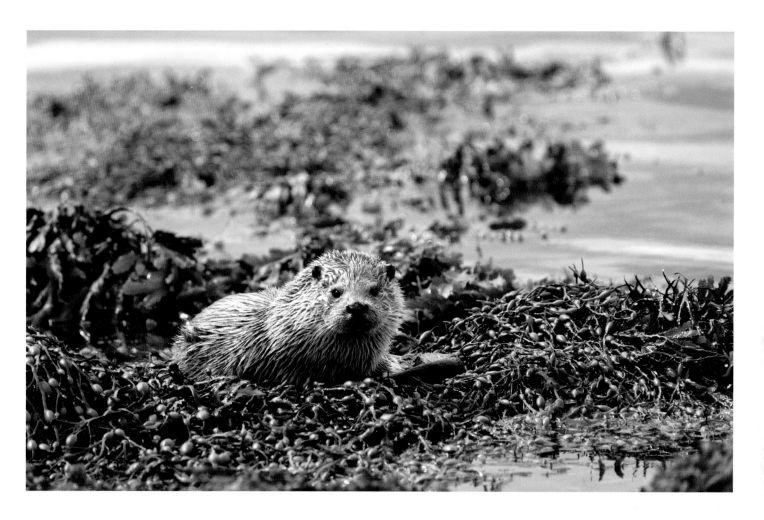

islands. My wife and I were sitting in the car alongside the harbour on a miserable grey-sky day with intermittent drizzle – a typical summer's day on Shetland, in fact. We had seen four or five seals swimming around and frequently diving below the surface, but no photographic opportunities had presented themselves. Suddenly a seal surfaced nearby and I quickly took some pictures. The first couple of images were not much good, but the sound of the rapid-fire shutter had clearly been heard by the seal, because it stopped briefly and looked towards me. Those big doleful eyes looking slightly back towards the camera created a very satisfactory image of this lovely animal.

Another mammal that is found along coasts in the Shetland Isles is the European Otter, and although

Shetland is its British stronghold it is still very difficult to see. My wife and I spent a month in Shetland and we only came across an otter on one occasion. I was photographing some birds when my wife spotted the otter swimming along the shoreline. We watched it from a distance, and saw it stop further along the shore among a large batch of seaweed. There was a gentle breeze, but it was blowing towards us so the otter could not detect our scent. I moved away from the immediate shoreline and set off slowly in the otter's general direction. I used some very large boulders as cover as I approached it. By the time I was in position and close enough for a shot, the otter had curled up and gone to sleep. It did not make a very good subject because I could not even see its head.

● EUROPEAN OTTER
(*Lutra lutra*)
Canon EOS 1D Mark II, 400mm lens + 1.4x converter, 1/1,000th sec @ f5.6, digital ISO 400
Shetland Isles, UK

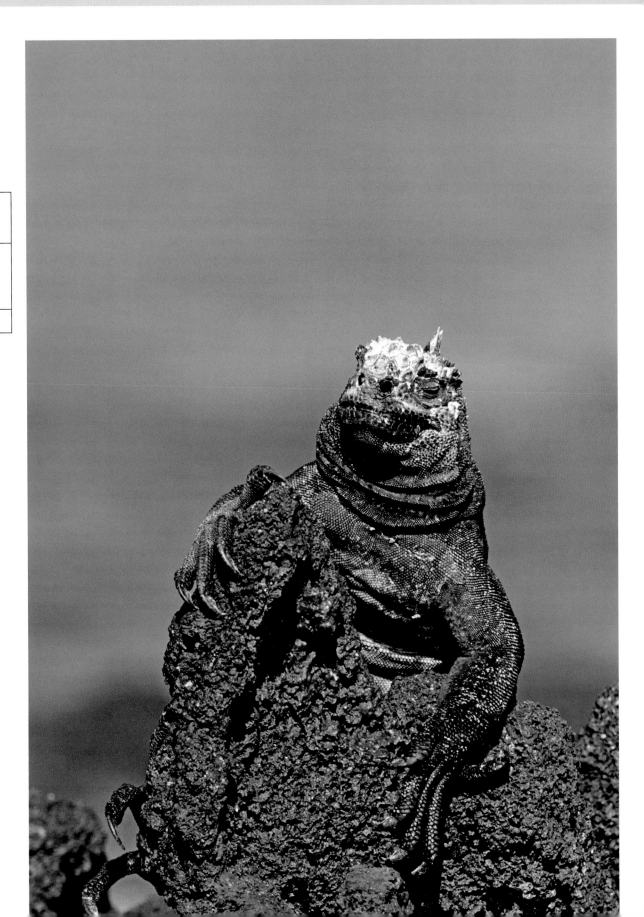

● MARINE IGUANA
(*Amblyrhynchus
cristatus*)

Canon EOS 1V,
500mm lens,
exposure unrecorded,
Fuji Provia film

Galapagos Islands

I waited around to see what would happen. A builder's truck eventually came along the road that runs parallel to the shore, and the sound of it woke the otter. As it looked up I got just a few pictures before this engaging animal returned to the water and swam off, no doubt looking for a more peaceful spot for its afternoon nap.

REPTILES

The seashore is not a great place to find reptiles, but one very special species has made the coast its home – the Marine Iguana, which is only found on the Galapagos Islands. This spectacular lizard can grow to up to 1.7 metres long, and has evolved to such a size because it feeds on algae growing on the rocks under the surface of the sea. Despite being on the equator the waters around the Galapagos are very cold. The larger the lizard, the longer it can stay in the water to feed, because a larger body takes longer to cool down. Being cold blooded, if a lizard stayed in the water too long it would become torpid and drown.

The image of the Marine Iguana shown opposite was taken on the island of Fernandina, where much of the shore is covered in the random shapes produced by old lava flows from past volcanic eruptions. Most of the iguanas we saw were lying flat on the surface, and with their long and rather thin bodies did not lend themselves well to photography. Then I noticed this chap, walking slowly across the lava. When the lizard reached an upright piece of lava, it hauled itself up and settled down in the afternoon sun. With its claws wrapped around the black

lava to hold itself in place, it made an interesting image. The background of similarly coloured lava distracted from the image, so I placed my camera bag on the lava and rested the long lens on it. I then lay rather uncomfortably flat on the rough ground and composed the shot, which at this low angle now had the blue sea as a background. It took a while to get everything set up in the right position, but fortunately the iguana was very happy in its new-found resting place and did not budge during the whole process.

WEIRD AND WONDERFUL TIDAL LIFE

Many interesting creatures that are specialists live in the littoral zone, the area of shoreline that is exposed at low tide. This is a strange environment that is revealed to us land-based observers twice a day before being covered again as the tide turns and the sea rushes in. Some of the most photogenic creatures found here must surely be the starfish, or sea stars as they are known in the USA. There are around 1,800 species worldwide, although by no means all of them live in the littoral zone. Those that do provide the land-based photographer with the opportunity to photograph these weird creatures without wearing a wetsuit.

I have included three images of starfish to give an idea of the variety of techniques that can be used to take interesting pictures. All were taken in Olympic National Park in Washington State, in the far north-western corner of the USA.

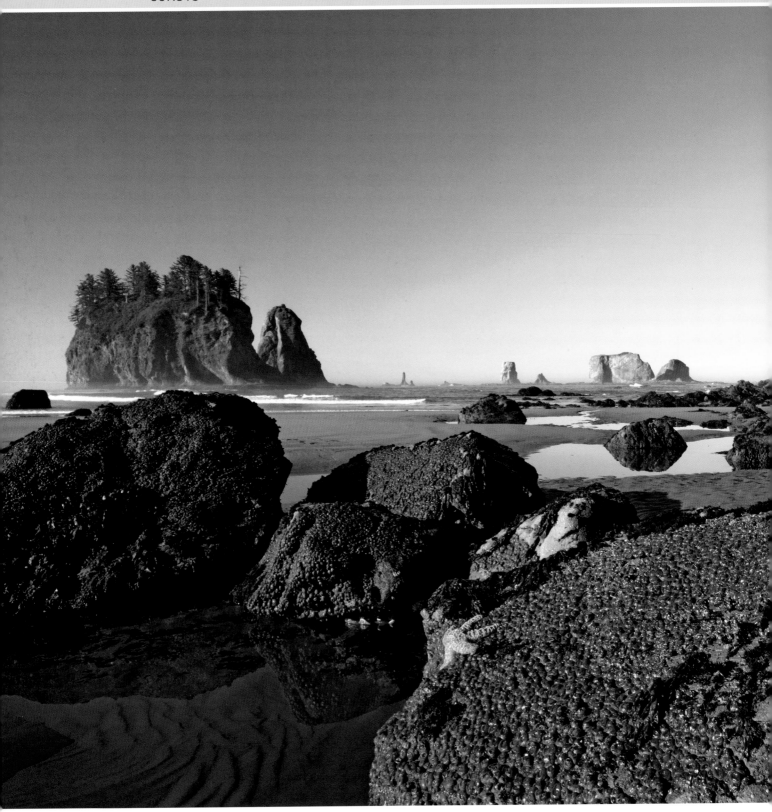

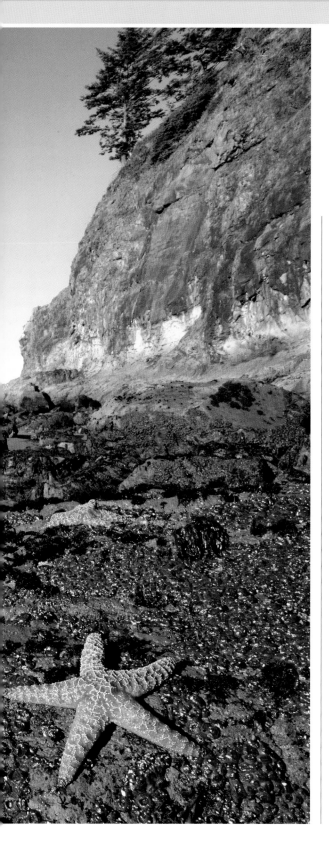

● SECOND BEACH
WITH STARFISH

Canon EOS 1Ds Mark II,
17-40mm zoom lens
@21mm, 1/25th sec @
f20, digital ISO 100

Washington State, USA

The first picture (left) returns to the theme of showing the subject in its environment, and was taken at the imaginatively named Second Beach. Low tide is essential for such pictures, because it is only then that the starfish can be seen. When we visited the area, low tide was in the early morning. This was good for photography, because apart from the nice light at this time of day, we were often alone. When I spotted a starfish clinging tightly to the exposed rock in an accessible position, I knew it would make a great foreground for the offshore stacks in the distance. It took a while to get my tripod set up in exactly the correct position. With the low sun behind me I had to ensure that shadows from both me and the camera gear did not fall across the foreground, especially since I was

● BLOOD STARFISH
(*Henricia leviuscula*)

Canon EOS 1Ds
Mark II, 28-135mm
zoom lens @135mm,
0.8th sec @ f22,
digital ISO 200

*Washington State,
USA*

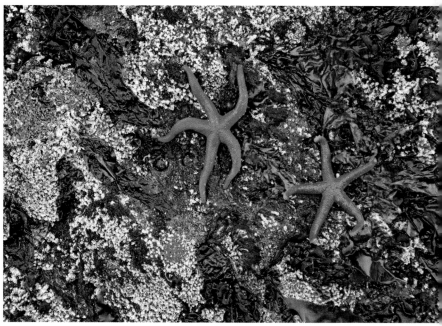

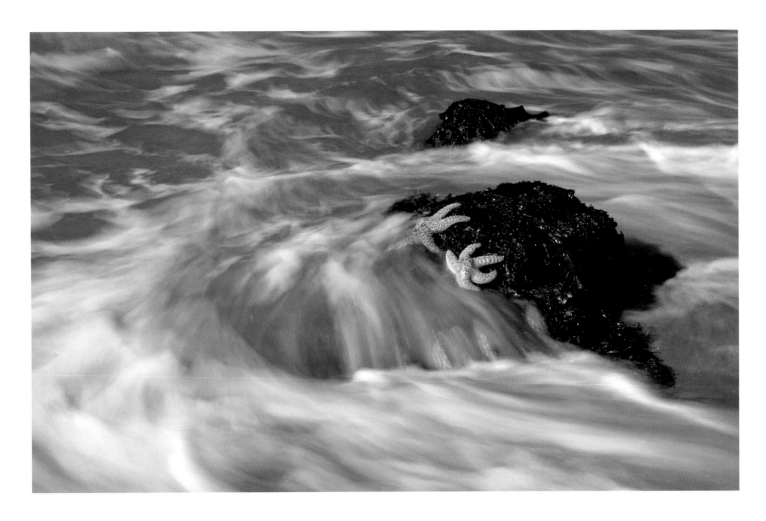

using such a wide-angle lens and was only centimetres away from the starfish.

The second image shown on the previous page was taken on Third Beach. It is a simple portrait of two of the smallest starfish we found in the area, called the Blood Starfish for obvious reasons. I did not want a real close-up because the various textures on the rock they were clinging to would add to the picture. I therefore composed the image, putting them right of centre rather than slap-bang in the middle. The central starfish is very flat on the rock, but the other one is slightly curled up at the edges. Quite why this is I do not know – perhaps it was trying to move. I like the incredibly bright colour of the starfish in contrast with the muted browns and greens of the background.

The final starfish image (above), also taken on Third Beach, took several attempts. The littoral zone is all about the movement of the tide, and I wanted to record this. As the tide began to turn, I searched around for a suitable rock with starfish that would soon be reclaimed by the sea. Once I had found it, all I had to do was set up my camera on a tripod and wait for the incoming tide. In order to show movement I wanted the slowest shutter speed possible, so I stopped down as far as the lens would allow and set the ISO to 'low', which was 50 ISO. I then added a polarising filter to reduce the light entering the camera even further. This gave me a shutter speed of 0.4 seconds. I would have liked this to be longer, but in sunny conditions this was the best I could manage. Camera manufacturers spend a lot of

time and money giving us ever-higher ISO values on their cameras, but sometimes it would be very useful to set the ISO at 10 ISO or even less. I suppose I really should get around to buying a set of neutral-density filters one day.

The problem with such slow shutter speeds is camera movement, but if the camera is set up on a sturdy tripod this should not be a problem. My tripod was set up on soft sand, however; as the tide came in and I took the shot, the incoming seawater shifted the sand under the tripod's feet and it began to slowly sink during the long exposure. I tried several times with the same result. Eventually I fetched a few stones from further up the beach, put them under the tripod's feet and rammed the tripod down into the sand as much as possible. This worked and I finally got the shot I was after, which shows the two starfish clinging to the rock as the tide sweeps over them.

For my final picture I have chosen a representative of one of the most familiar coastal animals, the crabs. This is not one of the rather drab-coloured crabs of my British seaside childhood, but the fantastically colourful and wonderfully named Sally Lightfoot Crab, photographed in the Galapagos Islands.

I encountered these crabs, which are common on the Galapagos Islands but not restricted to them, on several of the islands, but found them difficult to photograph. Whenever I approached them, they would skulk away and hide among the rocks. On the island of Fernandina, however, the crabs seemed much bolder and would scuttle around over the black lava shoreline scavenging for food. The lava made a dramatic background to my chosen crab, but being so dark needed to be taken into consideration

when determining the exposure. If used on automatic, the camera would have got it wrong and overexposed the crab. The picture needed to be underexposed by a stop compared with the camera's meter reading.

As the crab moved sideways over the lava it would raise itself up on its legs, and that was the shot I was after. I was working with a hand-held long lens and needed to maximize the shutter speed, so I was shooting wide open, giving me very little depth of field. I sat down and rested the lens on my knee so that I had some stability and was at a low angle. To ensure all of the crab was sharp, I positioned myself directly in front of it so that it was parallel to the back of the camera. This made the most of the limited depth of field available to me.

● SALLY LIGHTFOOT CRAB (*Grapsus grapsus*)
Canon EOS 1V, 100-400mm lens, exposure unrecorded, Fuji Provia film
Galapagos Islands

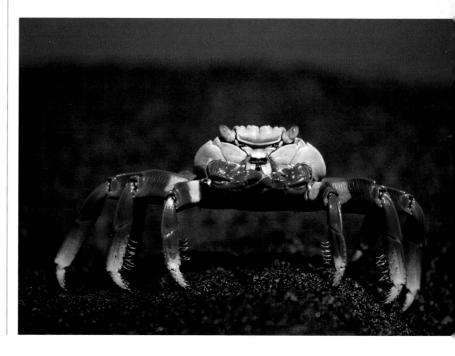

Forests

Forests cover an ever-diminishing percentage of the Earth's surface as humans do their best to destroy the planet that supports them. They are very important habitats that provide homes for countless thousands of creatures throughout the world.

THE FORESTS THEMSELVES provide fascinating photographic subjects, my favourites being the incredible autumn colours of the temperate forests of eastern North America. Tropical rainforests are the richest habitats on Earth, but are dark and damp places and do not easily not reveal their secrets to the visiting photographer. The wildlife within forests is often difficult to see, let alone photograph, so producing good images of the inhabitants can be very challenging indeed.

ON THE EDGE

Producing images of whole forests is actually extremely difficult, because it is hard to convey the scale of these environments in a single picture. Shooting forest interiors is completely different, as discussed later in this chapter. To show 'the forest' we really need to be outside shooting in, and this is surprisingly difficult to achieve. Unless you are fortunate enough to be in a small aircraft or helicopter, you will have to make the most of working on the ground around the forest edges. When visiting a suitable area, your first views of the forest are more than likely going to be from a car.

As a nature photographer I do not make a habit of including too many man-made objects in my pictures, but I could not resist the shot shown opposite, taken on a main highway in the Upper Peninsula of Michigan at the height of autumn colour. It appealed to me because the road gives it a strong graphic element, and it presented one of the few opportunities to give an indication of the scale of the forests, which are huge. The key to the image's success is the height that I was able to shoot from, which enabled me to include much more of the tree tops than would have been possible if the terrain had been flat. I chose a telephoto lens to effectively condense the perspective and reduce the amount of road that would be in the foreground, stopping down to make the most of the limited depth of field available when using such lenses.

I first noticed the potential of the place in my rear-view mirror as I was driving up the hill. The colour had not yet reached its peak, but I took a couple of test shots because we were staying close by and could return when the colours intensified. This can happen very quickly, and it was only a few days later that I parked the car on the verge at the top of the hill and started to set up for the shot.

By far the best composition required me to stand slap-bang in the middle of the road, probably not the most sensible spot from which to take pictures. I set up the camera on the tripod and set the exposure by the side of the road, then waited until there was no traffic and went to the middle of the road. I could clearly see if any traffic came towards me, but the biggest danger was traffic approaching from behind. For this reason, I would not recommend that you take such shots alone. While I was fiddling about with the camera, getting the composition just right, my wife kept an eye out for any traffic coming up behind me. This was not a particularly busy road, but cars and lorries would appear at annoyingly regular intervals. This meant not only having to move out of the road (and getting some strange looks from passing motorists), but also waiting for what seemed an age before the vehicles

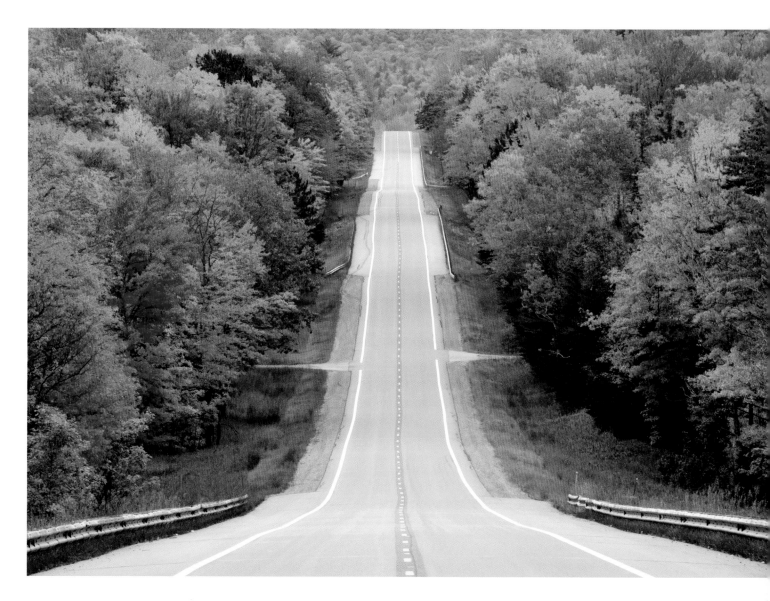

cleared the far crest of the road and disappeared from shot. In the end, though, I got the shot I was after.

Because most trees do not grow in water, lakes provide opportunities to photograph the forest edge, and such locations can make for very satisfying images. There are several factors that contribute to the success of the next image, shown overleaf, the most obvious being the reflection. Photographing reflections in this way requires very still water, which only occurs when there is no wind. The slightest breeze creates ripples on the water's surface,

and that perfect reflection is gone in a moment. Smaller lakes work best because they are by their very nature more sheltered than larger ones. You can increase your chances of getting good reflections by rising early, since the first hour of the day tends to be the calmest. As the sun warms the atmosphere later in the day, air currents occur that can quickly ruin your picture.

The clouds are also an important element in this image, and their reflections in the lake add symmetry to the scene. Using a wide-angle lens always makes the most

● MICHIGAN HIGHWAY
Canon EOS 1Ds Mark II, 100-400mm zoom lens @ 320mm, 0.8th sec @ f22, digital ISO 100
Michigan, USA

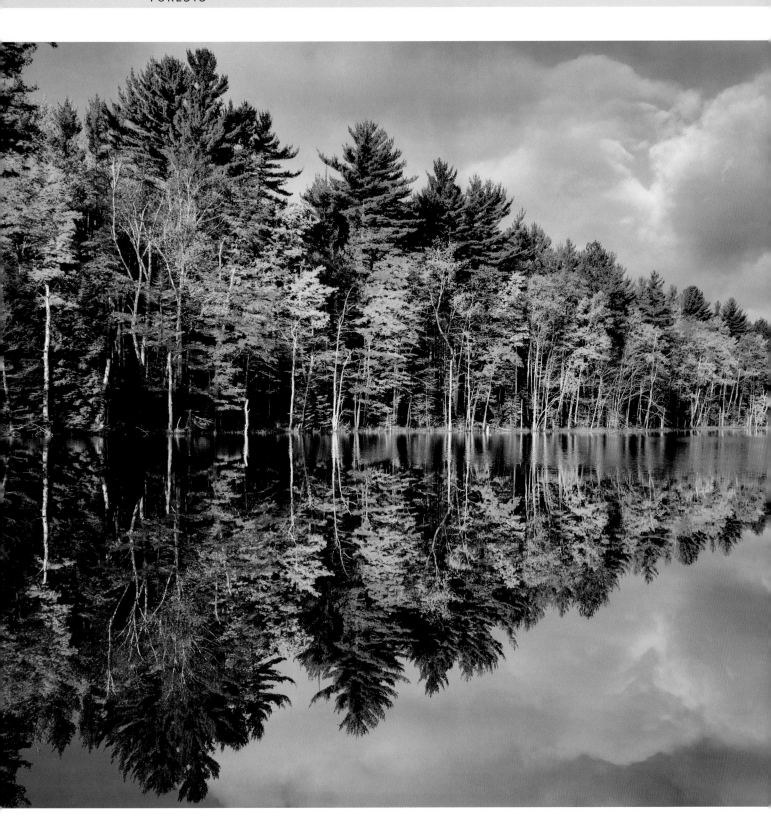

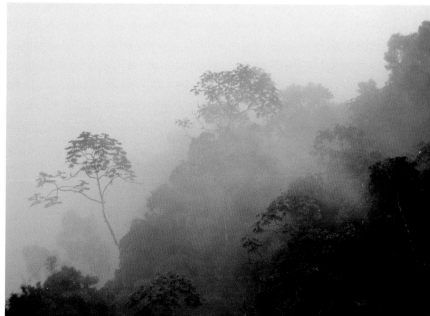

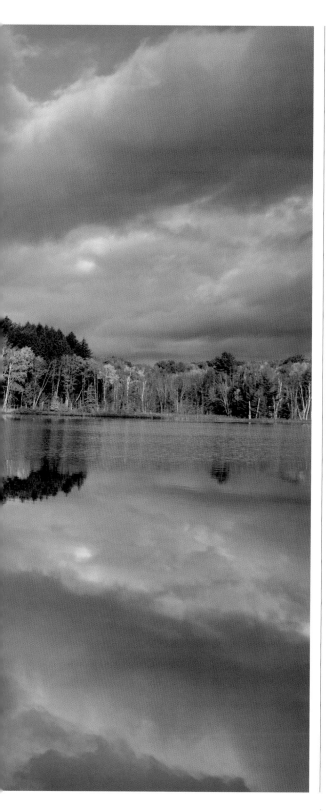

of cloud formations, and a polariser emphasized the small bits of blue sky. If you imagine this same picture with a clear blue sky, it would not be nearly as interesting; a dull, overcast and featureless sky would be even worse. The contrast range of the scene was too great for a single exposure to capture all the detail, so this is a composite of three separate exposures created using the technique known as HDR (High Dynamic Range, page 123).

The final forest-edge image, shown above, could not be more different from the previous shots, and features the Amazon rainforest during a rainstorm. Rainforests are notoriously difficult places to photograph, but I wanted to capture the atmosphere during one of the frequent downpours. The weather can change quickly in a rainforest. I had been sitting quietly on a small ledge attempting to photograph some of the forest birds, when the rain suddenly poured down. Retreating to the primitive lodge in which I was staying, I surveyed the forest around me, most of which was obscured by the heavy rain and low cloud (the forest was about 1,820 metres above sea level). The normal lush green view was now almost monochromatic and all detail was lost. I spotted a couple of Secropia trees

Above:

⬤ RAINFOREST IN RAIN
Canon EOS 1n, 600mm lens + 1.4x converter, exposure unrecorded, Fuji Sensia film, ISO 100
Peru

Opposite:

⬤ LAKE REFLECTION
Canon EOS 1Ds Mark II, 24-105mm zoom lens @ 24mm, HDR image @ f11, polarising filter, digital ISO 100
Michigan, USA

45

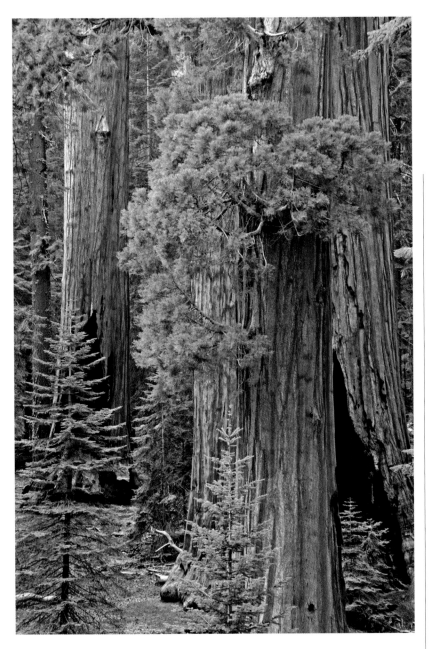

GIANT SEQUOIAS
(*Sequoiadendron giganteum*)

Canon EOS 1Ds Mark II,
28-135mm zoom lens @ 135mm,
1 sec @ f11, polarising filter,
digital ISO 100

California, USA

growing out of a hillside some distance away. Their distinctive shapes gave structure and interest to the scene, but they were too far away for a normal zoom lens. I do not usually take 'landscape' pictures with a 600mm super-telephoto lens, but I needed to add a 1.4x converter to reach out and compose the shot I had in mind. There were a couple of other photographers sheltering in the lodge,

and they thought I was mad shooting into the forest in pouring rain with such a huge lens, but I was very happy with the result because it captured the moment so well.

FOREST INTERIORS

Photographing when you are inside a forest can produce much more intimate forest portraits. When you are photographing in wide-open areas, it is relatively easy to find simple and clean lines with which to build your composition. Inside a forest there are so many subjects, all getting in each other's way and making it very difficult to find pleasing compositions. The first thing you have to do is make sure that the lighting conditions are on your side and undertake your forest forays on cloudy days. Light overcast is best, but anything other than sun will do. Sunny days produce far too much contrast for your camera to handle as light penetrates the dark interior, although you can try HDR techniques to overcome this. It is also best if it is not very windy, because you generally require slow shutter speeds and any wind-blown branches result in blurred images.

When my wife and I visited Sequoia National Park in California, we were plagued with bright sunny weather all day. This made it impossible to photograph the forest, so we spent the day exploring the area and looking for potential pictures should the cloud arrive. Unfortunately no cloud appeared, but as the sun approached the horizon at the end of the day there was a brief period before dark when parts of the forest were not affected by the sun. We

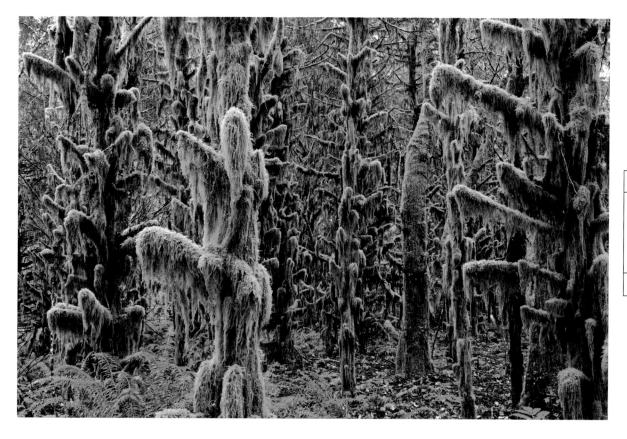

● MOSS FOREST

Canon EOS 1Ds
Mark II, 17-40mm
zoom lens @ 40mm,
5 sec @ f16, polarising
filter, digital ISO 100

Oregon, USA

worked very quickly, visiting as many of the sites we had identified earlier in the day as possible. The majestic Giant Sequoia trees loomed above us, their reddish-brown trunks contrasting nicely with the green leaves. My favourite image is shown opposite. I turned the camera on its side to make the most of the massive and very distinctive trunks of the world's largest tree, common in America before the arrival of Europeans, who felled more than 90 per cent of this fantastic ancient forest.

Further north, in Oregon, we encountered the moss-covered forest shown above. This forest was completely unprotected and has by now almost certainly been destroyed. We were exploring the back roads near the coast in Oregon when we came across this remarkable piece of forest. The area was being 'developed', and two new houses were being constructed nearby. The forest itself had a bulldozer track cutting a great swathe right

through it. It was a surprisingly small piece of forest, although no doubt the whole area would have looked like this many years ago. The north-west coastal region of the United States has a lot of rainfall, and the moist conditions provide an ideal habitat for the moss to grow. We found quite a few forests with moss-covered trees, many of them within protected areas, but this was by far the best.

The forest was very dense and with all that hanging moss had a surreal, rather fantastical air about it, like a set from a Harry Potter film. The best moss-strewn trees were well inside the forest, and I could not shoot them from outside because there were too many other trees in the way. I finally found a spot where I could get a view of a group of the best trees, but had to use a wide-angle lens to achieve it. This made life difficult because the angle of view with such a wide lens made it tricky to avoid the white sky. Eventually, though, I found a composition that worked.

THE CANOPY

CROWN SHYNESS

Canon EOS 1n,
20mm lens,
polarising filter,
exposure unrecorded,
Fuji Velvia film, ISO 50

Big Island, Hawaii

When photographing inside a forest, I usually go to great lengths to make sure that the sky does not appear in my pictures. There is one situation, however, where this cannot be avoided, and this is when you are shooting the canopy. As a photographer I am always searching for new compositions, and shooting directly upwards in a forest certainly provides a different viewpoint. This shot of the forest canopy shows the phenomenon known as 'crown shyness'. It occurs where trees growing adjacent to each other avoid contact by leaving small gaps between their outermost branches. I came across the forest when visiting Hawaii and was struck by the amazing patterns overhead.

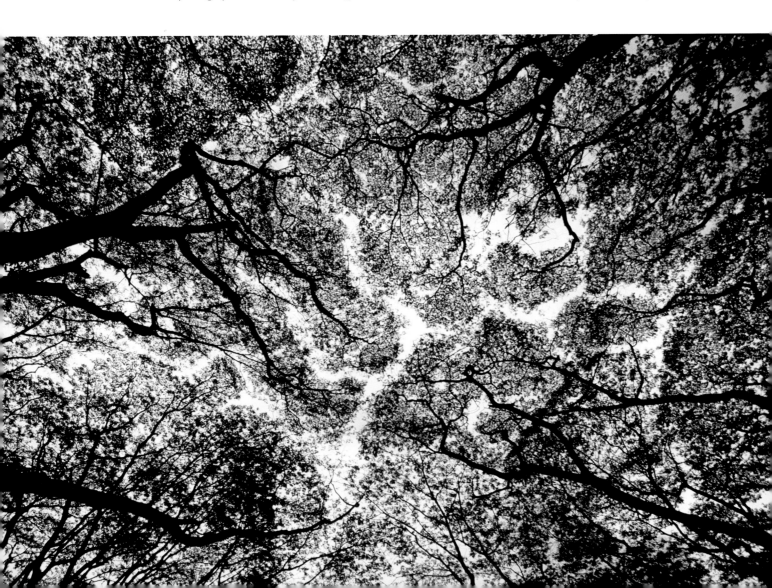

Wherever possible I like to use a tripod when shooting in a forest, but I wanted the camera to be as low to the ground as possible. It would have been difficult to get the camera set up low enough on the tripod, and even had I achieved this it would have been tricky to look through the viewfinder, then move the whole set up until I found the best composition.

I decided that the best solution was to lie flat on the ground and hand-hold the camera. Shooting directly overhead in this position allowed me to look through the viewfinder while steadying the camera against my head, which helped to prevent camera shake.

With a bright sky and shady forest, the scene was high in contrast, but I wanted to throw the trees into silhouette, so simply exposed for the sky. I wanted to show as much of the canopy as possible, and therefore used a wide-angle lens. As well as giving maximum coverage, the wide-angle lens produced the effect of distorting the tree trunks, making them appear to be tilting towards the centre of the image. The result is a surprising and graphic image that I was very pleased with.

FOREST FLOOR

Having covered what is above you, it is often worth looking down as well. The floor of a forest is often a bit of a mess, but if you can find something to use as a focal point it is possible to produce interesting images. The forest floor is also home to a variety of small plants, and particularly fungi, which thrive in the often dark and damp conditions.

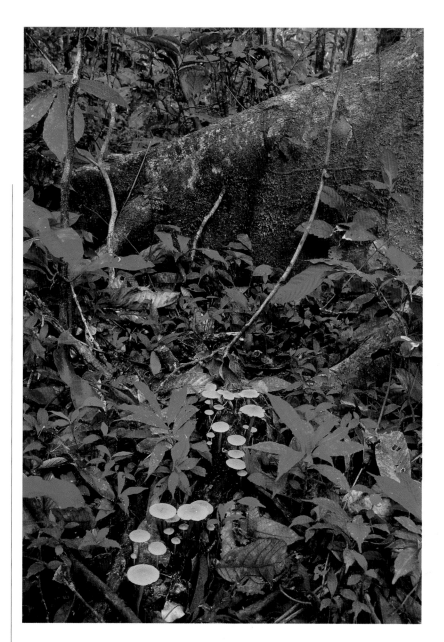

When I came across the above patch of bright orange fungi in the Manu Biosphere Reserve in Peru, I knew it would make an excellent picture. I composed the image so the fungi led the viewer's eye into the scene towards the tree-root buttress in the background. The buttress roots are a feature of rainforest trees, having evolved to help support the trees in the shallow soils, so they were a key element of the picture.

● FUNGI ON RAINFOREST FLOOR

Canon EOS 1n, 24-85mm lens @ 24mm, 90 sec @ f22, polarising filter, Fuji Velvia film, ISO 50

Peru

A polariser was essential to cut down on the light reflecting on the leaves; without it the leaves would have been rather washed out. Because a maximum depth of field was required to ensure that both the fungi in the foreground and the buttress roots were in sharp focus, I needed to use a small aperture. I was using Fuji Velvia film at the time and this was just 50 ISO. The slowest shutter speed on the camera was 30 seconds. However, with the very dim light reaching the rainforest floor, the camera indicated that even at this exposure, the image would be underexposed by one and a half stops. The camera did have a 'B' setting that would keep the shutter open as long as the shutter button was depressed. However, I could not use this manually because my finger

on the camera during the long exposure would have caused camera shake, and I did not have a remote camera release with me. What could I do? I needed a 90-second exposure, so for the first time ever I decided to make a multiple exposure. I took three 30-second exposures on the same slide. On returning from Peru weeks later and processing the slides, I must confess to being a little surprised that the image I had made was perfectly sharp.

In a rainforest environment the fruiting bodies of fungi can appear at any time of the year, but in temperate forests autumn is by far the best season to find the greatest variety of mushrooms. While wandering around a local wood looking for subjects, I chanced upon a little group of mushrooms growing on a rotting piece of wood. It was a damp autumn morning and the delicate parasols were covered in dew. However, the forest floor behind the mushrooms was a complete mess, and whatever angle I tried I could not make a suitable background from it.

Unless I am trying to convey a sense of the whole environment, as in the rainforest image of fungi taken in Peru, I prefer simple and clean compositions. When I am looking to photograph small subjects I often carry a small background sheet mounted on a stiff card. It was this that I used as a backdrop for the shot on the left, successfully excluding the undesirable background.

● MUSHROOMS
Canon EOS 1Ds Mark II, 100mm macro lens, 0.5 sec @ f16, digital ISO 100
Essex, UK

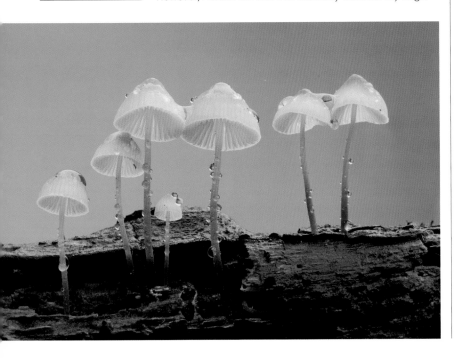

BIRDS

Forests throughout the world hold thousands of bird species, but are one of the most difficult habitats for bird

● THREE-TOED WOODPECKER
(*Picoides tridactylus*)

Canon EOS 1Ds Mark II,
500mm lens + 1.4x converter,
1/1,000th sec @ f8,
digital ISO 400

Finland

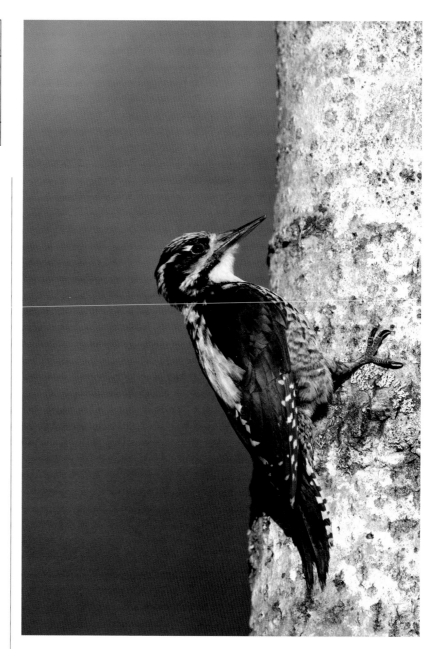

photography. If you visit a wetland habitat, for example, you can observe many of the birds immediately because you can see for miles. Your only problem here is getting close enough for photography. In a forest your view is very restricted, and although you may be able to hear birds all around you, you often cannot see a thing. This is particularly true of rainforests, which hold the greatest number of bird species in the world, but you can spend hours wandering around without seeing one of them.

It seemed very apt that I should include a species of woodpecker here, since these must be one of the archetypal forest birds. The species I have chosen is the Three-toed Woodpecker, which I photographed in Finland. It is not particularly common, and I would have had very little chance of coming across it on my own. Fortunately, I was given an exact location by a local bird guide, although I had to travel 145 kilometres to reach the site. This was in a woodland clearing, where a pair of the birds was nesting in an old Aspen tree. Much of the Finnish forest consists of commercial conifer plantations, and in some areas most of the deciduous trees have been removed. The clearing had been created when the conifers had been harvested, and fortunately a few large Aspens had been left standing.

The chicks inside the nest-hole had obviously hatched, and the parents were taking food to the nest every five minutes or so. The frequent visits were very good for photography. I turned the camera on its side and shot in portrait mode, because this suited the upright nature of the trunk and the bird when it arrived.

Much as I enjoyed photographing this somewhat scarce species that I had never photographed before,

I soon began to search for a more challenging image. The adults often simply fed the young at the nest-hole, but at other times they disappeared inside with the food and to tidy up the nest, occasionally removing the young's faecal sacks to keep the nest clean. When the adults left the nest they did so at some speed. I thought this would make a good picture, so set about capturing it with my camera.

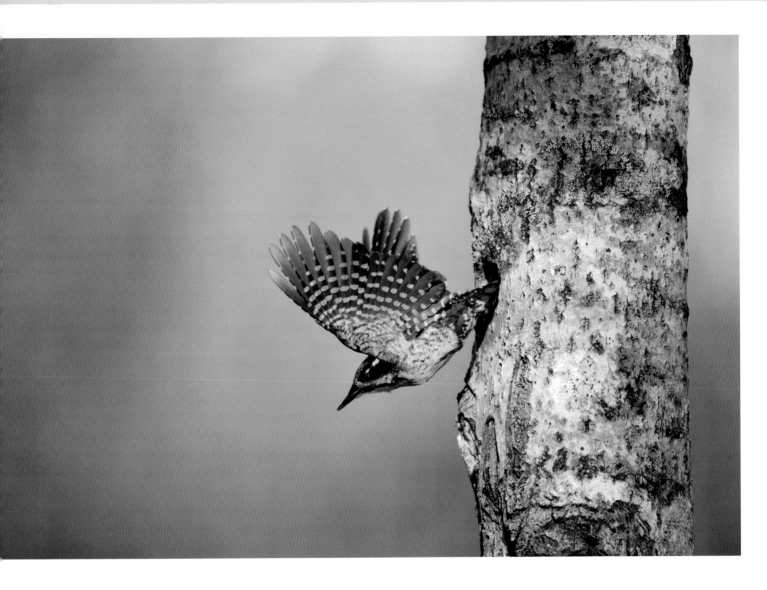

● THREE-TOED
WOODPECKER
(*Picoides tridactylus*)
LEAVING NEST

Canon EOS 1Ds
Mark II,
500mm lens,
1/4,000th sec @ f4,
digital ISO 400

Finland

To give myself the best chance of doing this I removed the 1.4x converter, but stayed in the same position, so the area covered was roughly twice that of the previous shot. This gave me more space in which to capture a bird as it left the nest-hole. I also turned the camera back into the landscape position and positioned the trunk on the right-hand side of the frame, allowing plenty of space as the bird flew out. Without the 1.4x converter I was able to use the maximum aperture of the lens, which is f4. The big advantage we had was that with the tree being situated in the open, we were able to work in bright sunshine. This

enabled me to shoot with a very fast shutter speed of 1/4,000th second, enough to freeze the fast-moving bird.

The most difficult part of getting the shot was trying to figure out exactly when the bird was going to leave. Several times it poked its head out of the hole and I would hit the shutter button, only for the bird to stop or drop something out of the hole as it tidied up. After several missed attempts and not a little swearing, I managed to catch the bird just as it launched itself out of the nest.

The image of a Tengmalm's Owl shown opposite, taken deep in a Finnish forest, demonstrates the main

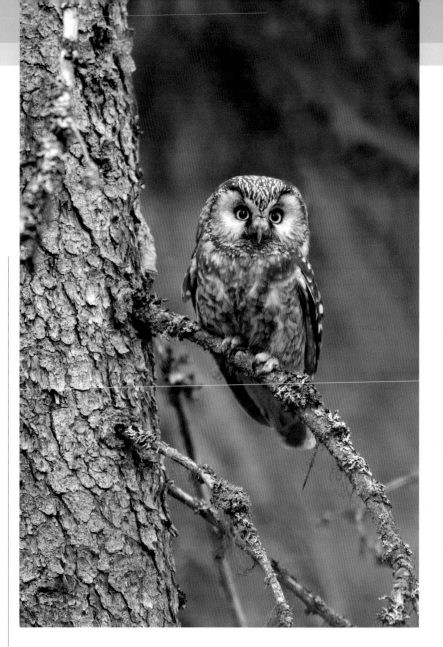

difficulty of forest-bird photography, which is the lack of available light. I was shown where the owl was breeding in a nest-box specially put up for this species. It was a long walk from the nearest road to the site, which was only photographable on an overcast day. On a sunny day the background would have been in dappled sunshine, and the contrast range would have been far too much for the camera to handle. The sun had been out on the day we were shown the site, and this was followed by a further three blue-sky days. Eventually, we got the cloudy conditions we were after and headed back to the site.

The owl did not seem to be bothered by our presence and sat around outside the nest site. I did not want to get too close, however, and used a 500mm lens and 1.4x converter. The ground was very soft and uneven, so it was difficult to make the tripod really steady. I had the lens set up on a Wimberley head and tried to keep the whole rig as still as possible. The shot had to be taken at a shutter speed of only 1/80th second, which is pitifully slow for such a long lens, but the lens I was using had IS, which is very useful when shooting at such slow shutter speeds. Even with this technology, care had to be taken when making the exposure; had the bird moved its head as the picture was taken it would have been blurred. Luckily, while all this was going on the delightful little owl simply sat and watched, allowing me to make a nice portrait. It was fortunate that our cloudy day turned up when it did, because I heard from the guide that the young fledged just two days later. When these owls fledge they disperse quickly into the extremely dense forest and are very difficult to find.

MAMMALS

Forest mammals are even harder to find than forest birds, and many of them are nocturnal. You would think that something as big as a European Brown Bear would be easy to find, but although this species is seen during the day by some lucky photographers, it is most often seen at night. In northern Finland this is in the month of June, although this is a relative concept, because it never really gets so dark here that you cannot see. My wife and I were in a very remote area of Finland, close to the Russian border and

● TENGMALM'S OWL (*Aegolius funereus*)
Canon EOS 1Ds Mark II, 500mm lens + 1.4x converter, 1/80th sec @ f5.6, digital ISO 400
Finland

53

about 50 kilometres away from the nearest town. To reach the hide in which we were to spend the next three nights, we had travelled the last 15 kilometres over rough gravel roads, taking enough food with us to last for the duration of our stay. We had to enter the small hide by 6 p.m. each evening, not coming out until 8 a.m. the next morning, because bears could appear at any time between these hours. With little activity early on, staying awake was the most difficult task, but when on the first night a pair of bears appeared at around 11 p.m. we were wide awake, watching the huge carnivores tear into the flesh of a long-dead moose that had been transported to the site in order to attract them. This was the first time we had seen these bears in the wild, and I could not quite get over how huge and powerful they were. When one came wandering over towards our hide and we stared at it through the thin plywood structure that was the only thing between us, they seemed even bigger.

Although it was dusk, I was able to shoot at 1/60th second, which was barely enough with the IS to prevent camera shake. Unfortunately, this was the earliest that the bears appeared during our time in the hide. On the final night, a bear turned up at around 2.30 in the morning. He seemed a lot more active than the bears usually were, and ran through the woodland at the edge of the clearing. Due to the low light levels I was shooting at the ridiculously

● EUROPEAN
BROWN BEAR
(*Ursus arctos arctos*)

Canon EOS 1Ds
Mark II, 400mm lens,
1/60th sec @ f4,
digital ISO 400

Finland

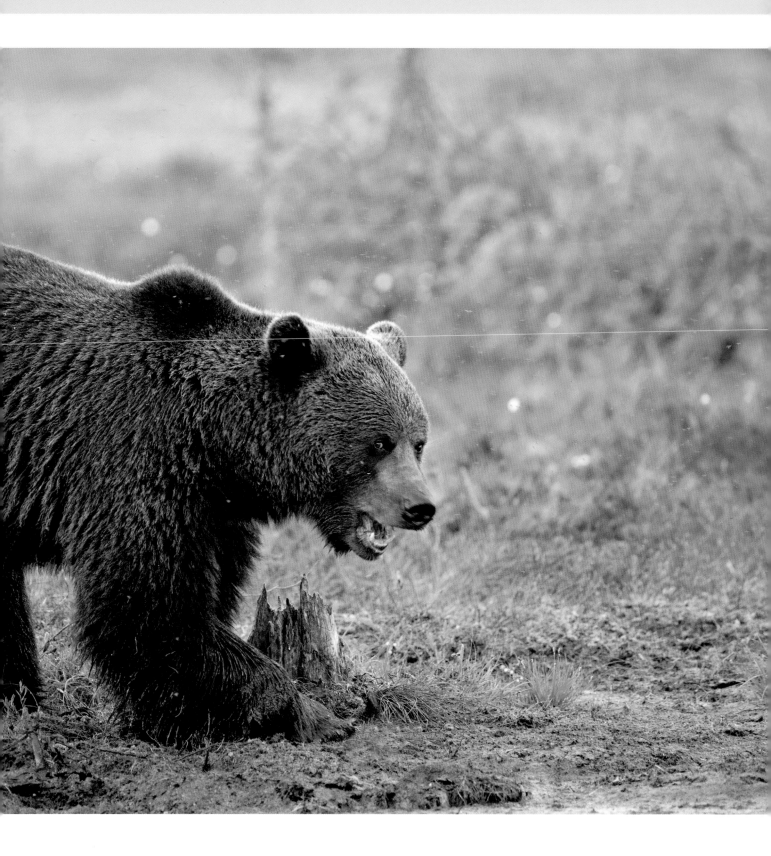

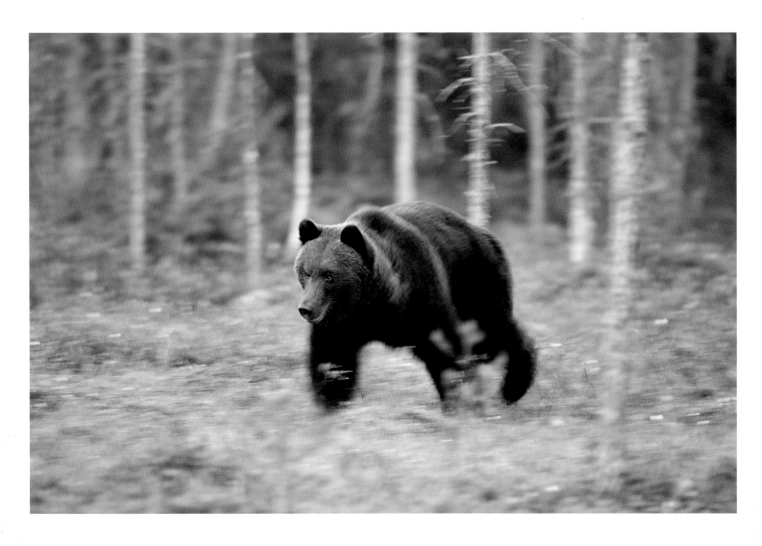

slow speed of just 1/15th of a second, but I panned with the bear as smoothly as I could in an attempt to keep the animal sharp. The result, shown above, is one of my favourite bear pictures, giving a real sense of movement. The forest trees are blurred and the legs of the bear also show the movement as it ran along. The head, however, is sharp, which is exactly the effect I was trying to achieve.

AMPHIBIANS AND REPTILES

Warm and moist tropical forests are home to a wide range of amphibians and reptiles, many of which make excellent photographic subjects. If you watch Hollywood films, you may get the impression that reptiles such as venomous snakes are hanging from every tree, waiting to strike you at every turn. This is not reality, however, and in my experience finding amphibians and reptiles takes a considerable amount of effort.

The Cane Toad shown opposite was discovered in the primitive toilet block at the place where I was staying in the Amazon district of Peru. I did not think the surroundings were suitable for a picture, so placed the toad in a large bucket and searched for something suitable to use as a background. The lodge had a huge Breadfruit tree growing in the grounds, and some of its large dead leaves were

scattered beneath it. I placed the toad on one of these. The little amphibian did not seem enamoured with its new surroundings and squatted with its head down low, almost touching the leaf. I was not very impressed with this pose, and very gently moved my finger under its chin and raised it up slightly. I half expected the toad to leap off and disappear, but it stayed in exactly my preferred position while I took its portrait. If only all animals would be so cooperative! I usually return an animal to the same spot if I have moved it, but in this case I decided to find some suitable habitat outside the toilet block for its release. I felt that was the least I could do.

The next image, of the amazing Mossy Leaf-tailed Gecko, is a little bit of a cheat because it is of a captive animal. Finding one of these in the wild would be very difficult, and I photographed this one at a reptile centre

● CANE TOAD
(*Bufo marinus*)

Canon EOS 1n, 100mm macro lens, flash, exposure unrecorded, Fuji Velvia film, ISO 50

Peru

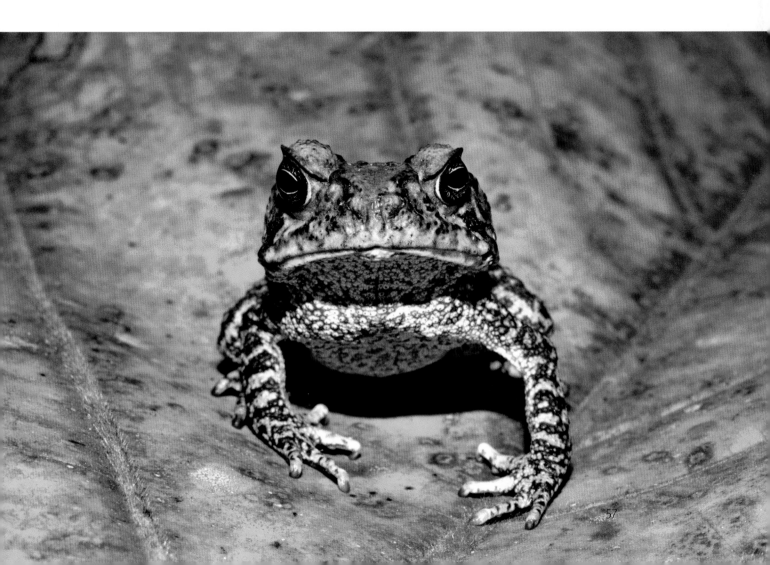

● MOSSY LEAF-TAILED GECKO (*Uroplatus sikorae*)
Canon EOS 1n, 100mm macro lens, exposure unrecorded, Fuji Velvia film, ISO 50
Madagascar

in Madagascar. A fantastic range of unique reptiles is endemic to Madagascar, but their future looks bleak as more and more forests are cleared by mining companies and the ever-growing human population. Given that humans only arrived on the island about 1,500 years ago, their impact on the fauna and flora has been catastrophic. To make matters worse, many species are collected by the local people to be sold for the international pet trade, from which there is a huge demand.

The entire genus of leaf-tailed geckos is only found in Madagascar, and the lizards are incredibly well camouflaged against the lichen-covered tree trunks in the forests in which they live. To take the above picture, I found a suitable tree trunk in the vicinity and asked one of the keepers to place the gecko on it. I chose a part of the trunk that was in the shade, because harsh shadows would have spoiled the image. The animal remained completely still on the trunk, and I was able to make a relatively long exposure in natural light. Like sunshine, flash would have added contrast, which would have detracted from the camouflage effect that was such an important element in the picture.

● SPIDER ON
TREE TRUNK

Canon EOS 1n, 100mm
macro lens, 1/200th
sec @ f16, TTL flash,
Fuji Velvia film, ISO 50

Peru

INVERTEBRATES

Forests are by far the richest habitat for invertebrates, and although they are small they are so abundant that they are relatively easy to find if you keep your eyes open. When I come across an interesting-looking subject I always try to photograph in situ, as some of these creatures have painful bites or stings, while others are covered in poisonous hairs that can cause great irritation with just a touch.

I have never been a fan of spiders, but when I saw one sitting flat on the trunk of a rainforest tree among some beautiful lichens in the Manu Biosphere Reserve, I could not resist taking its picture. Rainforests are particularly dark places, and it is often not possible to set up a tripod close enough to your subject. Without this stability, using either natural light or fill flash would be impossible due to the long exposure required, even with fast f2.8 or f4 lenses. When working with such small subjects at close range, depth of field is at a premium, so an aperture of f16 or even f22 is required, making the exposure even longer.

To overcome this limitation I use full flash. I set the camera shutter speed manually to the highest flash sync speed available on the camera – typically 1/200th or 1/250th of a second. The aperture is set manually to f16 or f22. Setting the flashgun to TTL flash I take the picture, which with a normal 'mid-tone' subject should be correctly exposed. With the instant feedback of digital you can quickly check the exposure, and make any adjustments using your camera's flash-exposure compensation controls. This approach enables you to hand-hold the camera, because you are shooting at a reasonable shutter speed.

● IRON PROMINENT
(*Notodonta dromedarius*)
Canon EOS 1n, 100mm macro lens, f16, around 1/8th sec, fill flash @ -2/3rds, Fuji Velvia film, ISO 50
Essex, UK

There are downsides to this technique, because images lit solely by flash can suffer from high contrast and harsh shadows. Flash fall-off can also be a problem, and if the background is even a medium distance behind the subject, it may well appear black or at least unnaturally dark in the resulting picture. The spider image shows the perfect situation for this technique – the tree trunk covered the entire background and the spider was flat against it, which resulted in very little shadow.

The second invertebrate image, shown right, is of a subject that I could control, allowing me to set up the composition exactly how I wanted it, and to use fill flash for a more refined result. Unlike the full flash used for the image of the spider, fill flash combines the natural ambient light with the light from the flashgun. This produces a more natural-looking result, with the flash picking up detail in the subject and lifting the image a little. When using fill flash I usually reduce the flash exposure by two-thirds of a stop. I find this results in a natural-looking image that has not been overpowered by the light from the flashgun.

Most moth species are nocturnal and often quite docile during the day, so with careful handling they can be placed on a suitable prop to be photographed. This moth was on a tree trunk, but I coaxed it onto a lichen-covered small branch that was on the forest floor, because this provided a much more photogenic resting place.

The woodland did not provide a good background because it was full of harsh shadows due to it being a sunny day, so I used an artificial background. If it is sunny, always make sure you keep your subject in the shade. It will not appreciate being placed in the heat of the sun.

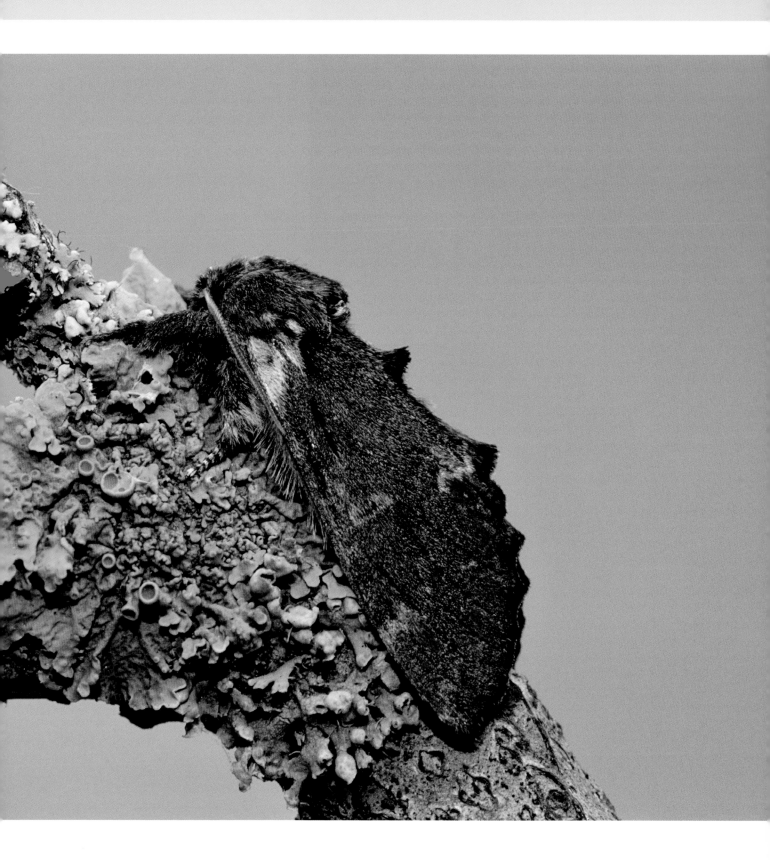

Arid regions

All life on Earth is dependent on water for survival, so the arid regions of our planet are the most difficult areas for life to exist in, and just finding wildlife – let alone photographing it – can be extremely difficult.

ON THE OTHER HAND, arid regions such as deserts can be wonderful places for photographing landscapes where the scenery changes colour before your eyes at both ends of the day as the sun rises and sets. Once the sun is high in the sky and the heat has increased, most animals seek shelter and the subtle colours of the landscape become washed out, so photography at this time is best avoided. In this chapter I have included the most obvious arid habitats of both sand and rock deserts, as well as environments that can have strong seasonal rains but dry up completely at other times of the year. From a photographic point of view, they both require similar approaches.

SAND

The first image depicts what most of us would consider to be the ultimate arid environment – the desert. There are different types of desert, but great sweeps of dunes disappearing into the horizon provide the classic desert image. The Namib Desert in Namibia has the highest dunes in the world, and I took this picture in beautiful low light at the end of the day. During the heat of the day the sand looked a rather boring beige colour, which turned more orange in the late afternoon. As the sun set, however, the whole scene took on a more reddish hue and the harsh

● NAMIB DESERT

Fuji 6x17 panoramic
camera, 105mm lens,
f16 @ around 1 sec,
Fuji Velvia film, ISO 50

Namibia

 GYPSUM
SAND DUNES

Canon EOS 1n,
20mm lens,
exposure unrecorded,
Fuji Velvia film, ISO 50

New Mexico, USA

shadows became much softer. We were travelling through this area over a rough sandy track, and our four-wheel drive vehicle got stuck. Against my better judgement, I had been persuaded by a farmer friend that his greater experience of driving such vehicles meant that he should drive, so I was not impressed when we ground to a halt. It was late in the day and we still had a long way to go, but the truck could not be shifted. I therefore headed off to take the picture before the light disappeared completely. Fortunately, on getting back to the vehicle I found that a passing tourist travelling by foot had turned up. With me driving he helped to push us free of the sand and we made it back to camp.

For great sweeping landscapes like this I love the panoramic format, and in the days before digital I used a special medium-format panoramic camera to capture such images. Everything on it was manual – even the focusing had to be done on the basis of the depth of field marks on the lens. You had to use a specially made neutral-density filter to even the spread of light across the entire frame, and you only got four pictures to a roll of 120 film.

I have not used the camera since converting to digital because I can now take several images on a digital camera and stitch them together afterwards to create a panoramic image, which is far more convenient. An example of a digital panoramic is included in the chapter on polar regions, but you could easily make the picture shown here using this technique.

The silica sand dunes, shown opposite, in the south of New Mexico, USA, provide a unique habitat with its own special challenges for the photographer. The first thing you notice about them is that they are not the normal 'sandy' colour, but completely white. The sand ripples are perfect for making strong graphic images, since they can be used to lead the viewer's eye into the distance. Although we visited the area in November, bright blue sunny skies were the order of the day, and this produced conditions that were of a very high contrast, something that would not be conducive to good images. As mentioned earlier, dawn and dusk are the best times for photography, and this picture caught the last of the sun's rays.

CANYON COUNTRY

The most photographed landscapes on Earth are surely in the great national parks of the south-western deserts in the USA. Grand Canyon, Bryce Canyon, Monument Valley, Zion and Arches all have an amazing array of landscapes just waiting to be captured. The trouble is that they have already been photographed time and time again by so many photographers. If you let this put you off, though, you would never go anywhere, and these places are popular for a good reason – they are incredibly photogenic.

Although you normally associate heat with deserts, this whole region is high desert, some areas of Bryce being over 3,000 metres above sea level, which can result in very cold weather at times, especially in winter. We arrived at Bryce in the evening in clear conditions, but on opening our cabin door before dawn the next morning we were very surprised to find that it had been snowing heavily – so much so that our car was completely covered and looked

● BRYCE CANYON
AND SNOWSTORM

Fuji 6x17 panoramic
camera, 105mm lens,
f16 @ around
1/4th sec,
Fuji Velvia film, ISO 50

Utah, USA

like a giant snowball. After brushing off much of the snow, we eventually found the door and made our way very slowly towards the park in extremely slippery conditions. Did I mention it was mid-June?

By the time we reached the first viewpoint the sun was already up, but the snow-covered landscape in front of us looked wonderful. The best spot was down a large number of icy steps. We gingerly made our way to the bottom, using the tripod legs to break away the ice from the worst

sections. Having reached the bottom, it became clear that a storm was approaching because the sky was gradually turning black as the clouds rolled in towards us. The sensible thing to do in these circumstances would have been to take a number of pictures on my 35mm camera, which would have been quick and easy. However, the scene before us cried out for a panoramic.

It takes a while to set up and work out the exposure for a manual panoramic, and I did so with the black sky

66

looking more and more ominous. By the time I had exposed the second roll of film the show was over. The wind suddenly got up and the storm hit. I turned my back to the wind and removed the camera from the tripod, placing it under my parka to protect it as much as possible. This was just as well because the tripod then blew over. We gathered up the rest of the gear and made the slow climb back up the frozen steps. It was a relief to finally reach the shelter of the car without losing any equipment or falling over. The picture is one of my favourites of the incredibly beautiful landscape that is Bryce Canyon.

Unlike the dune systems of the sandy deserts, the high deserts are composed of sandstone rather than sand. This is a relatively soft material, and when the sun is low it glows as it reflects the soft warm light, with the rocks turning a riot of yellows, oranges and reds. The following image of balanced rock, in Arches National Park, could not demonstrate this better. It had been a rare cloudy day in

● BALANCED ROCK
Fuji 6x17 panoramic camera, 105mm lens, 6 sec @ f16, Fuji Velvia film, ISO 50
Utah, USA

the park and I was struggling for pictures, but as dusk approached a small gap appeared in the clouds along the western horizon. Because this was where the sun was going to set, I set up my Fuji panoramic in the hope that the sun might peep through before it set. I wanted to incorporate the two large rock formations on either side of the balanced rock itself, so unless I included lots and lots

of boring sky, the panoramic format was the obvious choice. We waited for a long time in dull flat light; suddenly, without warning, the rocks lit up as the dying rays of the sun finally dropped below the cloud.

The colour was stunning, the deepest red I have ever seen in the region. I had to work rapidly because these effects are only fleeting, and quickly took a meter reading

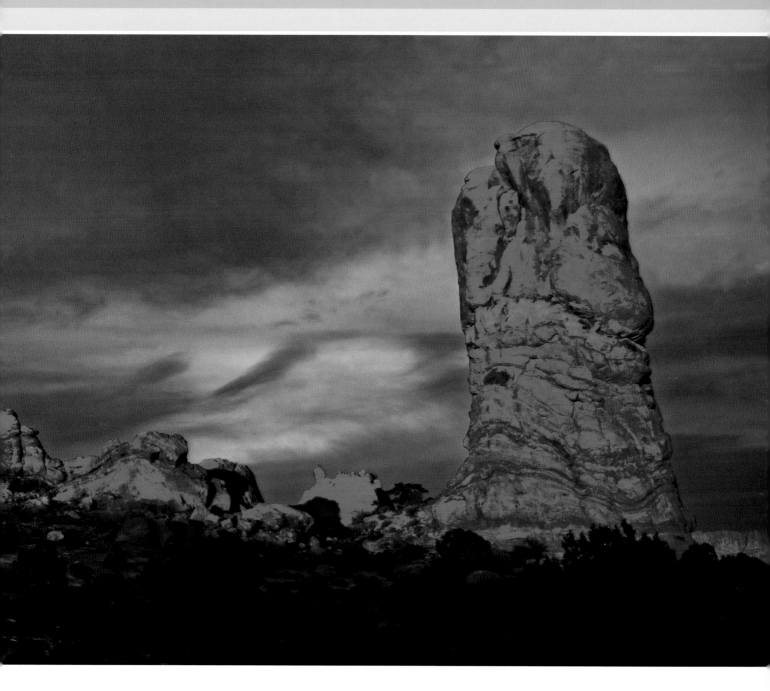

with my 35mm camera, using this as a guide to set the
manual exposure on the panoramic. I remember to this
day that it was a very long six-second exposure, and that
by the time I took the last of the four frames on the roll of
film, the light had gone. There had not even been time to
put the 35mm camera on the tripod for some back-up
shots of the incredible light.

USING BACK LIGHT

The deep canyons of the high deserts can provide dramatic
backlighting that can be used to create some interesting
images. The Grand Canyon runs roughly east-west, so at
sunrise and sunset the light streams along the canyon.
When shooting with the light behind you, the warm light

GRAND CANYON

Canon EOS 1n,
100-400mm lens,
exposure unrecorded,
Fuji Velvia film, ISO 50

Arizona, USA

of the low sun produces the deep colours seen in the previous images. When shooting against the light, along the length of the canyon, you get a completely different effect, and the image takes on a bluish hue. This was the case one morning when I visited the desert view area of the canyon.

The shot below was not immediately obvious because it formed just a small part of the huge landscape before me, but I was drawn to the numerous overlapping ridges in the distance. I therefore set up with a long zoom lens and concentrated on this area. Using a long lens not only enabled me to isolate the elements I wanted in the picture, but also had the effect of compressive perspective, so that the ridges appear much closer to each other than they really are. The result is a very different image of the much-photographed Grand Canyon.

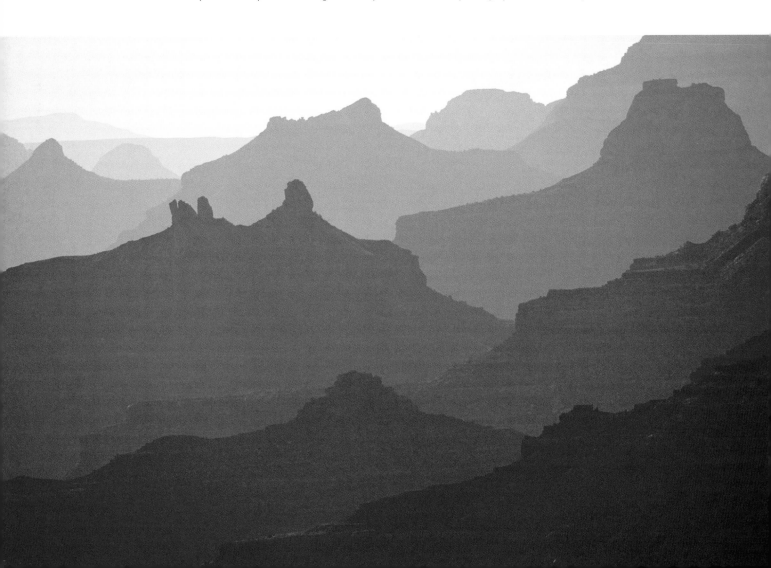

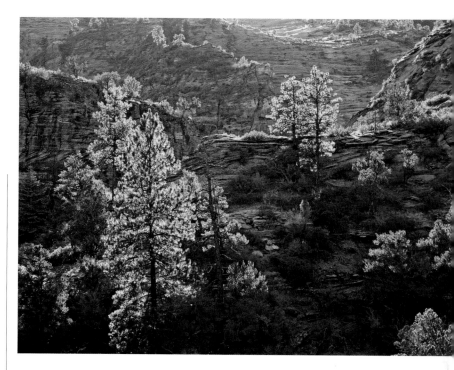

Zion National Park is different from most of the other canyon country parks. Instead of being on top of the canyon looking down, you drive through the canyon's bottom with much of the surrounding scenery towering above you. Zion is less bare than the other sites, and has many pine trees and shrubs growing in the lower areas by the road. It is these features that can be used to produce images that are a little different from the standard ones. You need to utilize your telephoto lens to make the most of the situation, and be on site just after dawn. As the sun rises slowly above the canyon rim, it catches anything standing upright in the canyon, but the steeper west-facing rock that forms the canyon wall remains in shadow. This contrast can be exploited to make very pleasing pictures, as shown in the example of back-lit conifers on the right.

To make images like this you have to move fast, because the interesting light does not last for long, disappearing quickly as the sun rises higher in the sky. Exposure is also difficult, since it is easy to blow out the highlights in this situation, especially if you rely on your camera's meter, which will almost certainly get it wrong. With digital, a quick check of the histogram after the first exposure enables you to identify any overexposed areas and adjust your settings accordingly. The other problem when shooting against the light is flare caused by the sun shining directly into the camera lens. To overcome this a lens hood is essential, but I often use my hand or a paper to provide additional shade for the lens when the sun is particularly low. Needless to say, you must check the viewfinder carefully to make sure that your hand or the paper does not obscure the picture.

The back-lit image of Zion Canyon on the next page takes things to the extreme, in more ways than one. While driving around the bottom of the canyon in the early morning, I noticed that as the sun just clipped the canyon rim, any plants growing on it were lit up dramatically, as though a searchlight had been turned on them. There were several problems to be overcome in photographing this scene, not least the distance of the potential subject. Due to the large size of the canyon, its rim was a long way off. Fortunately I had my 500mm wildlife lens with me. I set this up on the tripod with a 2x converter attached, giving a 1,000mm focal length.

The next problem was potentially the most serious one. Due to the extremely strong light, I felt a little uneasy about looking directly into the sun through the very long lens. The canyon rim light is very fleeting indeed and is over in a few seconds, but it is predictable once you have found a spot on the rim where the sun is about to rise over the lip. As the first rays lit the top of the plant I had selected as my subject, I pointed the camera quickly at it and composed the image before the sun rose any further,

● BACK-LIT CONIFERS
Canon EOS 1n, 100-400mm lens, exposure unrecorded, Fuji Velvia film, ISO 50
Utah, USA

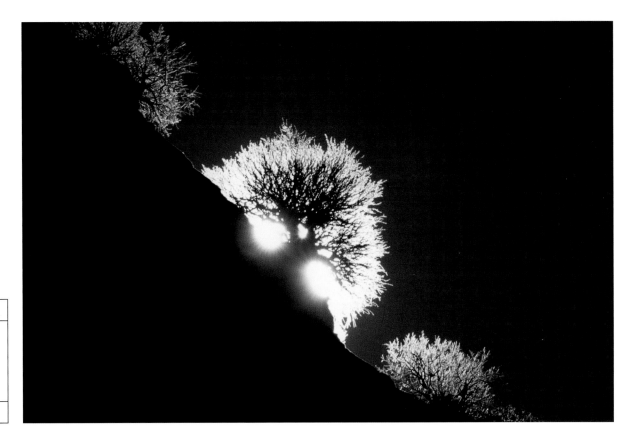

● CANYON RIM LIGHT

Canon EOS 1n,
500mm lens + 2x
converter,
exposure unrecorded,
Fuji Velvia film, ISO 50

Utah, USA

stopping the lens down manually so as to reduce the effects of the sun on my eyes. Once I had planned the composition, I removed my eye from the viewfinder and started making exposures – lots of exposures. The sun was very bright indeed and I did not want to overexpose the whole scene, although I realized that the highlights would blow anyway unless the rest of the picture was completely black. To give myself the best chance of getting it right, I used the camera meter's exposure and auto bracketed two stops either side of this, in one-stop increments. I cannot remember exactly what the exposure was, but it was pretty extreme, stopping down to f16 (effectively f32 with the 2x converter) and shooting in thousandths of seconds. When I had the slides developed, I found that the last few on the roll were completely blown out, but the camera and – most importantly – my eyes were not damaged by the encounter.

UP CLOSE

The starkness of the desert environment has so far been a feature of this chapter, and this theme can be represented in the most unlikely details that the photographer can seek out with a practised eye. I am always on the lookout for patterns in nature, and thought a dried-up lake bed in the Namib Desert would make an interesting, rather abstract image. The lake bed had dried up relatively recently, and the cracked mud left behind retained its structure. There seemed to be two levels of cracks – every large mud piece was separated by quite wide cracks, and each of the separate pieces had much smaller cracks in them. The picture opposite works not only because of the patterns and the abstract nature of the shot, but also because it leaves no doubt that this isolated detail could only have come from an arid environment.

● DRIED LAKE BED

Canon EOS 1n,
28-135mm lens,
exposure unrecorded,
Fuji Velvia film, ISO 50

Namibia

● SAGUARO CACTI
(*Carnegia gigantea*)

Canon EOS 1n,
300mm lens,
exposure unrecorded,
Fuji Velvia film, ISO 50

Arizona, USA

PLANT LIFE

Of the plants associated with the desert environment, cacti must be the best known. They can survive in the driest of environments, and are found in suitable places in the Americas. The biggest is the Saguaro Cactus, which can grow to more than 15 metres high and live for well over 100 years. These magnificent plants are common in southern Arizona, and while photographing them I was struck by the slight halo effect produced when they were back-lit against the low sun. This was caused by the light catching their rather soft downy spines, which let through some of the light, with the main body of the cacti blocking the light completely. The effect was only visible when the cacti were viewed against a dark background. Fortunately the location was hilly, and using a long lens I was able to compose my shot against the hillside and omit the sky from the picture altogether.

As I moved the lens around looking for a suitable composition, I noticed that the more out of focus a cactus was, the greater the halo effect became. Intrigued by this, I experimented by throwing the whole scene out of focus, and eventually created the rather ghostly image of these desert giants that you see in the second picture. Some nature photographers are not comfortable with this type of 'arty' image, feeling that such pictures have no place in 'nature photography'. Personally, I do not subscribe to this view and am always looking for new and interesting ways to portray the natural world. I love creating straightforward, beautiful images from the world around me, but also get a real sense of satisfaction from creating an image that uses

● SAGUARO CACTI
(*Carnegia gigantea*)

Canon EOS 1n,
300mm lens,
exposure unrecorded,
Fuji Velvia film, ISO 50

Arizona, USA

nature as a starting point, with my own creativity added to the end product.

The Quiver Tree is a large desert plant that grows in the most arid regions of southern Africa. Despite its name it is a not a tree at all, but a member of the aloe family of succulents that can grow to more than 6 metres high. It has a very distinctive shape, and it is this aspect of its appearance that makes it look good in a silhouette. One of the difficulties of working in a desert environment is that it tends to be very sunny, with few if any clouds around. Good sunsets are dependent on the presence of some cloud which, when lit by the last rays of the sun as it drops below the horizon, are turned to the pink, red and orange colours that create the perfect sunset backdrops.

Determined to make the most of my Quiver Tree silhouette plan, as dusk approached I searched around for a suitable composition. There were lots of Quiver Trees around, and as is usual in this type of situation, they tended to get in each other's way. I was after stark silhouettes, so it was particularly important for there to be space between them in the picture. I could have chosen to isolate just a single plant, but thought this would make a much less interesting picture than would a small group. Eventually, I found the grouping you can see in the picture overleaf. I positioned myself so that the western horizon was behind the trees, because this was where the sun would go down. The trees were all leaning slightly to the right, so when framing the shot I left more space on the right than the left, giving a more balanced composition.

Even with no clouds, as the sun disappears the western horizon often glows orange for a short while. It is

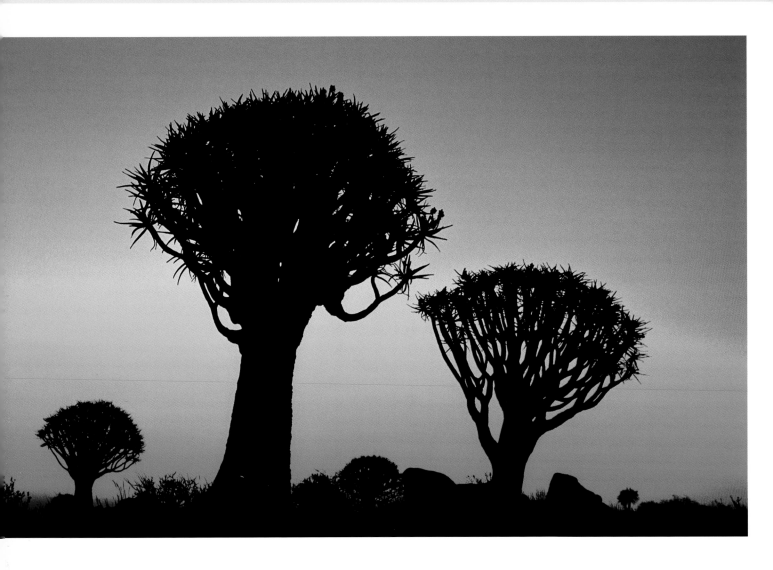

QUIVER TREE
(*Aloe dichotoma*)

Canon EOS 1n,
100-400mm lens,
exposure unrecorded,
Fuji Velvia film, ISO 50

Namibia

this narrow band of colour that I used as my backdrop. As mentioned, the choice of lens and distance from the subject was crucial to ensure that the orange band was as large as possible in the picture. A long lens used further away would achieve this, but to make the most of the colour I needed to be as high as possible, in order to shoot slightly down towards the horizon. The terrain was pretty flat, but I did manage to find a large rock on which the tripod could be placed and set up at its maximum height. Even though I am tall I could not see through the viewfinder, so had to manoeuvre a nearby rock into place to stand on to make the final adjustments.

So far the plants discussed have been large species that can conserve enough water to survive as permanent structures in the arid regions of the Earth. There are many much smaller and more delicate species that exist on the very edge of survival in these areas, growing, blooming and dying in a short season, sometimes only once every few years. One such plant group is known as the 'everlastings' due to its characteristic paper-like flowers, which when dried and used in flower arranging keep their colour and form for a long time.

The plants are most common in the dry, desert-like regions of Western Australia, emerging from the sandy soils

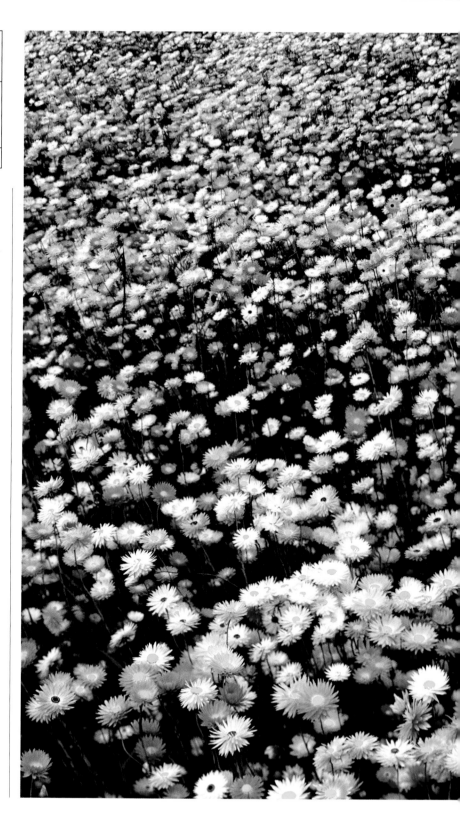

ROSY EVERLASTINGS
(*Rhodanthe chlorocephala rosea*)

Canon EOS 1n,
90mm tilt and shift lens,
125th sec @ f8,
Fuji Velvia film, ISO 50

Western Australia

in the late winter months. This is not an annual occurrence, however, because the seeds from previous generations only bloom after there have been sufficient winter rains. When this happens, areas of previously featureless scrubby desert are transformed by carpets of flowers that are making the most of the opportunity to reproduce and set seed, before disappearing again prior to the arrival of spring, when the weather warms up and the land dries out completely.

We visited the region after heavy winter rains, and according to the locals the flowers were the best they had seen for at least ten years. The owners of the small roadhouse we stayed in, which was surrounded by flowers, had lived there for four years but had never seen a flower in the area before. Some of the flowers grew in loose groups, but they were most impressive when they formed dense mats that completely covered the ground. I wanted to reflect this density of blooms in a picture. However, because the flowers were quite small this necessitated getting quite close to those that would appear in the foreground. This would restrict the depth of field, but I could not use a small aperture to increase it because there was always a slight wind that was moving the delicate blooms around. The solution was to use a tilt and shift lens to 'tilt' the plane of focus across the tops of the flowers instead of in its normal vertical position. This enabled me to use a much wider aperture and in turn a faster shutter speed, preventing the appearance of any wind-blown movement in the flowers in the shot.

I was particularly taken with a little group of white everlastings on their comparatively tall and thin stems, the

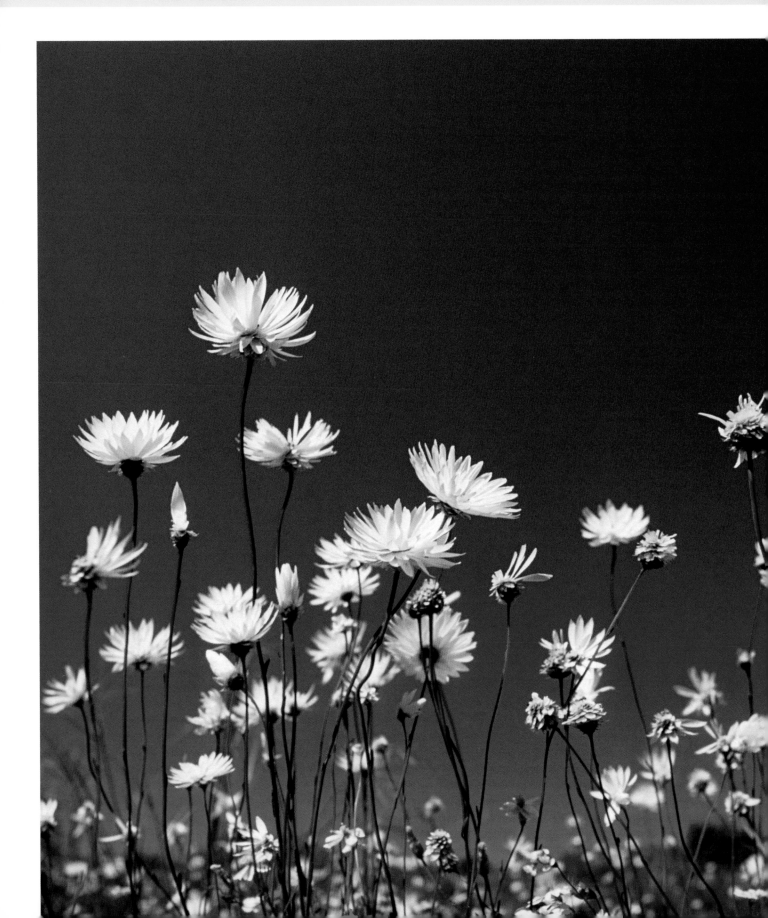

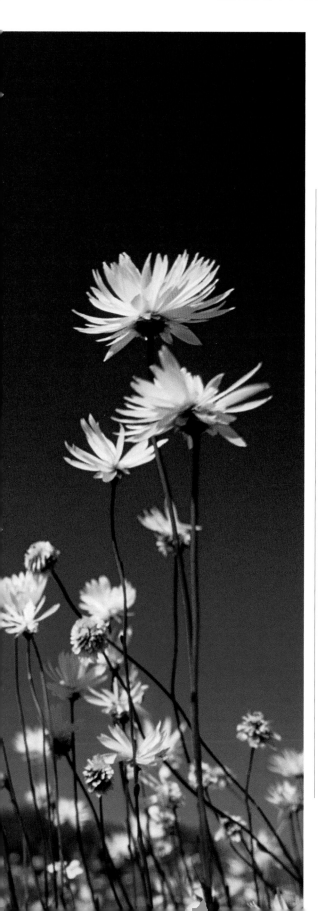

● WHITE EVERLASTINGS
(*Rhodanthe chlorocephala splendida*)

Canon EOS 1n, 20mm lens, exposure unrecorded, Fuji Velvia film, ISO 50

Western Australia

flowers reaching up towards the blue Australian sky. Although taller than many of the other species in the area, they were still only a few centimetres high and were thus tricky to isolate from their surroundings. To create the picture I had in mind required pretty much the opposite approach to that taken in the picture on page 76. That image required a high viewpoint and a long lens to emphasize the sky close to the horizon; this one needed a very low angle and a wide-angle lens to emphasize the blue sky and minimize the intrusion of the carpet of other flowers around the subject. I achieved this by using a 20mm wide-angle lens rested on the ground, and fitting a right-angled finder to the viewfinder so that I could actually see through the viewfinder as I pointed the camera slightly upwards. A polarising filter made the most of the blue sky and allowed the white blooms to stand out against it.

BIRDS

Habitats without water contain few plants and insects, so there is little food for birds to live on. Because of this, bird species that have adapted to this environment are usually found at low density. Locating them in the often vast terrain can therefore be difficult. On the plus side, the openness of the habitat does make them relatively easy to see and photograph if you can get close enough.

Etosha National Park in Namibia is one of those locations where the climate changes dramatically during the year. In the wet season the park gets around 35 centimetres of rain, lakes fill up, insects become abundant

⬤ BLUE CRANES
(*Anthropoides paradisea*)
Canon EOS 1v, 600mm lens + 1.4x converter, 1/1,000th sec @ f5.6, Fuji Sensia film, ISO 100
Namibia

and birds breed. In the dry season the whole area dries up and the wildlife struggles to survive until the next rains.

As you can see in this picture of Blue Cranes, any grass that had grown earlier in the year had completely dried up, and the three birds were foraging in it looking for something to eat. Photographing three birds together is always difficult when using a long telephoto, because the depth of field is rarely enough to keep all of them in focus. As the birds walked around in the grass, I followed them in my four-wheel drive vehicle. I kept some distance away and used a very long lens so as not to disturb them. At one spot they stopped and appeared to be feeding. I wanted to make sure their heads did not rise above the skyline, since this would have spoiled the picture. Fortunately there was a small mound close by, and I drove onto this to create a better shooting angle.

The birds continued to feed in the same area, constantly lowering their long necks to the ground. They spread out in front of me along a line parallel with the vehicle, until all three of them were equidistant from me and would thus all be in focus. It was at this point that the two outer birds lowered their necks in unison, the central bird staying upright. This produced the symmetry I was looking for and I took the shot.

The following bird image was taken on the steppes of Spain and shows a Great Bustard strutting across the arid landscape, calling out to ward off a rival male. Spring in the Extremadura region, where this picture was taken, can be very variable; like Western Australia, it is dependent on the amount of winter rainfall. When there is sufficient precipitation the steppe can be awash with colourful

● GREAT BUSTARD
(*Otis tarda*)

Canon EOS 1D Mark II,
500mm lens + 1.4x
converter, 1/500th sec
@ f5.6, digital ISO 200

Extremadura, Spain

blooms, but when the rains fail the area remains dry and the plant life is dormant, having been scorched by the previous hot summer sun.

The muted tones of the dry vegetation make a nice clean background to the bird, which requires a special permit to photograph in Spain because it is a protected species. The terms of this permit require the photographer to enter and leave a specially constructed stone hide in darkness, so if you want to photograph the bird you have to be prepared to enter the hide before dawn and remain

in it for the 15 hours before it gets dark in the evening. I chose the image shown opposite to demonstrate that arid conditions do not only exist in deserts, but can also occur seasonally in habitats that do not necessarily immediately spring to mind when considering the Earth's dry places.

MAMMALS

The best arid region I have visited for mammals is undoubtedly Etosha National Park in Namibia, where I photographed the Blue Cranes discussed earlier. During the long dry season the park dries out under the hot tropical sun, and although there are a few hardy species about this is a very poor season for bird photography. It is, however, by far the best season for mammal photography, because the animals are forced together to drink at the few waterholes that are the only places left where life-giving water can still be found in the parched landscape. When the rains eventually come, the wildlife disperses throughout the park and is difficult to see and photograph.

During the dry season herds of antelopes and Zebras jockey for position at waterholes, but they all give way when the African Elephants arrive. These largest of land mammals love water and call out loudly as they approach. They are common and easy to see at Etosha, and herds of more than 20 animals are seen regularly.

In the national park, you are not allowed to leave your vehicle (there are lions about, so this is probably a good idea), and all photography is done from the car. I would pull up at a suitable spot by a waterhole and set up the tripod, with a Wimberley head on it, outside the driver's door. With the long lens set up on the Wimberley head this gave me maximum freedom of movement and stability, the use of the long lens resulting in the camera body being just inside the car window.

While most wildlife photography is best done towards either end of the day, waterhole photography is often at its peak around midday. This is because as the day heats up, the animals become more and more thirsty and start looking for somewhere to drink. It is not generally a good time for photography because of the strength and angle of

● AFRICAN ELEPHANT
(*Loxodonta africana*)

Canon EOS 1v,
600mm lens + 1.4x
converter, 1/1,000th
sec @ f8, Fuji Sensia
film, ISO 100

Namibia

the sun, but towards the end of the dry season in Etosha the atmosphere is very hazy, helping to reduce the harshness of the light. The first image of elephants, previous page, shows a small group approaching the waterhole, and captures the sense of urgency and excitement as these great beasts get close to the water.

The second picture of elephants could not be more of a contrast. A group of elephants stand close together, the trunk of a youngster wrapped around its mother's leg as if to support it. It is extremely hot and the elephants stand completely still, not moving a muscle. They are close to a dried-up waterhole. The only moisture that remains is in the sticky white clay, and the elephants have covered themselves with it to keep cool. This is a common practice in the park and explains the frequent references to the 'White Elephants of Etosha'. Standing so still and covered in clay, they look like giant porcelain figures glistening in the bright sunshine.

The elephants are some distance away, but I use the big lens to make a tightly cropped composition that is almost an abstract pattern. It is so hot in the car that I am stripped to the waist and have all the windows open to make the most of any slight breeze, but the elephants just stand still and take the heat of the sun, waiting for nightfall to give them some relief.

OTHER ANIMALS

Small animals such as invertebrates are highly vulnerable to dry conditions because they tend to dry out very quickly.

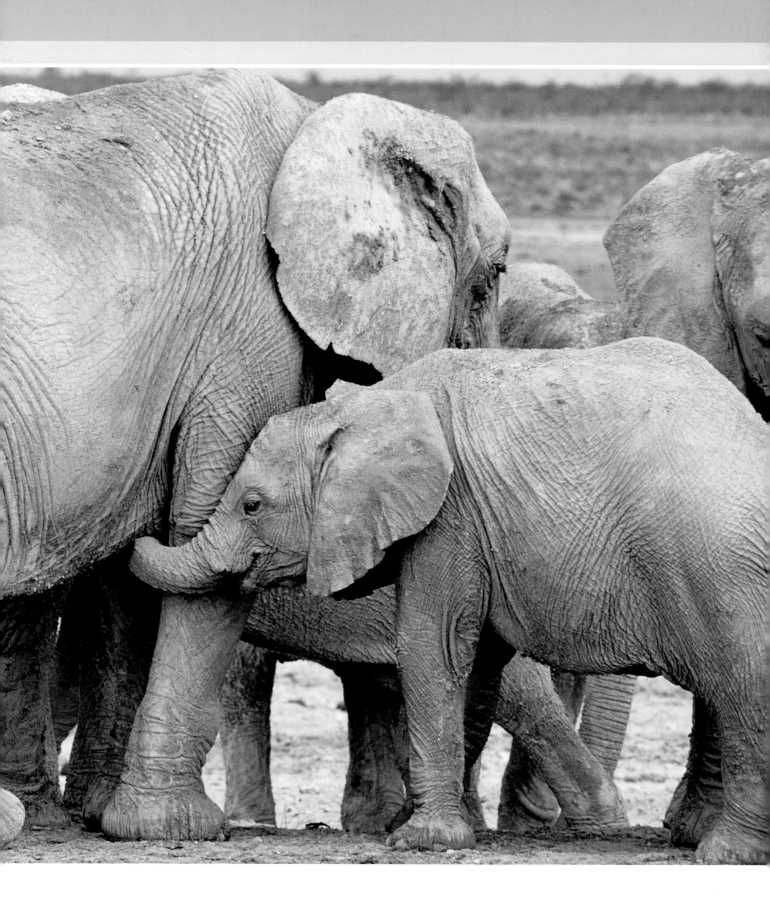

● STUMP-TAILED
SKINK (*Tiliqua rugosa*)

Canon EOS 1v,
24-85mm lens,
exposure unrecorded,
Fuji Velvia film, ISO 50

Western Australia

They generally appear at night, when it is much cooler than during daytime, which is not the easiest of times for photography. One group of animals that can tolerate the dry and hot conditions is the reptiles, and the rather fat-bodied family of lizards known as the skinks can often be found basking by the sides of roads in the deserts of Western Australia. It is in the winter months, when the temperatures are much cooler than during summer, that they are most attracted to roads. This is because the asphalt absorbs and retains the heat, allowing the cold-blooded lizards to warm up quickly. We saw a few dead ones that had been run over, so I am not sure if this practice is a good long-term survival strategy.

The typically broad skink body can be seen in this image of the Stump-tailed Skink, taken in the early afternoon. At this time of day reptiles are very active because they have fully warmed up. This one sort of snarled at me as I passed by him, and as he did so I noticed his amazing blue tongue. I had already photographed this species before, but only in its early-morning torpid state, so I had never seen the tongue before. As I got closer to the skink, it would come towards me and open its mouth to threaten me, but this did not make for a good angle. I wanted to be close in with a wide-angle lens, showing the lizard in profile, which would be a more interesting shot. I moved very slowly and settled down quietly, close to the ground, staying still until he ignored me, which did not take long. My wife then approached from the left. As she did so he immediately reacted by opening his mouth and poking out his blue tongue at her – and I got the shot I was after.

Wetlands and rivers

This chapter discusses photographing the freshwater marshes and rivers, and the wildlife that can be found in these habitats. Wetlands in particular are essential wintering grounds for millions of birds throughout the world.

⬤ BIEBRZA MARSHES

Canon EOS 1n,
24-85mm lens,
exposure unrecorded,
Kodachrome 64
ISO film

Poland

MARSHLAND IS OFTEN REGARDED AS 'WASTE' LAND by humans, and much of it has been drained for farming. Despite this, the small patches of marshland that are left still provide rich pickings for the nature photographer – they are certainly one of my favourite ecosystems for bird photography. Wildlife that you can encounter here includes countless birds such as waders, herons and ducks, and insects like dragonflies and butterflies.

THE OPEN LANDSCAPE

I find photographing the flat open landscape of wetlands difficult to execute well, and had to dig back as far as several years into my image library for the opening shot of the Biebrza Marshes in Poland. The trouble with this habitat is that there is very little in it, so producing an interesting image is challenging. The Biebrza Marshes are

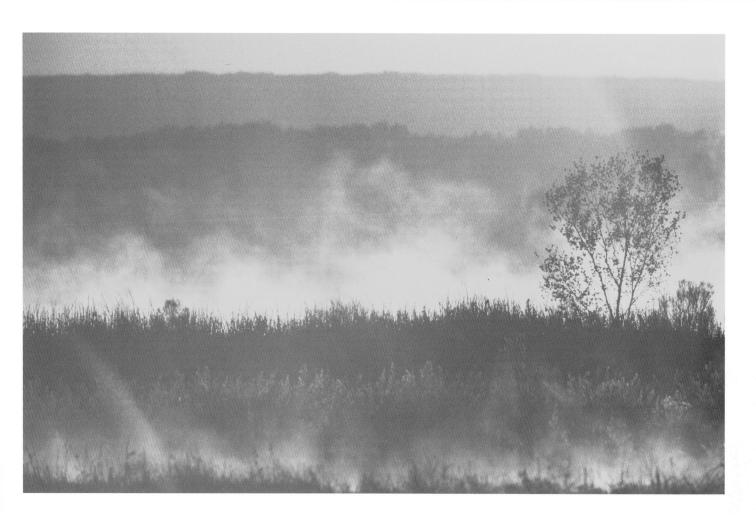

huge, covering around 1,000 square kilometres. I felt that the flowering plants covering the vast area of shallow water supplied sufficient interest to make a successful picture. In order to capture the scale of the place, I used a wide-angle lens. The blue sky was dotted with fluffy white clouds that added interest not only to the sky itself, but also to the water that reflected them.

In relatively featureless landscapes such as marshes, a way to create interest in a picture is to photograph at dawn, when the first rays of the sun give colour to the scene. The warmer the air is, the more moisture it can absorb, so as the temperature increases during the day more and more water from the marsh evaporates into the atmosphere. During the night, as the temperature falls,

the moist air can no longer contain all the water, and in still conditions mist forms over the marsh. Shooting towards the sun at dawn on a still day, the back-lit mist adds drama to the scene, as can be seen in the picture above taken at Bosque del Apache National Wildlife Refuge in New Mexico. These conditions do not last long, so you have to be in position before sunrise and wait for the right moment. In this case the mist was rising some distance away and I had to use a long telephoto lens to make the most of it. The scene was impressive – the marsh appeared almost ablaze – but I needed a focal point to hold it together, and positioned a lone willow tree to the right of the frame to achieve this. As the sun rose further, the mist quickly burned off and the colour disappeared.

● MIST AT SUNRISE
Canon EOS 1n, 500mm lens, exposure unrecorded, Fuji Provia film, ISO 100
New Mexico, USA

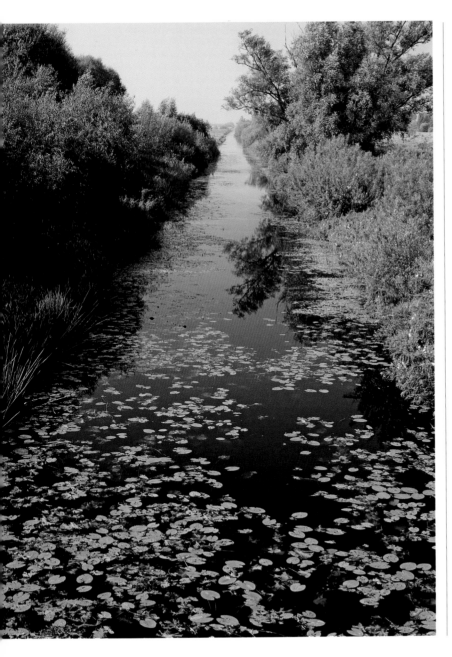

● OLD
BEDFORD RIVER

Bronica ETRs,
200mm lens,
exposure unrecorded,
Fuji Velvia film, ISO 50

Norfolk, UK

RIVERS

Ironically, the Old Bedford River in the picture on the left is man-made, having been built to drain the fenlands of East Anglia in the early 1600s. With the creation of a deep straight channel from the Great Ouse River to the sea, the low-lying fens were starved of water and dried out. This act of ecological vandalism destroyed nearly all of the wild fenland that had existed here for many tens of thousands of years.

From a photographic point of view, it was the arrow-straight line of the river as it disappeared into the distance that attracted me. To make the most of the elongated shape I turned the camera on its side and shot in portrait mode, because this way as much of the river as possible could be included in the frame. A simple composition further emphasized the shape, and I placed the river slap-bang in the middle of the frame. I used a polarising filter to reduce the reflection in the water and darken it, which made the floating vegetation stand out.

FLOWING WATER

Fast-flowing rivers can make very interesting subjects, because the movement of the water can be used to add interest to a scene.

Sol Duc Falls in Olympic National Park, Washington State, are reached by a well-marked trail, but the falls themselves are pretty unimpressive and not very photogenic. Even though it was late June when we arrived

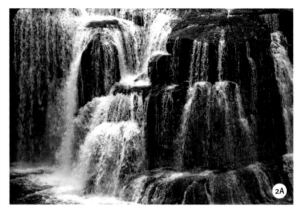

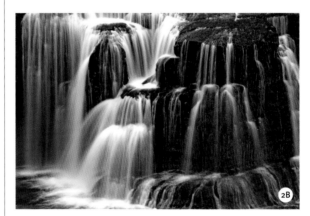

there, this far north the Aspen leaves were still a bright yellow-green, and their colours were reflected in the Sol Duc River, just above the falls. It was an overcast day and the light under the canopy was very poor, but the colours made the river look like a flow of liquid metal and it was crying out to be photographed.

I set up the tripod on the riverbank and chose an interestingly shaped rock in the river as a focal point. The resulting two images, shown above, illustrate how selecting different shutter speeds affects a picture when photographing moving water. The longer the exposure, the more movement is recorded, and the more blurred the water becomes.

In the second pair of pictures, shown above right, you can see how this effect is exaggerated when the water is tumbling over a waterfall because it is moving much faster. Personally, I much prefer the ethereal effect of the water

that can be obtained when you are using a slow shutter speed, even though the faster shutter-speed image does look more natural.

Overcast days are best for this type of photography, because it is often impossible to get a sufficiently slow shutter speed on bright sunny days. To help achieve the slowest speed possible I use a polarising filter, which effectively adds a couple of stops.

A big advantage of digital is that you can change the ISO rating for each shot, which means that you can use the slowest ISO available to obtain the longest exposure possible, then up the ISO for the next shot when you want a fast shutter speed. On most digital cameras the minimum ISO is 50.

I used a small waterfall as the foreground in the next picture, which at first glance looks as though it was taken on the coast. It was quite a windy day and the waves were

WATERFALL AND LAKE SUPERIOR

Canon 1Ds Mark II,
24-105mm zoom lens
@ 40mm,
1/10th sec @ f16,
digital ISO 50

Michigan, USA

breaking along the shoreline, but this 'coastal' scene is in fact the southern shore of Lake Superior, the largest freshwater lake in the world.

The waterfall was not an impressive sight because it only dropped half a metre or so, but photographed up close with a relatively wide-angle lens it made an impressive foreground. I worked the scene using various focal lengths, although I could not go too wide because the position of the sun was such that I had to avoid obstructing the image with my shadow – it is just out of shot near the bottom of the frame.

The white clouds in the blue sky pick up the white surf in the waves, and this theme is continued in the white hue of the waterfall itself. All the elements are in place in this landscape shot, which is certainly my favourite waterfall image.

PLANTS

A number of plant species thrive in damp boggy conditions in marshy areas or at the sides of rivers, but some, like water-lilies, grow in permanent shallow water and can be considered true aquatic plants. They are commonly grown in garden ponds, but in the wild can completely cover large areas of water. They do not like fast-moving water, so the still water in a cypress swamp in North Carolina is the perfect environment for the white-flowered American Water-lily featured in the above picture.

Unfortunately, when I came across the plants they were some distance away across open water with a few cypress trees dotted about. I wanted to fill the frame with water-lilies, but needed to use a telephoto lens to do this. I could not use a tripod because the only clear shot through the trees was too high, so I leaned against a tree trunk and took the shot hand-held. Due to the shallow depth of field of the telephoto lens, it was impossible to get the whole frame in sharp focus, so I concentrated on the foreground and let the background go, which was the best compromise. What I really needed was a 300mm tilt and shift lens to control the plane of focus, but such an optic does not exist.

The Marsh Orchid in the next picture prefers damp marshy conditions, and in appropriate habitats can be

○ AMERICAN
WATER-LILY
(*Nymphaea odorata*)

Canon EOS 1n, 300mm lens, exposure unrecorded, Fuji Provia film, ISO 100

North Carolina, USA

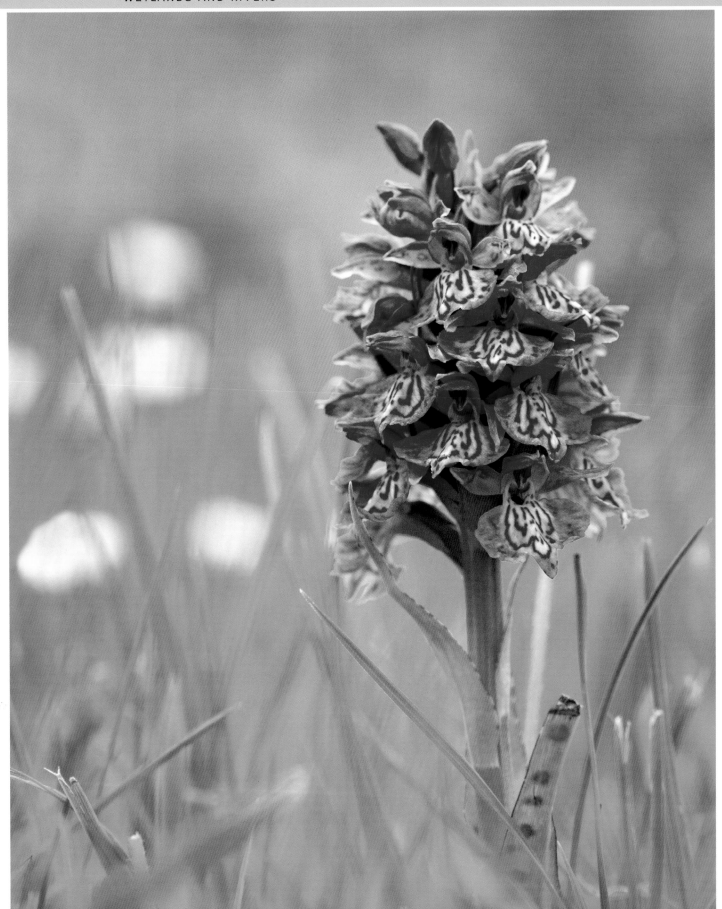

● MARSH ORCHID
(*Dactylorhiza majalis*)

Canon 1Ds Mark II,
100mm macro lens,
1/320th sec @ f8,
digital ISO 400

Shetland Isles, UK

quite common. When I saw this particular flower on the Shetland Isles it was surrounded by rough grass, so it was difficult to get a clear shot of it. Rather than start 'gardening' the area around the flower, I decided to try and use the surrounding vegetation in the picture. I lay down on the rather wet ground in order to shoot at the same level as the orchid. This meant shooting through some of the grass. I did not want this to detract from the flower itself, so used a relatively wide aperture of f8 to restrict the depth of field. An even wider aperture could have been used, but I wanted to keep as much of the main subject in focus as possible. Working close-up, depth of field is minimal, so f8 was a good compromise. I liked the 'V' shape made by the grass in front of the orchid, which was mirrored by a similar 'V' in the grass behind and to the left of the flower. There were some daisies in bloom in the background. I kept them in the frame because their soft, out-of-focus shapes provided background interest.

The final picture here, shown right, is of lichen – something I had not set out to photograph when visiting the Corkscrew Swamp Sanctuary in Florida, but could not resist when I came across it. The whole sanctuary is so wet underfoot that access is via an extensive wooden boardwalk that takes visitors into the heart of an otherwise inaccessible habitat. Much of the area is rather overgrown cypress swamp, so wildlife viewing is difficult and photography even more so. Some of the trees had large pink-coloured lichens on them, but these were difficult to photograph well because they were some way off the boardwalk. I noticed that some of the older parts of the boardwalk itself had colonies of the same lichen, which

I later found out was called Baton Rouge. The smooth flat wood of the boardwalk was perfect for photography, so I set about searching for potential compositions.

I did not have a macro lens with me, but the 90mm tilt and shift I had put in the gadget bag focuses very close, and this was a good substitute for a true macro lens. Due to the dull light a slow exposure was required, which was not a problem because I was using a tripod. The biggest obstacle to getting a sharp image was other visitors – anyone walking along the raised boardwalk would cause it to move and the vibrations would spoil the shot. Eventually, though, we found a big enough break in the traffic to get some pin-sharp pictures.

● BATON
ROUGE LICHEN
(*Cryptothecia
rubrocincta*)

Canon 1Ds Mark II,
90mm tilt and
shift lens,
1/4th sec @ f16,
digital ISO 100

Florida, USA

● MUTE SWAN
(*Cygnus olor*)
Canon 1Ds Mark II, 70-200mm zoom lens @ 145mm, 1/250th sec @ f20, digital ISO 400
Norfolk, UK

BIRDS

Rivers have birds that breed in this specialized habitat, but marshes are one of the best ecosystems in the world for birds and bird photography. Many species breed in marshland, and during the winter thousands of birds gather together in these often remote places that are vital to their continued existence. The Ouse Washes are one such wintering area. They are an artificially created habitat used to contain the floodwaters of the River Ouse, preventing the surrounding farmland from returning to the natural fenland that it replaced. In the winter they are an important wintering ground for several species of wildfowl. I chose a picture of a Mute Swan from this location as my first wetland bird image.

I had noticed the clear channel running through the reeds from the foreground, and thought it would make a nice picture of the washes themselves. As I set up to take the shot, I noticed the swan swimming around beyond the first bank of reeds, and thought it would vastly improve the picture if only it would pose in the right place. I watched it for some time as it meandered around, first swimming one way, then another. Eventually it started to swim across the gap in the reeds and I got the shot I was after.

To frame the shot as I wanted it, I had to use a focal length of 145mm, but because both the foreground reeds and the mid-distance swan had to be in sharp focus I had to stop down, and ended up taking the shot at f20. It was a bright day and I shot at ISO 400, so was still able to use a reasonably sharp shutter speed to freeze the slow-moving swan.

● POCHARD
(*Aythya ferina*)

Canon 1D Mark II,
500mm + 1.4x
converter,
1/1,000th sec @ f5.6,
digital ISO 200

Norfolk, UK

Ducks are, of course, a group of birds that you would associate with wetlands. The picture of a drake Pochard flying low over the water was also taken on the Ouse Washes during the winter months. The Pochard winters in large numbers in this habitat, and nearly all the birds encountered are males. Surprisingly, the males and females winter separately, with the females gathering in the much warmer climate of Spain during the winter months. The colourful males are far more photogenic than the rather drab females, so this is really good news for UK-based photographers.

The Pochards can easily be viewed from the hides at the Welney Wildfowl and Wetlands Trust Reserve. Food is put out each day, mainly for the wintering swans, but the Pochards have got used to the free handouts and hang around for most of the day. It can get quite crowded at

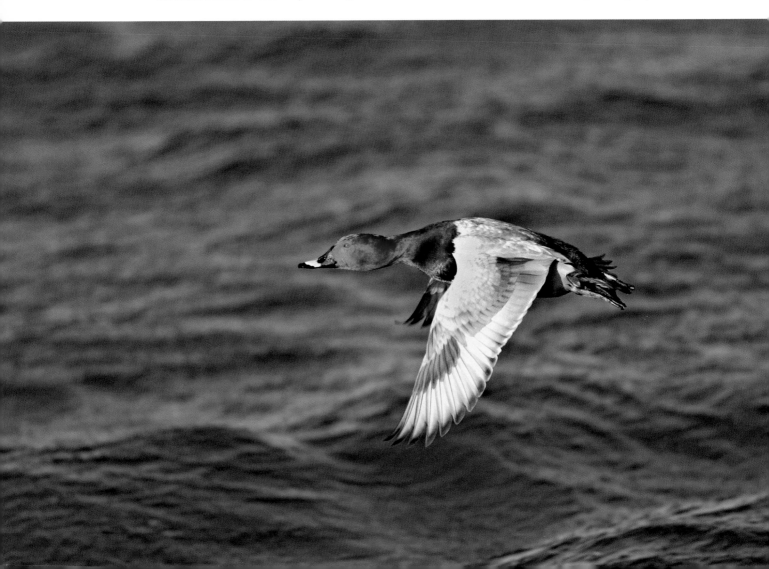

● GREY-HEADED
SWAMP-HEN
(*Porphyrio
poliocephalus*)

Canon 1D Mark II,
500mm,
1/1,250th sec @ f4,
digital ISO 400

Bharatpur, India

feeding times, so picking out individuals as they fly around in front of the hides can be tricky. A long lens is necessary, and taking into consideration the 1.3x multiplication factor of the camera body, I photographed this individual with the 35mm equivalent of a 910mm lens.

The extensive wetlands at Bharatpur in India also attract vast numbers of birds, some breeding and many others wintering there. One common species is the Grey-headed Swamp-hen, a wetland specialist that spends much of its time feeding on aquatic vegetation.

Before taking the above shot, I found a spot where 20 or so of these birds regularly foraged during the morning. When I first arrived and set up my equipment at the edge of the marsh they moved away, but after ten minutes or so they ignored me and went about their business as usual. They fed almost constantly, and I took a few pictures of this behaviour and a few portraits, but nothing special. Suddenly, the entire group of birds panicked and ran for

cover. This was completely unexpected, so I did not get any pictures and wondered what had happened.

As I looked up a large bird of prey passed overhead. Clearly the swamp-hens had seen the raptor long before I had, and feeling rather vulnerable out on the open marshland had headed for the cover of the trees and bushes that grew around the margins.

It was only a few minutes before the swamp-hens returned to their feeding grounds. There are a large number of wintering raptors at Bharatpur, so I thought it quite likely that another one would appear and cause another panic. This time, however, I would be ready, and was determined to photograph the swamp-hens as they ran for cover. These heavy birds do not fly very much, but as they run they hold their wings high in the air. This was the shot I wanted. It took three mornings and several eagle fly-bys until the shot was in the bag, but I felt the effort was well worth it.

● SNOW GEESE
(*Anser caerulescens*)

Canon 1Ds Mark II,
24-105mm zoom lens
@ 32mm,
1/6th sec @ f4,
digital ISO 400

New Mexico, USA

I could not write about wetland birds without including a couple of pictures from my favourite bird-photography location, which is Bosque Del Apache National Wildlife Refuge in New Mexico. Tens of thousands of Snow Geese spend the winter here, roosting in the wetter areas of the reserve, where they are relatively safe from land-based predators such as Coyotes. As the sky starts to brighten in the pre-dawn light, the geese start to get restless, suddenly taking flight and leaving the roost to head off to the surrounding fields to feed. To see this spectacle you have to be on site very early, and in winter the temperature is likely to be below zero. The biggest challenge to the photographer is the light, or rather lack of it, because sometimes the geese take off very early indeed. Do not let ridiculously slow shutter speeds put you off, though, because they can produce interesting results.

When there are clouds in the sky they are sometimes lit up by the rising sun, making the sky reasonably bright. However, on this particular morning the sky was pretty clear, and 1/6th second was the fastest shutter speed available to me at ISO 400. It goes without saying that at these speeds the camera has to be on a tripod. This prevents camera shake, but cannot possibly freeze the movement of the flying geese as they cross the sky. The result is a sharp background, but the geese are recorded as ethereal streaks across the pink-tinged dawn.

The following Bosque picture shows the other main winter visitor to the reserve, the Sandhill Crane. Unlike the Snow Geese, the cranes leave their roost sites in small groups rather than in one great flock, and do so over a much longer period of time. By the time this group left

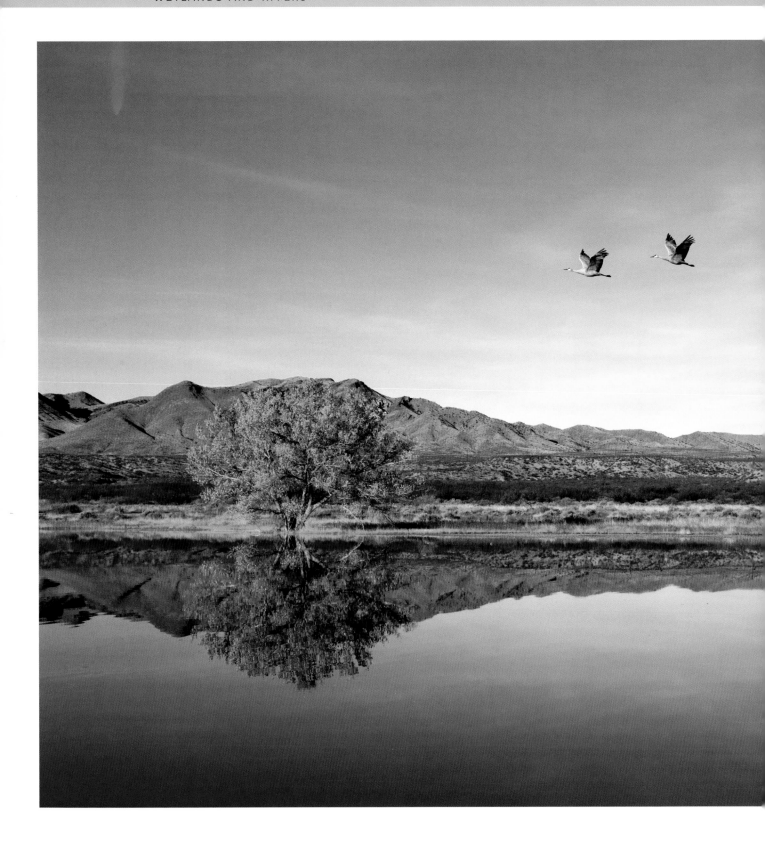

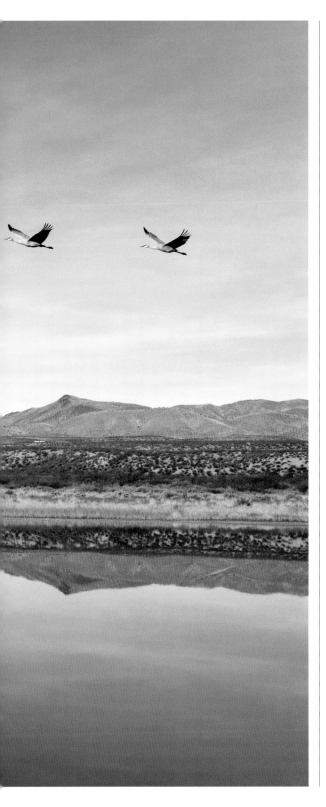

the sun was well up, although it was still around 7 a.m. There was no wind, so the small roost lake had a perfect reflection of the surrounding rather stark countryside. As I watched previous groups fly off, I noticed that although most of them would fly too high, sometimes they would be low enough to enable the lake and reflection to be included in the picture. Finally a group of four birds arrived at just the right height and I pressed the shutter.

The final image of birds is one of a Dipper, a species that has made rivers its home. The Dipper prefers fast-flowing streams, so hilly areas tend to be the best places to see it. I photographed this one in the Peak District in northern England during early spring. In this particular location the river is surrounded by trees, so it is best to photograph the birds before the leaves break on the trees and create too much shade. The Dipper regularly perches on its favourite rocks along the river. Once you have identified these, the best strategy is to sit quietly on the riverbank nearby and wait for the bird to appear. Dippers feed primarily on river invertebrates, wading into very fast water to catch their food. In this case the bird has caught a caddis fly larva, one of the Dipper's favourite snacks.

Above:

| ● DIPPER |
| (*Cinclus cinclus*) |

| Canon 1Ds Mark II, |
| 500mm lens + 1.4x |
| converter, |
| 1/200th sec @ f5.6, |
| digital ISO 400 |

| *Peak District, UK* |

Opposite:

| ● SANDHILL CRANES |
| (*Grus canadensis*) |

| Canon 1Ds Mark II, |
| 24-105mm zoom lens |
| @ 50mm, |
| 1/2,000th sec @ f8, |
| digital ISO 400 |

| *New Mexico, USA* |

MAMMALS

The vast wetlands of the Orinoco Delta in Venezuela are known as the Llanos. They support huge populations of Capybara, also known as the Orinoco Hog. These animals can grow to up to a metre long and are the world's largest rodent. They are very much adapted to life in swampy areas, and even have slightly webbed feet. They can occur in large herds. If danger threatens while they are grazing on land, they rush into the water and swim away from the bank to where land-based predators cannot reach them.

I photographed the group shown below from a small boat after a horse rider had just galloped along the bank where the Capybara were resting. They dived into the water and swam towards us. As they got closer I wanted to

● CAPYBARA
(*Hydrochoerus hydrochaeris*)

Canon T90, 50m lens, exposure unrecorded, Kodachrome 64 film

Venezuela

capture the whole scene, so fitted a short lens to the camera. Although they did not panic when they noticed us, they turned slightly to avoid us, heading up a channel clear of vegetation. As the last animal came into shot I took the picture. The line of Capybara heading into the frame with the vast empty wetland behind it provides an attractive composition.

Some mammals, such as Racoons, occur in a wide variety of habitats, including towns, and when I saw a pair of youngsters sifting through the mud at the edge of a shallow wetland in Florida, I could not resist photographing them. We were sitting in the car eating lunch, when a Racoon mother and her two young appeared. The young were about half the size of the adult, and she seemed happy to leave them to their own devices as she wandered around searching for food. Because this was Florida, I reckoned that Racoons were probably as used to people as birds, so I fitted a telephoto zoom lens to my camera and quietly got out of the car. Being lightweight, the zoom lens gave me a great deal of freedom to follow the Racoons around, and I could easily hand-hold it, so did not need the cumbersome tripod.

The Racoons mostly wandered around the side of the dirt road, possibly looking for discarded bits of food, so there was not much of a background for photography. Then they both moved into the shallows and started turning over rocks with their front paws.

I crouched low to get a good angle and waited until the two animals drew side by side. This gave a good image, and with both of them in the same plane the depth of field was enough for the two of them.

● NORTHERN
RACCOONS
(*Procyon lotor*)

Canon 1D Mark II, 100-
400mm zoom lens @
330mm, 1/320th sec
@ f8, digital ISO 200

Florida, USA

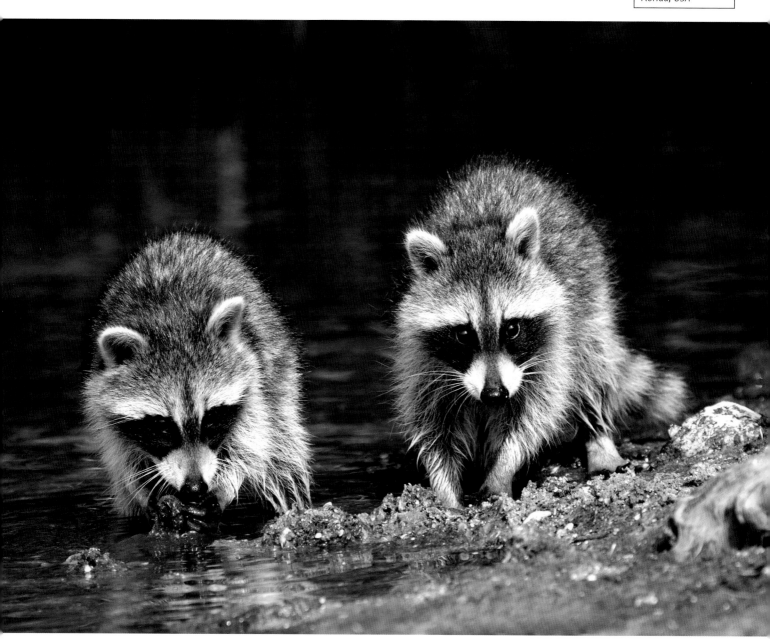

105

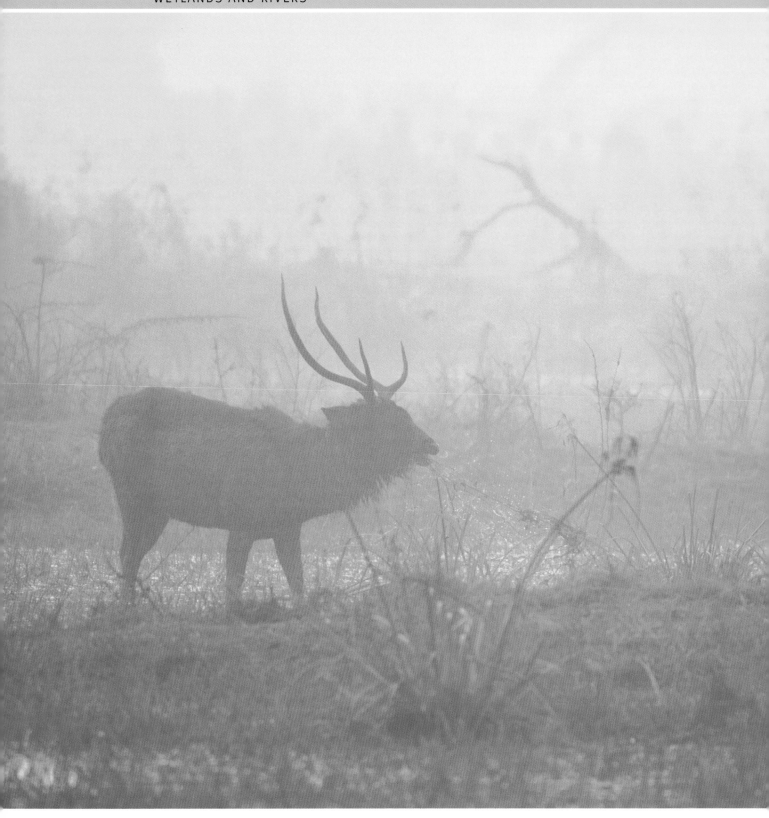

The final wetland mammal image shows a Sambar deer in early-morning mist. As previously mentioned, such mists are a feature of many wetlands. At the world-famous Bharatpur Reserve in India they occur almost every morning and sometimes last most of the day. This can make photography difficult, of course, but can also provide opportunities for producing atmospheric images. The distinctive shape of the male Sambar in the distance made a nice silhouette. The shrubby background that would normally have looked a bit of a mess was rendered much softer by the mist.

When photographing silhouettes you cannot make out much detail on your subject, so it is essential that its outline is clear and distinct. You must wait for the right moment or change your angle to achieve this, otherwise all you will end up with is an indistinct-looking blob. The other major consideration when photographing in mist is the exposure. Misty scenes tend to be at least one stop brighter than mid-tone, and if you rely solely on the camera exposure meter you will end up with an image that is underexposed. Working with digital it is easy to make a quick test exposure, then dial in compensation to make sure you get it spot on.

SAMBAR
(*Cervus unicolor*)
Canon 1D Mark II, 500mm lens + 1.4x converter, 1/800th sec @ f5.6, digital ISO 400
Bharatpur, India

REPTILES AND AMPHIBIANS

There can be little doubt that the crocodile family is the most impressive group of wetland-loving reptiles. Being such large predators, crocodilians are feared by humans; this, combined with the use of their skins for the vain and

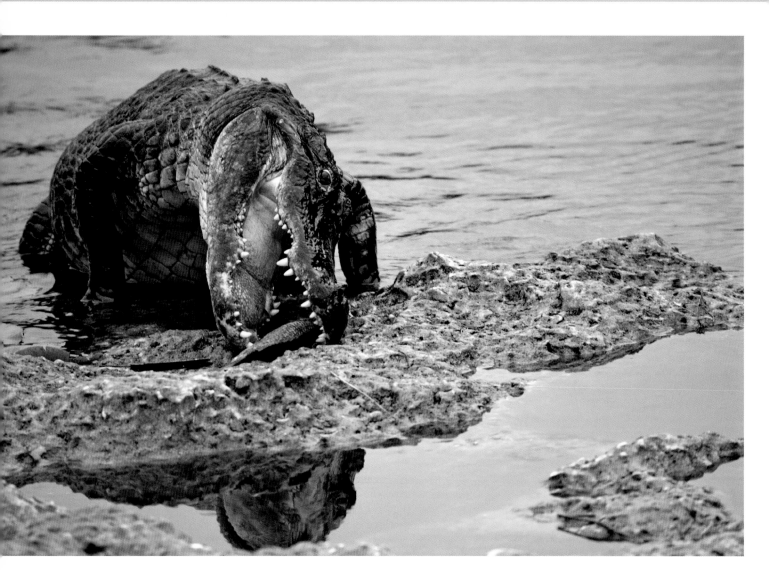

● AMERICAN ALLIGATOR (*Alligator mississippiensis*)
Canon 1D Mark II, 100-400mm zoom lens @400mm, 1/250th sec @ f5.6, digital ISO 400
Florida, USA

superficial fashions of certain people, has led to their downfall in many countries, although nowadays the destruction of their habitat is probably the biggest threat to their survival. Although alligators were hunted to the brink of extinction in the past, Florida now holds large numbers, which are easily seen in many of the state's excellent reserves. One of the best places to see them is the Everglades National Park, where both of the pictures shown here were taken.

We were working the Anhinga Trail and came across a heron that had caught a large fish and was standing by the edge of the water with its prize. I was focused on it when it suddenly dropped the fish, called loudly and flew off. At first I was puzzled by this behaviour, but as a huge alligator emerged from the shallows next to where the heron had been standing, realized that the bird's behaviour had been quite sensible. The prehistoric beast reached over towards the abandoned fish, took it in its impressive jaws and disappeared with it, back under the water. I am sure it would have been more than happy to have taken the bird with it too had it stayed around. The alligator was too close for me to use the big telephoto, but fortunately I had the

100-400mm zoom set up on another camera body and quickly switched to that. It was a windless day and the reptile's head was reflected in a small section of water at the very edge of the bank. I stood as tall as possible to capture as much of this as I could, getting a couple of shots before the action was over.

The second alligator image was also taken on a leaden-sky day at the Anhinga Trail. To explore the area we used several boardwalks that crossed very muddy wetland, as well as areas of open water that were populated by some enormous alligators. Occasionally they would swim under the boardwalk, which was only a metre or so above the water. This provided a rare opportunity to photograph them from directly above. Most of the body of each alligator remained under the water, so I decided to frame the picture to show just the head of a reptile. The grey sky reflected in the water added to the final image, which would have had far less impact on a sunny blue-sky day.

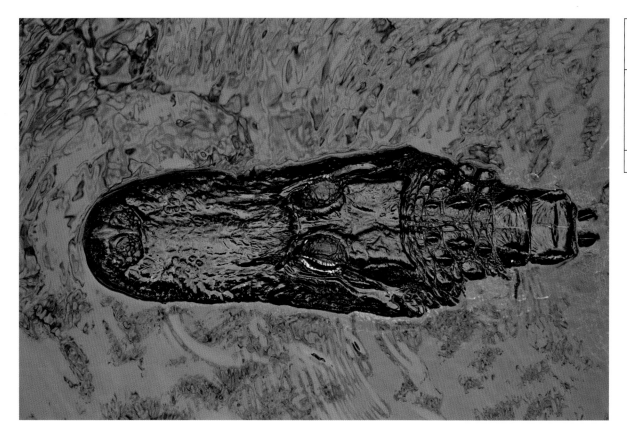

● AMERICAN ALLIGATOR (*Alligator mississippiensis*)

Canon 1D Mark II, 100-400mm zoom lens @160mm, 1/160th sec @ f5, digital ISO 400

Florida, USA

With the increasing pressure on the remnants of wetlands, garden ponds have become more and more important as refuges for wetland wildlife, and my rather small pond is certainly a haven for frogs in the early spring. The surface is covered in frogspawn, and later in the year tiny froglets can be found hopping around everywhere. I have a water-lily in the pond, and the tiny frogs clamber over the lily pads and the flowers themselves. They look very photogenic in the large flowers, so I set up the shot on the left with a macro lens and flashgun and 'encouraged' a couple of the little amphibians onto the nearest bloom to get the picture.

INVERTEBRATES

Large numbers of invertebrates are completely dependent on rivers and wetlands for their existence. Many species of flying insect, for example, spend nearly all of their lives underwater during their larval stages, and only crawl out when the adults are ready to emerge. The dragonfly family is one such group, and being relatively large it is possible to photograph its members without specialist equipment. I have always loved the challenge of photographing birds in flight, so could not resist having a go at dragonflies as they flew around a local slow-flowing stream. The species in question was the Common Darter. With a body length of just over 40 millimetres this is not the largest of dragonflies, but there were a lot of them about and a target-rich environment is important when you are trying something with such a high degree of difficulty.

● COMMON FROG
(*Rana temporaria*)
Canon EOS 1n, 100mm macro lens, autoflash, 1/200th second at f16, Fuji Velvia film, ISO 50
Essex, UK

● COMMON DARTER
(*Sympetrum striolatum*)
Canon 1D Mark II, 70-200mm zoom lens + 1.4x converter @ 280mm, 1/1,600th sec @ f4, digital ISO 400
Essex, UK

Dragonflies can change direction in a fraction of a second, so they are very tricky to follow with a camera. Being so small, photographing them is difficult, because the depth of field gets narrower the closer you are to your subject. They also move very quickly, so a fast shutter speed is essential – you cannot stop down to increase the depth of field available. My favourite lens for this type of work is the 70-200mm f2.8, which is very bright, will focus quite close and is also fast focusing. At its maximum of 200 millimetres you still have to get too close to your subject for a good-size image, so I add a 1.4x converter and use a camera with a 1.3x magnification. Putting all this together you end up with the equivalent of a close-

focusing 364mm f4 lens, which allows a reasonable working distance from the subject.

The image shown above is of a pair of Common Darters flying over the stream looking for suitable places to lay their eggs. The male grips the female on her head and holds her up as she dips her abdomen into the water to lay her eggs. It is quite a remarkable piece of behaviour.

I was sitting in a public hide on the Ouse Washes in Norfolk photographing birds one mild winter's afternoon, when I saw some dancing mayflies a distance away. They looked good in the soft sunlight, but I could not exactly get out of the hide to get closer because this would have frightened all the birds away. Determined to get a shot

of some sort, I used my biggest lens, a 500mm telephoto, and fitted it with a two times converter, giving me the equivalent of a 1,000mm lens. The winter sun was not very bright and I used a 1/15th of a second shutter speed, ridiculously slow for such a large focal length. I steadied the lens on the Wimberley head, turned on the lens IS facility to combat camera shake and took a few shots. I have to say that this is the only time I have ever used a 1,000mm lens for photographing insects – you never know what lens might come in useful for a subject.

The result is an interesting image – although it does not seem to suffer from camera shake, the slow shutter speed was not, of course, sufficient to freeze the mayflies' movements as they danced in a group. Interestingly, many of the mayflies were recorded as four separate images during the exposure, each one slightly higher in the picture than the last. This would indicate that to stay airborne they carry out a series of little mid-air 'jumps' at the rate of around 60 a second, another amazing piece of behaviour in the small-scale world of invertebrates.

| ● MAYFLY |
| (*Ephemeroptera* species) |
| Canon 1Ds Mark II, 500mm lens + 2x converter, 1/15th sec @ f11, digital ISO 400 |
| *Norfolk, UK* |

Mountains and moorlands

Uplands form a different ecosystem from the lower elevations that surround them, and support plants and animals that are often unique. It is the difference in the weather that makes upland habitats distinct, and the most noticeable is the much lower temperature.

● CASCADE RANGE

Canon 1D Mark II,
100-400mm zoom
lens @ 400mm,
1/60th sec @ f16,
digital ISO 200

*Washington State,
USA*

ON AVERAGE THE TEMPERATURE DROPS 6.5 degrees Centigrade per 1,000 metres in altitude. The tops of some mountains are so high that they have permanent snow cover, even though they are in temperate or even tropical regions, and their ecosystem has more in common with the polar regions than the surrounding lowlands.

THE VIEW FROM ON HIGH

We were standing on a ridge around 2,000 metres above sea level when I took this picture of the Cascade Range of mountains in Washington State, in the north-west corner of the USA. The day was gloriously sunny, and from the high viewpoint you could see for many kilometres. It was early morning and the sun raked across the scene at a 45-degree angle towards us as we faced north-east. The low angle threw the nearest hills into shadow, while the high snowy mountain in the far background was lit by the sun. At such an early hour the low cloud in the valleys had not yet burned off, adding to the sense of being on high, looking down on the land.

To emphasize the repeating pattern of the ridges I used the longest lens I had with me. We walked a total of 14 kilometres that day, a lot of it uphill, so I was not carrying a big telephoto lens with me. The 100-400mm lens is a fine piece of equipment and produces excellent pictures, but it is not compatible with a 1.4x converter (although it does physically fit, the quality is poor). I needed more length than the 400mm the lens gave me, so I used a 1.3x camera body to obtain the equivalent

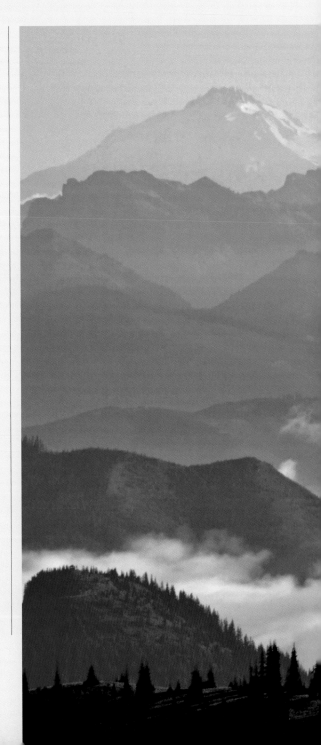

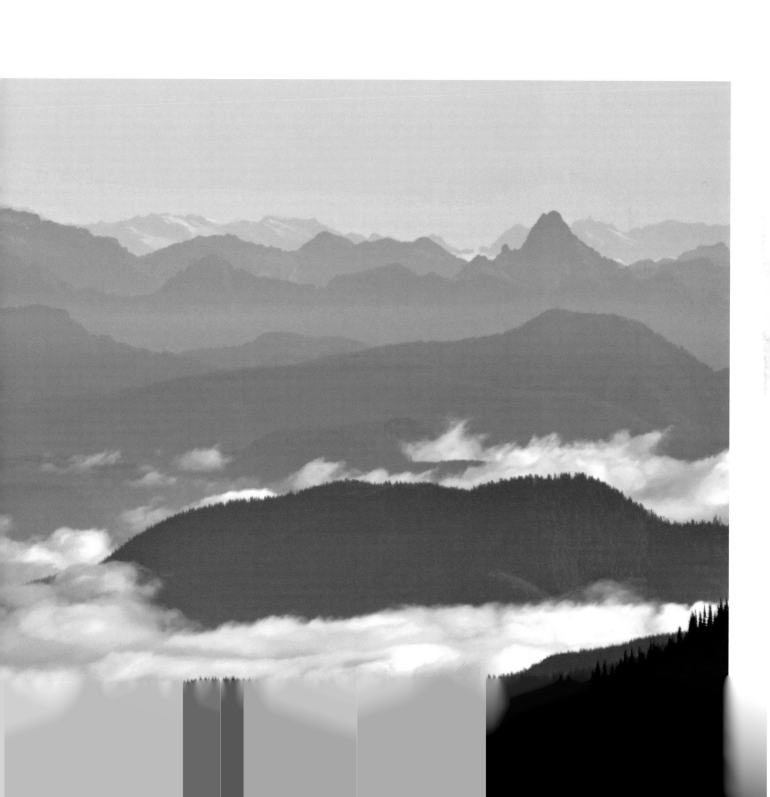

focal length of a 520mm lens. I stopped down to f16 because I needed a reasonable amount of depth of field. I was using a tripod, but to ensure that there was absolutely no camera movement, I employed both mirror lock-up and the self-timer set at two seconds to make the exposure.

I often use mirror lock-up when taking images of static subjects at relatively slow shutter speeds, because when the mirror raises it can cause vibrations. This is not normally an issue when shooting at high shutter speeds, but at lower speeds (particularly when using a long lens, as here) it can result in unsharp images. I use the self-timer for much the same reason – at slower shutter speeds, when you press the shutter your contact with the camera can also produce vibration. An alternative to the timer is a remote camera release, but I prefer the convenience of the camera's own self-timer, rather than using yet another piece of kit.

THE IMPORTANCE OF LIGHT

When visiting Yosemite National Park for the first time, we had clear blue skies every day. For many tourists this was perfect weather, but in the land made famous by Ansel Adams, in these weather conditions I was struggling to make anything other than basic 'postcard' images of the place. Dark brooding skies is what I had hoped for, not featureless blue ones. The scenery is still spectacular, of course, and when I exited the road tunnel and stopped at the aptly named Tunnel View I took a snap. This was a

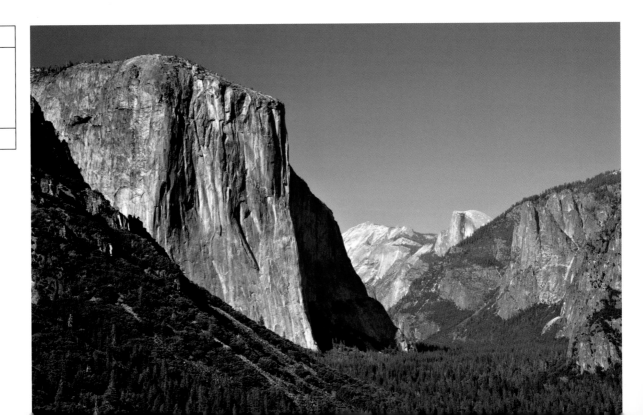

● EL CAPITAN

Canon 1Ds Mark II, 28-135mm zoom lens @ 70mm, 1/80th sec @ f11, digital ISO 200

California, USA

popular stopping point, where cars and buses full of people arrived at regular intervals, spent ten minutes taking pictures, then were off to the next viewpoint. I did my best, but you cannot fight the light and the result was a rather boring shot (opposite) of this lovely scene.

From our shooting point I reckoned that in the very early morning the light would be coming pretty much at us, and that the same view would provide a reasonably interesting picture at this time. We were staying about an hour's drive from this viewpoint, and set off around 4 a.m. the next morning. When we reached the spot, the scene was even more spectacular than I had hoped it would be, with the back-lit valley stretching out before us. What made it even better was that at this early hour we were the only people for many miles around. For the first time in Yosemite, we experienced the sense of wilderness that the early explorers of this beautiful place must have felt.

The sun was in front of us, and the very bright, almost white sky contributed nothing to the image. I therefore used a slightly longer focal length and lower angle than for the first image to emphasize the shapes of the mountains and make the most of the sea of pine trees that flowed through the valley floor. This resulted in a far more interesting picture (above) than the one taken the previous day. As a photographer visiting a region for a relatively short period of time, you often find yourself having to

● EL CAPITAN
Canon 1Ds Mark II, 28-135mm zoom lens @ 95mm, 1/80th sec @ f10, digital ISO 100
California, USA

shoot in less than ideal conditions, so finding different ways to make the most of difficult situations is essential in order to produce worthwhile images.

COLOUR AT DAWN AND DUSK

The distinctive topography of mountain regions lends itself well to the colourful skies of dawn and dusk, the shapes of the peaks making for interesting silhouettes. I have included two images from the Scottish Highlands as examples of photography in such an environment, one taken at dawn, the other at dusk.

 Clear blue skies are rarely the order of the day in Scotland, and we had spent a few days in almost constant drizzle, scouting out locations. The weather cleared the evening before this shot was taken and the forecast for the next day was much brighter, so a dawn shoot was worth attempting. The problem with this plan was that in the Highlands of Scotland in June, dawn is at around 3 a.m., so I had to make a very early start indeed. I crept out of the bed and breakfast as quietly as I could, having warned the owners of my intentions the night before in case they thought I was trying to avoid paying the bill!

 Fortunately, my chosen location was just a few kilometres up the road, and I arrived on site as the sky began to colour up. Loch Leven is a large expanse of water, and even the very slight breeze left ripples on the water, although the more sheltered area close by was calm enough to record a reflection. I was disappointed that there were no clouds in the sky at all, because it is usually

● LOCH LEVEN SUNRISE
Bronica ETRs camera, 200mm lens, exposure unrecorded, Fuji Velvia film, ISO 50
Scottish Highlands, UK

119

the clouds in the east lit by the low sun that provide most of the colour at sunrise. As the first rays of the sun cleared the top of the mountain on the right of the picture, the whole scene was flooded with orange. I quickly composed the shot to just exclude the rising sun and had the picture in the bag. The orange then slowly disappeared from the sky, and half an hour later I was back in bed, a successful morning's work done and dusted.

The above shot was taken at the other end of the day a few minutes after the sun had set in the far north-west of Scotland, in the Inverpolly Nature Reserve. It was taken on a warm calm evening during the month of July. It is a simple composition, showing the distinctive shape of Stach Pollaidh flanked by Cul Beag and Cul Mor, all in silhouette against a lilac sky and reflected in the small loch in the foreground. Although small in the frame, Stach Pollaidh is smack-bang in the centre and dominates the picture. Unlike in the previous image, the clouds are an essential part of the picture; without them the sky would have been featureless as well as colourless – no picture at all, in fact.

This trip was the first and last that I made to the Scottish Highlands in high summer. At this time of year the air is full of biting midges, which are at their very worst close to water, especially on windless evenings, so exactly in the situations where the best images are to be found. On this particular evening it was impossible to set up the tripod close to the loch due to the density of midges. I could not set it up in the car, so walked around quickly and extended the tripod legs, then secured the camera to the head. The midges do not seem to fly fast, and even a brisk walk leaves most of them in your wake.

As I stopped to put the camera in place, a veritable cloud of midges swarmed around it and in front of the lens. There were thousands of them, and I was not happy to take the shot through the fog of insects. I left the gear in place and returned to the car for help. Having recruited my wife as chief midge remover, she used our large road atlas to fan the midges away from the front of the camera for each exposure I made. I worked fast, and we soon had our pictures and left the area. The next day I discovered that three dead midges had actually got in between the prism head and the camera body (on the Bronica the prism head is removable). Three down, several trillion to go!

FOREGROUND

When photographing wildlife, one of the biggest errors made by inexperienced photographers is to pay too little attention to the background. The result is often a nice shot of a bird or mammal, with a mess of twigs or other animals in the background that detracts enormously from the picture. The mantra 'background, background, background' is the first piece of advice I give to budding wildlife photographers. When photographing wide-open spaces you are effectively concentrating on the background, and sometimes this is strong enough to create an image with real impact. However, in a lot of situations it is only by including a strong foreground element that you can achieve this.

On a visit to Glen Coe in the Scottish Highlands late one afternoon the light was interesting. However, a great deal of the mountainside was in shadow due to the angle of the sun, and I simply could not locate a composition I was really happy with. Wandering around the bank

● GLEN COE
Bronica ETRs camera, 70mm lens, exposure unrecorded, Fuji Velvia film, ISO 50
Scottish Highlands, UK

● VERMILLION LAKES

Canon 1Ds Mark II,
24-104mm zoom
lens @ 24mm,
1/200th sec @ f11,
digital ISO 100

Alberta, Canada

of a loch, I noticed a small patch of reeds growing close to the shore. They were lit by the low sun and added the foreground interest that the scene demanded.

I positioned the camera so that the reeds sat evenly across the triangular reflection of the sky created by the shape of the glen. The converging lines of the reflection lead the eye from the focal point of the brightly lit reeds into the picture. Without the foreground reeds the shot would be nowhere near as interesting.

In the case of the picture below, it would have been very easy to create nice images without any foreground – the snow-topped mountains reflecting perfectly in the still waters of the lake made lovely compositions. In fact, I made several different compositions of just these elements, and also created a digital panoramic of the scene. It was our last morning in Canada, and although we had visited Vermillion Lakes in Banff National Park on several other occasions, this was the first time we had

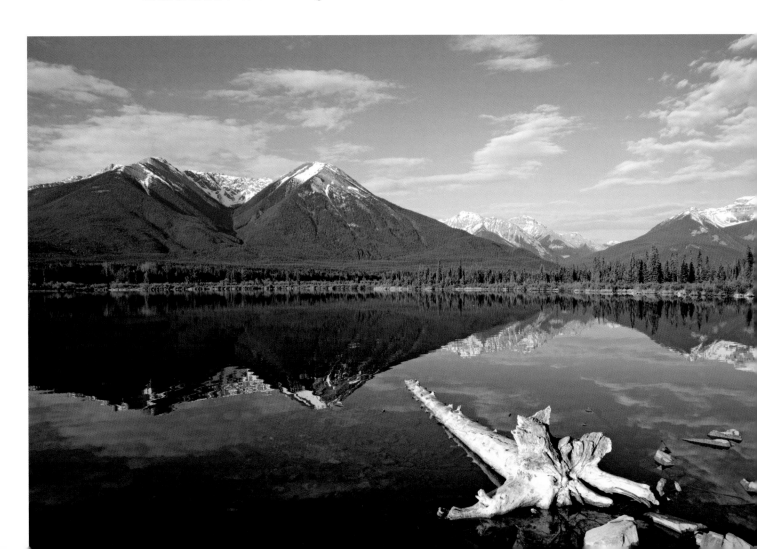

the completely calm conditions that are necessary for good reflections. The previous visits were not wasted, because we used them to scout out potential spots for when (we hoped) the conditions were right.

It was during one of these visits that I discovered the dead tree trunk lying in the water, its bleached white colour matching the snow on the distant mountains. The composition required careful consideration because access was not straightforward, and I needed to ensure that the tree did not overlap with the reflection of the mountain. To achieve this I had to shoot from a high angle, so that I was pointing the camera slightly downwards. The shot was a nice bonus at the very end of our trip to the incredibly scenic Canadian Rockies.

HDR IMAGES

There is a limit to the brightness range that both film and digital cameras can record. This is around five or six stops of light and is known as the dynamic range. Let us be generous and settle on six stops. This means that any scene that has highlights and shadows more than six stops apart cannot be recorded on the final photographic image without loosing detail in parts of the picture. From a photographic point of view, overexposed highlights tend to be unacceptable, so when faced with a scene of high contrast, photographers have traditionally made exposures based on the highlights and left the shadows to turn black and lose detail. Many landscape photographers use graduated filters to try and overcome this, but these are

based on straight lines and nature is not, so they are not perfect and their use is often obvious in the final image.

The limitations of the available dynamic range have been with us since the dawn of photography, but have at last been overcome by digital technology. It is still not possible to capture all of the information in a high-contrast image on a single digital frame, but by taking identical images at different exposures that cover the full range of the scene, you can combine them afterwards to produce an image that has an extended dynamic range. Such images are referred to as having High Dynamic Range, or HDR.

Snow-capped mountains such as those visible in the next shot from Banff National Park, where the early-morning sun lights up the white tops while the rest of the landscape remains in shadow, are impossible to capture on a single in-camera image. They are thus ideal for demonstrating the HDR technique, which is actually quite simple, as long as a few basic rules are followed.

It is important to secure your camera on a good tripod to ensure that each shot in your HDR sequence is identical in every aspect, except for the exposure. Since you are shooting the same scene in rapid succession, you should leave the camera to determine the colour balance using Auto White Balance, because it is not going to change between frames. It is also fine to use a polarising filter, because it will have the same effect on each frame. Finally, take a series of exposures to cover the complete range of tones within the scene. Because changing the aperture (f-stop) will change the depth of field, it is important to keep the same aperture for each image and change the shutter speed to control the exposure. To demonstrate this

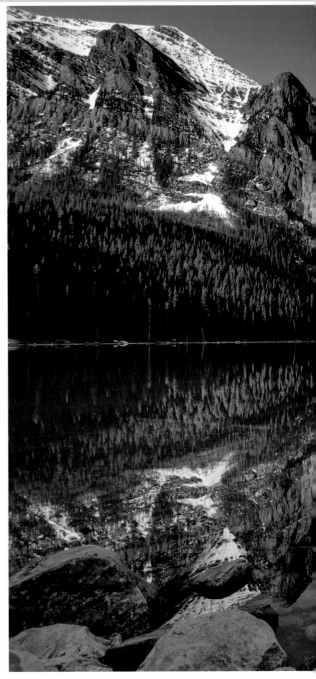

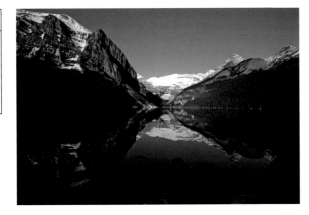

⬤ HDR 1

Canon 1Ds Mark II,
17-40mm zoom
lens @ 17mm,
1/500th sec @ f8,
digital ISO 100

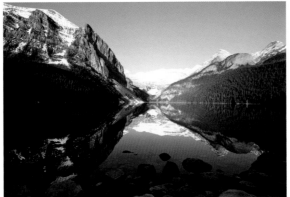

⬤ HDR 2

Canon 1Ds Mark II,
17-40mm zoom
lens @ 17mm,
1/125th sec @ f8,
digital ISO 100

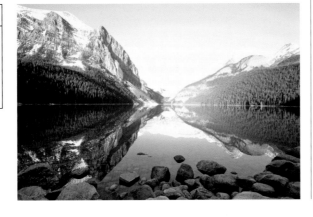

⬤ HDR 3

Canon 1Ds Mark II,
17-40mm zoom
lens @ 17mm,
1/30th sec @ f8,
digital ISO 100

technique, I combined three digital images taken at two-
stop intervals to capture all the detail in the scene.

HDR 1 | The first frame has been exposed for the
highlights. In this image only the brightly lit snow is
correctly exposed. The rest of the scene is underexposed

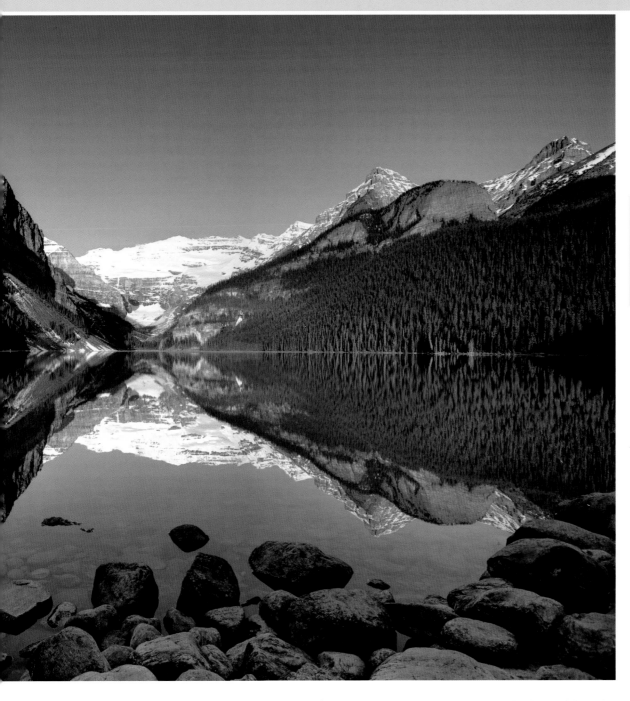

◉ LAKE LOUISE

Canon 1Ds Mark II,
17-40mm zoom
lens @ 17mm,
HDR Image

Alberta, Canada

and detail has been completely lost in the shadow areas. This is the only frame without blown highlights, and is the best that could be achieved on a single frame.

HDR 2 | This frame is two stops overexposed from the first frame and the highlights have been blown out, but the mid-tones are correct. There is still substantial loss of detail in the shadow areas, however.

HDR 3 | This frame is four stops overexposed compared to the first frame and looks dreadful when viewed on its own, but has been exposed for the shadows. Everything else has

● SUBALPINE FLOWERS
AND MOUNT RAINIER

Canon 1Ds Mark II,
17-40mm zoom lens @ 21mm,
1/60th sec @ f16,
digital ISO 100

Washington State, USA

completely blown out, but there is detail in areas that in previous exposures were very dark. This is very noticeable in the foreground rocks and the trees on the left.

Final HDR Image | This was created by using a special HDR software program (there are a number available), which has effectively kept the best bits from each frame and put them together to produce an image that would have been impossible a few years ago. I also cropped the final HDR image very slightly because it did not appear perfectly level. Clearly, it is important to make any crops to the final HDR image after it has been generated, rather than to each component picture beforehand, as they then might not exactly line up for the HDR process.

FLOWERS

At high altitudes the plant-growing season is a short one, with spring, summer and autumn being condensed into a few snow-free months. The shortened season results in many of the plants flowering at the same time, so the displays can be very photogenic. The most spectacular concentrations of blooms I have ever encountered were on the slopes of Mount Rainier in Washington State, at a location with the rather apt name of Paradise, and most of the images of flowers were taken here in early to mid-July. As usual, this section begins by representing flowers in the whole environment and works down to individual portraits, demonstrating the range of pictures that can be made using different approaches at one spot.

The first image from Mount Rainier, shown opposite, features the snow-covered mountain itself, which at 4,392 metres towers over the surrounding flower meadows that are still 1,600 metres above sea level, or around 300 metres higher that the tallest mountain in Great Britain.

To include the mountain-top in the picture, I set up the camera and angled it down slightly. Using a very wide angle lens, I placed the front flowers just a few centimetres from it. Extremely light winds, or better still no wind at all, are pretty much a requirement when photographing flowers, and as usual such conditions are most prevalent towards the start or end of the day. Apparently Mount Rainier is famous for the amount of cloud and mist that shroud the peak, and many visitors never actually see the mountain-top itself. I say apparently, because during the week or so we spent there, although there was

● BROADLEAF LUPIN
(*Lupinus latifolius*)

Canon 1Ds Mark II, 28-135mm zoom lens @ 135mm, 0.4 sec @ f22, digital ISO 100

Washington State, USA

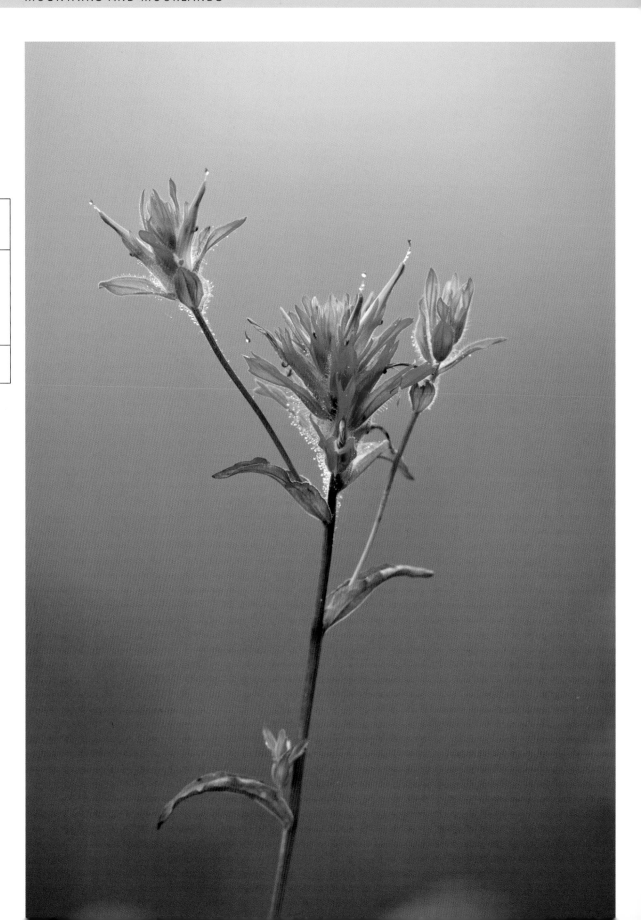

● SCARLET
PAINTBRUSH
(*Castilleja miniata*)

Canon 1Ds Mark II,
100-400mm zoom
lens @ 275mm,
1/640th second
@ f5.6,
digital ISO 400

*Washington State,
USA*

occasionally some early morning mist, the sun shone almost constantly.

Moving in closer to isolate a patch of flowers, the blue flowers and distinctive green leaves of the Broadleaf Lupin make a lovely combination. This lupin was one of the most common flowers growing in the subalpine meadows of Mount Rainier, but its season was short, the blooms fading after just a few days.

The sunny weather we experienced was fine for sweeping vistas of flowers that included the mountain, but for relative close-ups it was pretty disastrous, because the heavy shadows would have ruined the picture. However, in a mountain environment with steep-sided valleys, there was always a part of the mountainside that was in shadow. I worked in these areas, searching for suitable subjects.

In the days of film it was impossible to take pictures in shadow on a sunny day (unless you used colour-correction filters – which I never did), because a distinct blue cast would ruin the image. Unlike film, which had a fixed colour temperature, digital cameras can use a wide range of colour temperatures, depending on the lighting conditions and using the camera's AWB (Auto White Balance). I found that the results were very good, with no blue casts at all.

For the final picture taken at Paradise, Mount Rainier, I closed in on a single stem of a Scarlet Paintbrush to produce a portrait of an individual plant, shown opposite. Working in a flower-rich environment, photographing individual plants was the hardest challenge. I spotted a particular flower on the edge of a road that was cut into the side of the mountain. There was a steep drop-off on the side of the road where the plant was growing, so I could

isolate it against the pine-covered mountainside on the other side of the valley, some distance away. In normal light, these distant trees would have produced a rather uneven background that would not have been attractive. On this morning, however, a heavy mist was present, which gave a much more subtle and smooth look to the background. The water droplets from the mist clung to the flowers and this added atmosphere to the overall picture.

To make the most of the background I used my telephoto zoom lens to narrow the angle, and selected a large aperture to throw the background as out of focus as possible. To make sure that the plant was sharp, I ensured that it was parallel to the back of the camera, minimizing its depth in relation to the camera.

BIRDS

The harsh environments at the tops of mountains like those depicted above are not the most productive habitats for birds, but some species survive all year round in such places, although others only visit the higher altitudes in the summer months. Migrants often move to a warmer

| ● GRIFFON VULTURE |
| (*Gyps fulvus*) |
| Canon 1D Mark II, 500mm lens + 1.4x converter, 1/2,500th sec @ f11, digital ISO 400 |
| *Spain* |

● LAMMERGEIER
(*Gypaetus barbatus*)

Canon 1D Mark II,
500mm lens + 1.4x converter,
1/1,000th sec @ f5.6,
digital ISO 400

Spain

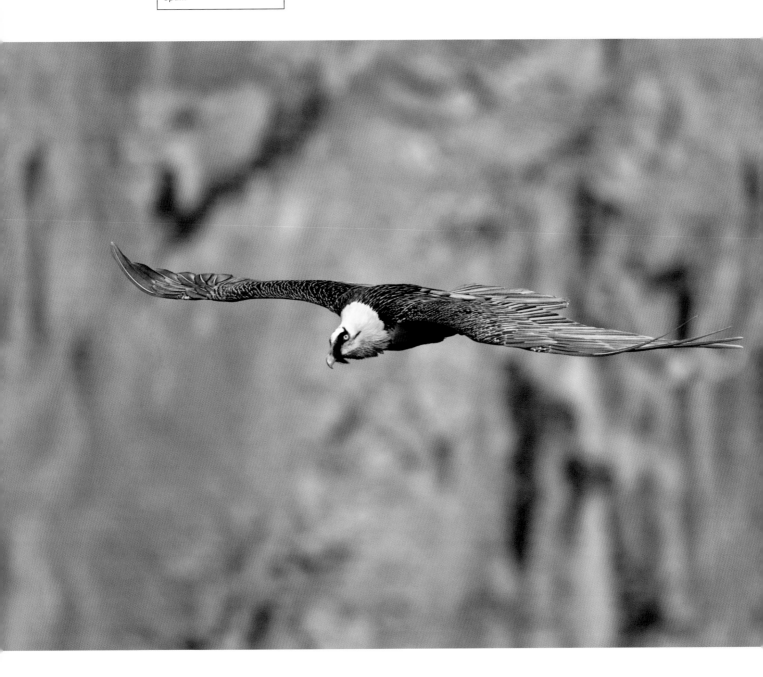

climate in winter, while other mountain specialists simply move to a lower altitude during the coldest months, returning to the heights only to breed in summer.

The Griffon Vulture in the image is a tiny silhouette in the frame, although it manages to dominate the scene. Working in the mountains north of Madrid, an area I was visiting specifically to photograph Griffon Vultures, I was standing on the edge of a cliff where the birds were breeding, photographing the large individuals as they flew by. These carrion feeders cover huge distances as they search for food, and a number of vultures were heading off towards a range of snow-capped mountains that was many kilometres away. The very tops of the mountains were obscured by dark clouds, and above these were lighter clouds that were back-lit by the sun. This resulted in dramatic light conditions, and I realized that I had a great backdrop. I set up for the shot, and as a vulture banked to produce a distinctive silhouette, the image that I had imagined was in the bag.

The following two pictures, shown on these two pages, are also of vultures, but are close-up portraits of the birds in flight. The species in question is the Lammergeier, an iconic mountain bird with a wide distribution in suitable habitats in Europe, Asia and Africa. The photographs were taken high up in the Spanish Pyrenees, close to the border with France. My wife and I spent a week in this mountain habitat, walking many kilometres each day to reach a look-out point high over a deep gorge where the birds would occasionally put in an appearance, drifting serenely by. For much of the time they were simply too distant for good photography, but just occasionally they would come within

range of my telephoto lens. The brief fly-bys were frenetic, because I had just a few moments to get some pictures. There was no way I could afford to start adjusting the exposure when a bird appeared, so I set it manually and was ready to shoot. The two images demonstrate how important it was to have used manual exposure – in both cases the bird is correctly exposed, despite the huge differences in tone of the backgrounds. The limestone walls of the ravine in the picture opposite are slightly lighter than mid-tone, and an automatic exposure would have recorded the bird itself as too dark. With some judicious post-processing you could have got away with this. This would not have been possible in the case of the above picture, which was taken as the Lammergeier caught the sun when it flew across a deep gorge that was completely in shadow.

● LAMMERGEIER
(*Gypaetus barbatus*)
Canon 1D Mark II, 400mm lens + 1.4x converter, 1/1,000th sec @ f5.6, digital ISO 400
Spain

RED GROUSE
(*Lagopus lagopus scoticus*)

Canon 1Ds Mark II,
500mm lens + 1.4x converter,
1/1,000th sec @ f6.3,
digital ISO 400

Yorkshire, UK

An automatic exposure would have rendered the dark ravine as a mid-tone and the bird would have been overexposed by several stops, ruining the picture.

From the mountains of the Pyrenees we travel to the rather less exotic moorlands of the UK for our next bird species, the Red Grouse. This species stays on the high moorland all year round, scraping away the snow in winter to feed on the heather shoots. The high heather moors are difficult to cultivate, but often managed by humans and burned regularly to encourage fresh young heather shoots. In some areas the hunting of Red Grouse is an important source of income.

The Red Grouse image on the left shows the bird in its moorland habitat, with a farmer's fields in the valley far below forming the background. The bird, like the Griffon Vulture on page 129, was placed to one side of the frame

RED GROUSE
(*Lagopus lagopus scoticus*)

Canon 1Ds Mark II,
500mm lens + 1.4x converter,
1/500th sec @ f7.1,
digital ISO 400

Yorkshire, UK

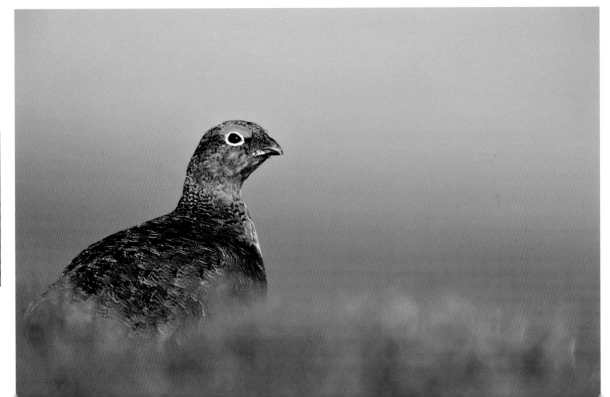

and is looking into the picture. The bare moorland in the foreground was not very interesting, so I excluded as much of it as possible from the picture. Careful positioning of the subject is essential when it is such a small part of the overall image.

The next image was taken on the same morning and is a much closer view of the Red Grouse foraging among the heather by the side of the road in the early-morning light. The out-of-focus heather that surrounds the bird emphasizes its subtle plumage, and again the bird is positioned to one side of the frame so that it is looking into the picture. Both images were taken on the uplands of the Yorkshire Dales National Park in early spring. At this time of year the male birds can often be found at the sides of the small roads that cross the moor, and can be photographed using the car as a hide. Early morning is the best time because there is little traffic; the birds tend to wander further from the road as traffic builds up later in the day.

The final bird image from the mountains is one of a summer migrant that would find it impossible to survive the winter in this habitat. This is the diminutive Rufous Hummingbird, which makes the long journey north from the Yucatan Peninsula in Mexico every year to breed as far north as Alaska. Given that the bird is only a few centimetres long, this is an incredible journey for it to undertake. Because hummingbirds feed primarily on flower nectar, their summer visits are timed to make the most of the seasonal flower feast. Hummingbirds also eat very small insects such as gnats and midges, which are abundant in these mountain habitats during high summer when the birds are rearing their young. As soon as the flowers fade and the insects disappear, there is no more food for the hummingbirds and they set off south again.

Hummingbirds are easily attracted to feeders full of sugar water, and many people hang these out in their gardens during the summer. I photographed this individual hovering in front of one such feeder using natural light on a bright overcast day. A Rufous Hummingbird is less than 8 centimetres long, so I fitted my 400mm f4 lens with a 25mm extension tube. This enabled me to focus more closely than is normally possible with this lens, and to almost fill the frame with the tiny bird. The glossy colourful gorget on the bird's throat does not photograph well in bright sunlight, so bright overcast is best. Such overcast conditions resulted in shooting at only 1/800th of a

● RUFOUS HUMMINGBIRD (*Selasphorus rufus*)

Canon 1D Mark II, 400mm lens + 25mm extension tube, 1/800th sec @ f4, digital ISO 400

Canadian Rockies

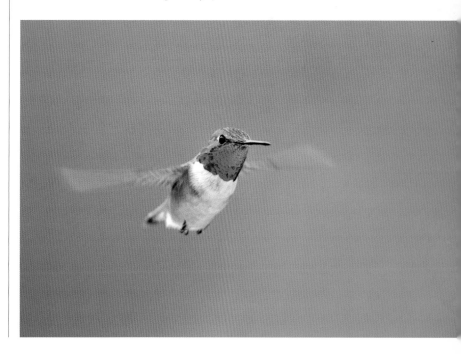

● BLACK-TAILED DEER
(*Odocoileus hemionus columbianus*)

Canon 1Ds Mark II,
100-400mm zoom
lens @ 180mm,
1/320th sec @ f6.3,
digital ISO 200

*Washington State,
USA*

second. Because the wings beat at more than 50 times a second, they were always going to end up as a blur, but I quite like this effect – most importantly for me, the head is sharp.

MAMMALS

As is the case with birds, many species of mammal cannot survive the winter at high altitudes and can only be found in this habitat in the summer months. Some winter at lower elevations, returning to the lush alpine meadows to feed only when the snow has gone. Others do spend the entire winter on their breeding grounds, but because there is not enough food for them they sleep through the entire winter – they hibernate.

The Black-tailed Deer is one of the species that winters at lower elevations, but in the summer it can be found grazing on the abundant vegetation on the slopes of Mount Rainier in Washington State. This is a very popular

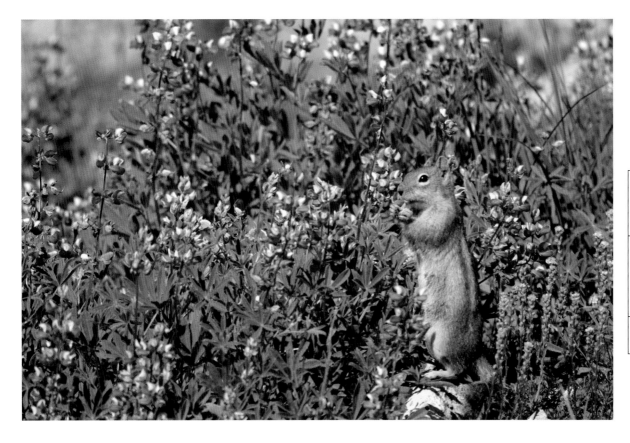

● GOLDEN-MANTLED
GROUND SQUIRREL
(*Spermophilus
saturatus*)

Canon 1D Mark II,
100-400mm zoom
lens @ 400mm,
1/1,600th sec @ f5.6,
digital ISO 200

*Washington State,
USA*

national park within easy driving distance of Seattle, so it can get very busy, especially at weekends. The deer are quite nervous animals and are easily spooked, so the best time to see them is in the early morning, before the crowds arrive and disturb them. On misty mornings they seemed particularly tolerant, and we came across a small group feeding close to a trail. We used slow and deliberate movements – far less likely to frighten any animal than fast and jerky actions – and after the deer stopped and looked up at us they resumed feeding. I took a few pictures before moving off slowly and leaving them in peace.

One of my favourite groups of mammal that can be found in mountain regions is the rodents. These are incredibly active creatures during the summer, frantically feeding and rearing their broods before winter descends again. Most of them hibernate in underground burrows, sometimes for up to seven or eight months at a time. They

can also be very confiding and are often found around picnic areas, where they scavenge for food.

Feeding is something that certainly occupies much of the daytime activity of ground squirrels, and they seem to make the most of the short flower season. The Golden-mantled Ground Squirrel is common in much of the Rocky Mountains range in both the USA and Canada. I spent some time following these lovely little animals around, and when one stood upright on its back legs and started feeding on a patch of lupin flowers it made a charming picture. Because the rodent was some distance away, I placed it on the right-hand side of the image, looking into the picture – exactly the same compositional technique as that used for the bird pictures on page 132.

The next picture, of the closely related Columbian Ground Squirrel, also shows the subject feeding on a flower, in this case a dandelion flower. This species of

● COLUMBIAN GROUND SQUIRREL
(*Spermophilus columbianus*)

Canon 1D Mark II, 70-200mm zoom
lens + 1.4x converter @ 280mm,
1/2,000th sec @ f6.3,
digital ISO 400

Canadian Rockies

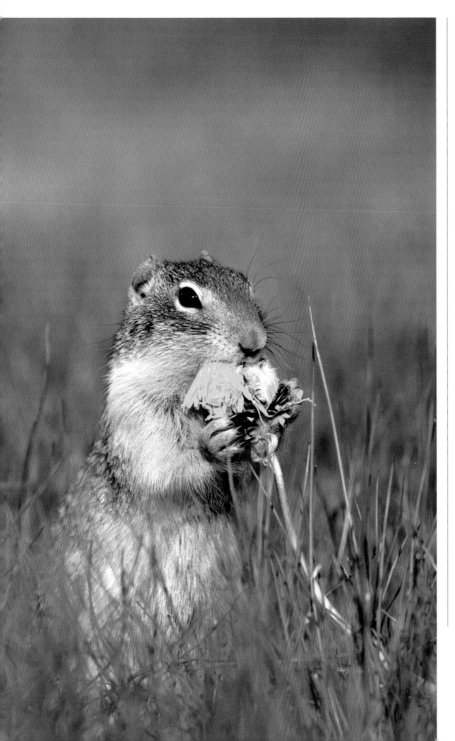

ground squirrel breeds in small colonies, and when I came across one on a south-facing bank by the side of a lake I simply sat down and waited. When I first arrived the rodents disappeared down their burrows, but after just a few minutes they started to emerge and go about their business. This individual came across a large dandelion flower, squatted down in an upright position and started to devour the flower, which did not take long.

The little rodents seemed to ignore me completely. and I lay down to get a squirrel's eye view of my subject. Unlike the Golden-mantled Ground Squirrel, the Columbian Ground Squirrel was large in the frame, so I turned the camera on its side into portrait mode, since this best suited the upright stance of my subject. Although this picture and the one preceding it were of essentially the same scene, the different size of the subject in relation to the rest of the frame dictated the composition.

Having spent some time watching the behaviour of the Columbian Ground Squirrels at close quarters, I noticed that they would spend a lot of time running around the colony area, often taking the exact same routes. When they ran they moved very fast indeed – they are pretty much at the bottom of the food chain, so I guess this is a survival trait that has evolved over time. Photographing this behaviour was not going to be easy, but I wanted to give it a try. Due to the fact that they used regular paths, I had at least a chance of being in the right place as one flashed by.

I sat myself down and waited by the side of the lake where the squirrels regularly ran by. I am used to photographing birds in flight, but against a blue sky the autofocus has little to distract it, so it locks on to the bird.

With the squirrels being on the ground, there were lots of other bits of the scenery that the camera could lock onto. This made it harder for the camera's autofocus to lock on in the first place, and to stay on the subject. To increase the chances of a sharp image, I would pick up a squirrel in the frame when it was some distance away, then track it through the viewfinder as it shot towards and in front of me. I was shooting with the Canon EOS 1D Mark II body, which can take 20 frames before the buffer fills up, and shoots at 8 frames per second. This gave me just two and a half seconds of photography. As a squirrel approached I waited until I could see the whites of its eyes before pressing the shutter and holding it down as it went past. I managed to get some lovely shots that show it with all four legs off the ground, seemingly frozen in mid-air.

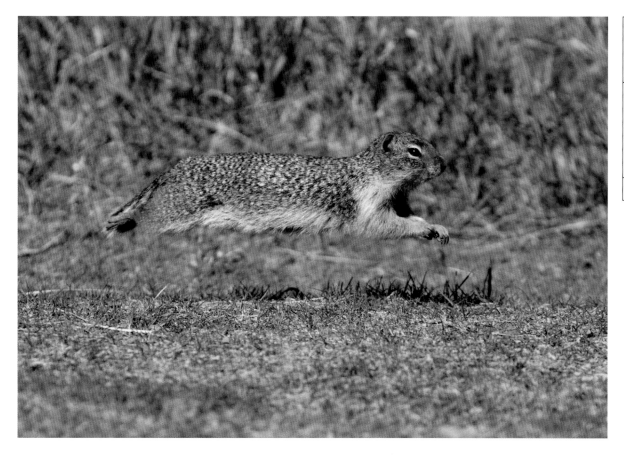

● COLUMBIAN GROUND SQUIRREL (*Spermophilus columbianus*)

Canon 1D Mark II, 70-200mm zoom lens + 1.4x converter @ 280mm, 1/3,200th sec @ f5.6, digital ISO 400

Canadian Rockies

Polar regions

It may seem strange to include the two parts of the Earth that are literally 'poles apart' in the same chapter, but in many ways these cold remote regions are very similar habitats and pose the same kinds of challenges for the visiting photographer.

THE WILDLIFE HAS UNDERGONE PARALLEL EVOLUTION, with the auks of the north filling the same ecological niche as the penguins of the south. Another thing that the wildlife has in common is that it is relatively unphased by the presence of humans and with care is very approachable, an excellent quality from a photographer's viewpoint. There are no reptiles, few plants and even fewer invertebrates, so wildlife photography is pretty much limited to birds and mammals, but the environment itself is stunning and is worth a visit for its attraction alone.

LAND OF SNOW AND ICE

Digital cameras have certainly made life easier for photographing the snow-covered landscapes of the polar regions. Photographers who did not have a good grasp of exposure and relied heavily on their cameras' exposure meters in such difficult conditions would inevitably end up with badly exposed images, although they would not discover this until they returned home. Camera meters in digital cameras are no better, but the flashing highlights on the little picture on the back of the camera instantly tell you when the highlights have blown out, so that the exposure can be adjusted and the picture retaken.

It is best to take a reading from the brightest part of a snowy landscape, then set the exposure manually so the white highlights are two stops overexposed. This ensures that the exposure is correct every time. The technique works fine when you can get up close to isolate the brightest area of a subject and take a reading from it, but you often find you are on board a ship when the most interesting landscapes appear, and will be shooting from some distance away. In these circumstances you will need to check the exposure frequently.

The Lemaire Channel in the Antarctic Peninsular is one of the most scenic locations in Antarctica, and when we entered it early one morning there was a lot of cloud cover. The sun was rising behind the mountain seen in the picture opposite, and as it did so it lit up the clouds from behind. The scene was a long way from the ship, and I had to shoot it with a long lens and converter, which I hand-held. To avoid camera shake I set the ISO speed to 400, which enabled me to shoot at a very fast 1/2,500th of a second, more than enough to make a pin-sharp image.

DIGITAL PANORAMICS

In the chapter on arid regions, I included a number of panoramic images taken on a Fuji panoramic camera that produced slides 17cm across and 6cm deep. This very specialist camera was expensive, large and difficult to use. Nowadays, digital technology provides the opportunity for anyone to make panoramic images with their existing digital camera equipment. This is achieved by taking several pictures of the scene and stitching them together afterwards using computer software, and is surprisingly easy to do.

The first thing, of course, is to take a number of pictures of your chosen scene. Many books tell you that you first have to level your tripod and camera, then go

⬤ LEMAIRE CHANNEL

Canon 1D Mark II,
400mm lens
+ 1.4x converter,
1/2,500th sec @ f5.6,
digital ISO 400

Antarctic Peninsula

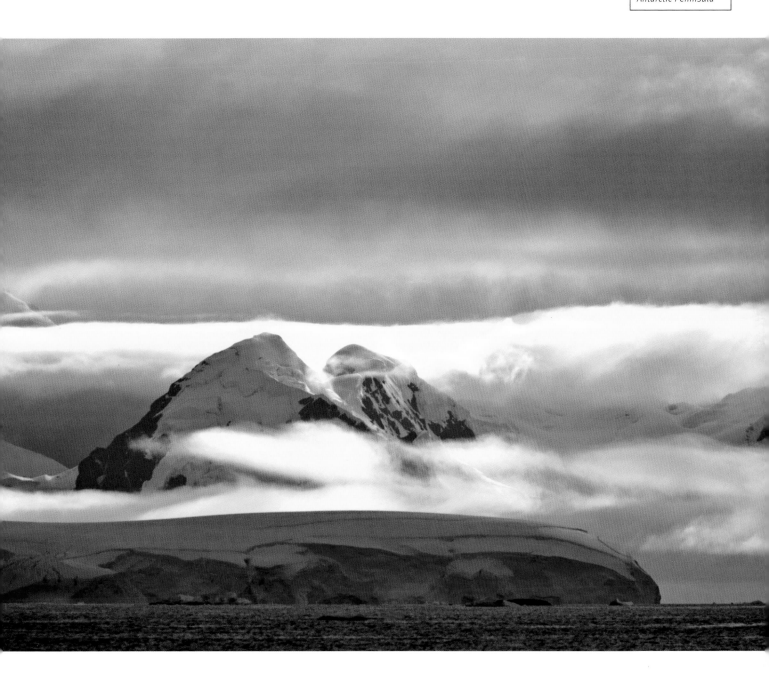

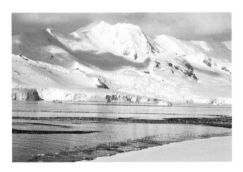

● THE SIX IMAGES THAT MAKE UP THE FINAL PANORAMIC

Canon 1D Mark II, 70-200mm zoom lens @ 70mm, 1/640th sec @ f13, digital ISO 400

Antarctic Peninsula

on about finding something called the nodal point. This is not an approach that I would use myself. When shooting from a ship it would be a waste a time, anyway, because the vessel is not a stable base on which to set a tripod. I like to keep it simple and often shoot hand-held. Here is some advice for making successful panoramic images:

- Do not use a polarising filter. It would darken the sky unevenly, depending on the sun's angle, producing an uneven sky when the frames are stitched together.

- Do not use AWB (Auto White Balance) because this can vary between frames, leading to uneven colour when the frames are stitched together. Set the white balance to sunny or cloudy, depending on the conditions.

- Always use manual exposure, and set it to ensure that the highlights in the brightest part of the whole panoramic scene are not overexposed. Make sure you do not just set the exposure on the basis of the

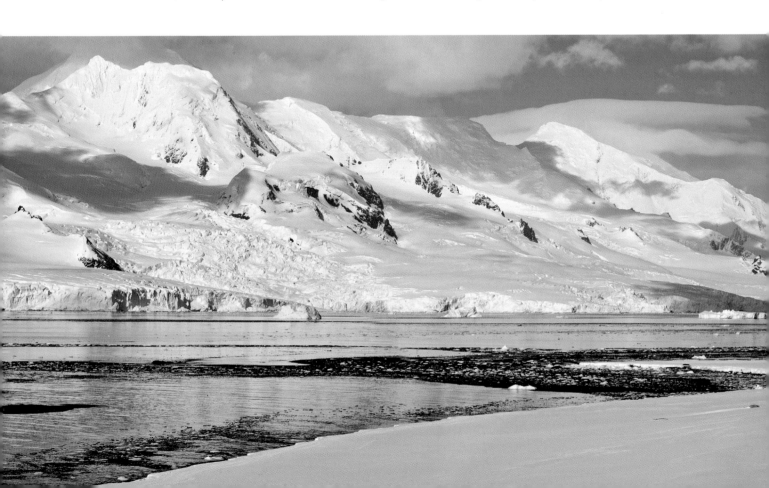

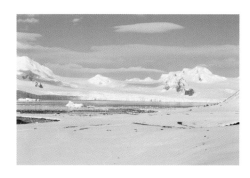 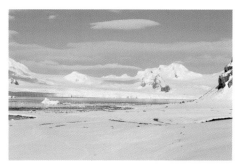 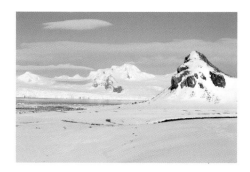

first frame, because subsequent frames may be overexposed. It is important that all the frames have the same exposure.

- Turn off autofocus, manually focus the lens on the first frame and do not change it for subsequent frames. Avoid very wide-angle lenses because they are prone to edge distortion, which does not lend itself well to an even panoramic.

- Always start on the left of the scene and make sure each picture overlaps at least 50 per cent with the previous picture. This reflects the way the final panoramic will look, and makes it easier to spot the group of images to be stitched together when they are on your digital lightbox.

- Allow space at the top and bottom of each frame to leave room for cropping. It is highly probable that the position of the horizon will vary from shot to shot.

HALF MOON BAY THE FINAL PANORAMIC, STITCHED TOGETHER FROM THE SIX INDIVIDUAL IMAGES AND CROPPED SLIGHTLY FOR THE BEST EFFECT.

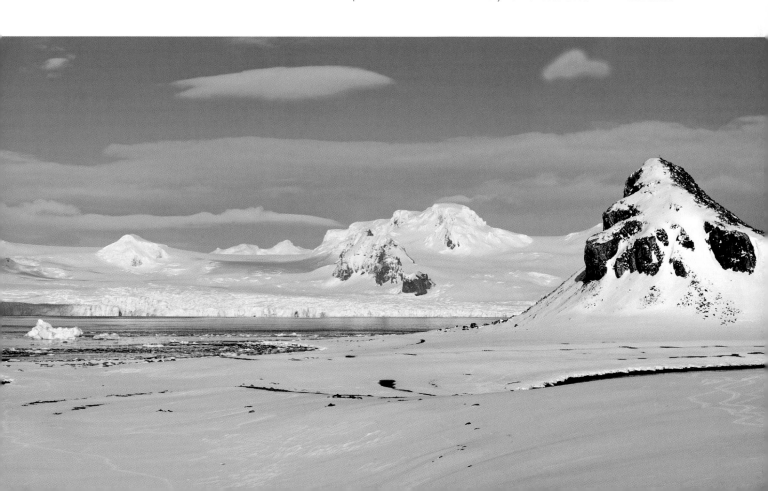

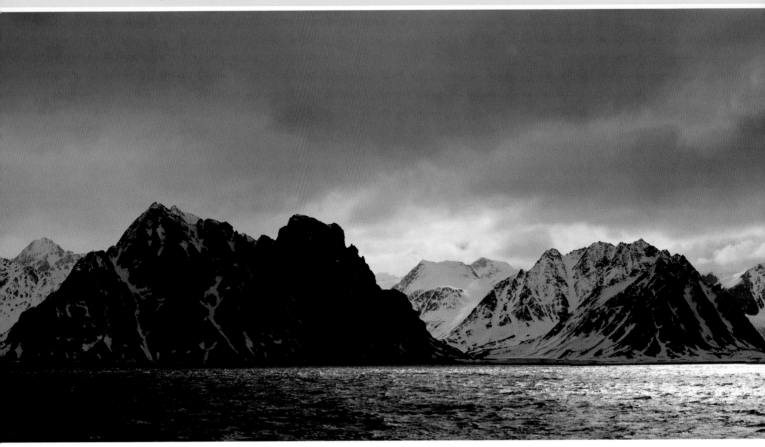

Above:

⦿ MOUNTAINS AND GLACIERS

Canon 1Ds Mark II,
24-105mm zoom
lens @ 105mm,
1/1,000th sec @ f11,
digital ISO 400

Svalbard, Norway

Opposite:

⦿ RAINBOW AT ST ANDREW'S BAY

Canon 1Ds Mark II,
28-135mm zoom
lens @ 100mm,
polarising filter,
1/640th sec @ f5.6,
digital ISO 400

South Georgia

You can buy special software that can be used to stitch the pictures together, but I find that the Adobe Photoshop photomerge function produces excellent results.

The above image is of Svalbard and is more dramatic due to the interesting light. It is made up of no less than ten separate images. High-contrast panoramics such as this demonstrate the need to work out your exposure from the whole scene and set it manually. The first two frames are very dark, and when taken would have appeared underexposed, because I set the exposure to ensure that the highlights towards the centre of the image were not blown out. Only when all the images are stitched together can the contribution of the seemingly 'underexposed' individual frames be seen to the whole picture.

COLOUR IN THE LANDSCAPE

Arctic and Antarctic environments are by their nature rather black and white, so when atmospheric conditions introduce some rare colour into the scene it is a good idea to make the most of it.

The weather in polar regions can be very changeable, and in these conditions the chances of rainbows occurring are quite high. My ship was anchored off the shore of South Georgia Island, and we were hoping to land at St Andrew's Bay to visit a vast King Penguin colony. Unfortunately, it was very windy, resulting in a metre-high swell at the landing site and making it impossible to go ashore. I remained on deck watching the clouds race

across the scene, when suddenly a lovely rainbow appeared that framed the distant mountain slowly being consumed by cloud. I knew this spectacle would not last long, so I added a one-stop exposure to the meter reading to allow for the amount of white in the sky and quickly took a shot. The composition was straightforward and the elements in the scene demanded that I place the rainbow on the left, where it would lean in towards the centre of the frame. To my mind the picture would not have worked with the rainbow in any other position. I realized afterwards that I had not even thought about the composition and had taken the picture intuitively. This is a very useful thing to be able to do when you are in a situation that is transitory and the picture could disappear at any moment.

Whereas rainbows are usually fleeting, sunrise and sunset in the polar regions seem to last forever due to the low angle at which the sun crosses the horizon at these extreme latitudes. Most visits to Antarctica take place during the summer, when the seas are relatively ice free and the seabirds are on land raising their families. During this season the days are very long, and in December the sun never sets at all. The image shown above was taken at sunset during February, which is pretty late in the Antarctic season so there are a few hours of darkness each day. Good sunsets are very unpredictable because they require quite a lot of cloud to be lit by the waning sun, but if the cloud is too dense it obscures the sun altogether and there is no colour.

I took some pictures on a particular day when the sky had turned yellow in the late evening. The colour lasted around 30 minutes, gradually turning more and more orange, and I kept on taking pictures before it finally faded away. Because I was shooting from a ship there was little to use as foreground interest, just the line of mountains in the distance, but the sky was such a lovely colour that the image still works.

ICEBERGS

Nothing says polar more than icebergs, and they can make iconic photographic subjects. They vary enormously in size and shape, and you normally have to shoot them from a moving ship. It can be tricky to make an iceberg image look interesting, particularly in dull flat light, and this was the case when we passed the iceberg in the picture shown here. Looking back as we sailed past the sky was very dark in the background. When a shaft of sunlight broke through and lit up the white iceberg, the contrast between it and the dark sky increased and made for an interesting image. The problem was that the iceberg was steadily disappearing into the distance as we steamed ever further away from it. My full-frame camera was fitted with a small zoom lens, which I was using for landscape photography,

● ICEBERG
AND STORMY SKY

Canon 1D Mark II,
400mm lens + 1.4x
converter,
1/800th sec @ f9,
digital ISO 400

*Weddell Sea,
Antarctica*

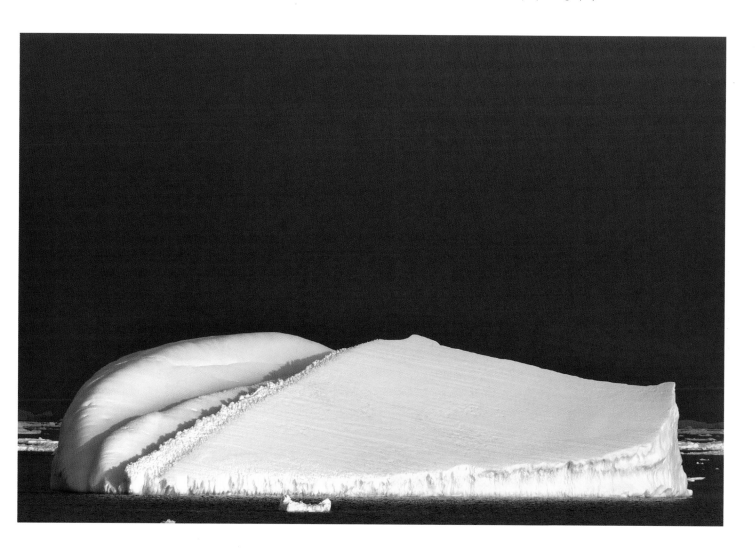

BLUE ICEBERG DETAIL

Canon 1D Mark II,
100-400mm lens
@ 400mm,
1/400th sec @ f8,
digital ISO 400

Antarctic Peninsula

but it provided far too short a focal length. Fortunately, I had another camera set up in case we encountered any birds flying by. I was able to use this to capture the beautifully lit iceberg before we got too far away. Shortly afterwards the sun went in and the scene returned to its previous, far less interesting light.

When seen closer up, the structure of some icebergs can be very intricate and makes for great abstract images, especially if an iceberg is of the blue variety. Most icebergs are white because they contain lots of air bubbles that scatter and reflect all the colours of the spectrum. Ice that has come from the base of a glacier has had much of the air squeezed out of it by the weight of the ice on top, and it now absorbs the light at the red end of the spectrum, leaving only the blue light to be reflected – hence blue icebergs. It is unlikely that you will get close enough to an iceberg to take intimate portraits from a ship. In such a perilous situation even the keenest of photographers would be more likely to be trying to get into a lifeboat rather than taking pictures. Most safe close encounters with icebergs are courtesy of Zodiacs, the rubber boats that take you ashore. With their small size and shallow draft,

they can get close up to bergs and allow you to wonder how such beautiful shapes can be produced from something as simple as frozen water.

Even though we were comparatively close to the lovely blue iceberg shown on the left, I wanted to isolate just a small area of it near the base that was particularly colourful and nicely shaped. To do this I used my zoom lens at its maximum focal length of 400mm. Hand-holding at this magnification is always tricky for still subjects, and being on a Zodiac full of people moving around did not help, but using an IS lens did – it is made for this situation. Even with IS technology I still wanted to keep a fast shutter speed, and compromised on depth of field to shoot at 1/400th second f8.

HUMANS AND WILDERNESS

Including people in nature photography is not something I do much, but the ultimate wilderness environment of the polar regions can often be best portrayed when people are featured to give a sense of scale and isolation. The image opposite of a group of people at the bow of the icebreaker *Kapitan Khlebnikov* as it pushes its way through the pack ice certainly achieves this. I went to the top deck of the ship and used a very wide-angle lens, since I wanted to include the horizon in the picture. This, more than anything else, gives the required sense of scale and shows the seemingly endless nature of the ice.

The only technical issue with this picture is, as always, allowing for the predominantly white scene. In this case it

● ICEBREAKER
PUSHING THROUGH
PACK ICE

Canon 1Ds Mark II,
20mm lens,
1/2,500th sec @ f5.6,
digital ISO 400

Antarctic Peninsula

was necessary to overexpose, compared with the meter reading, otherwise the ice would have been a dull grey. Apart from that it was an easy picture to execute, the trick being to think outside the normal 'nature photographer' box and make both man and his machine the focal point.

BIRDS

The polar regions are really good places for photographing birds, since they show little fear of humans, a big plus for the visiting photographer. Because of this, and also due to the fact that many general nature photographers visiting these areas are likely to turn their attention to the accessible birds, I have included more bird images here than in other chapters. When travelling in either region you spend a long time at sea, particularly if you visit Antarctica, where you have to cross the notorious Drake Passage, something I have now done several times.

This stretch of water between South America and the Antarctic Peninsula can get very rough indeed, with huge waves and howling gales. It is, however, a great place for photographing birds in flight because several species often follow the ship. These include the Wandering Albatross, which has a wingspan of more than 3 metres – the largest wingspan of any bird. Its large size and smooth flight make it a comparatively easy target for flight photography – the birds effortlessly keep up with the ship, often without a single flap of their wings.

If the weather conditions happen to be sunny you can photograph the birds against the blue sky, but on overcast days you will want to avoid the bland sky altogether and concentrate on photographing them as they swoop low over the ocean. The following picture was taken on a bright

● WANDERING ALBATROSS
(*Diomedea exulans*)
Canon 1Ds Mark II,
400mm lens + 1.4x converter,
1/2,000th sec @ f5.6,
digital ISO 400
Drake Passage

overcast day, enabling me to shoot at a high shutter speed, and producing an image free of the harsh shadows on the bird's body that are often created by its wings when the sun is out. Getting to and from the Antarctic takes a couple of days, and I have always been surprised at how few photographers spend their time out on deck taking advantage of probably the best opportunities for bird flight photography in the entire trip. Apart from enabling shots of birds in flight over the ocean, the deck of a ship can be

● CHINSTRAP
PENGUINS
(*Pygoscelis antarctica*)
AND CAPE PETRELS
(*Daption capense*)
Canon 1Ds Mark II,
100-400mm zoom
lens @ 400mm,
1/1,600th sec @ f8,
digital ISO 400
South Orkney Islands

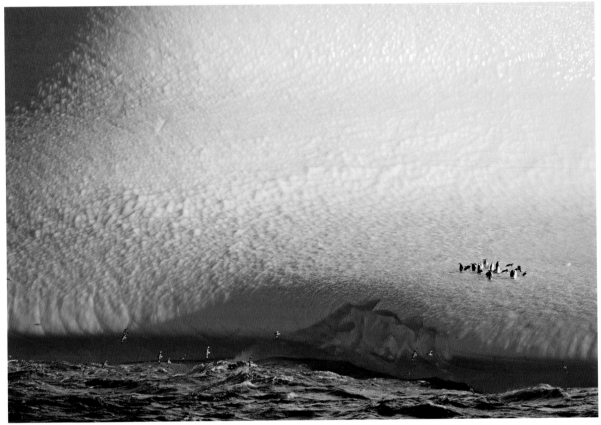

a good place to capture images of birds in the polar seas that would be impossible from land. Photographing penguins on icebergs is always a bit special, and I was hoping to come across a nice blue berg covered in penguins as our ship slowly cruised around the South Orkney Islands. Taking such pictures is actually quite easy, the most important element being luck – unfortunately, we did not have any. There were only a few scattered penguins, and all on white icebergs. Nature photography is often about making the most of a situation, however, and when I saw a huge iceberg with a few Chinstrap Penguins on it I could see there was a picture to be had.

The 20 or so penguins were dwarfed by the vast wall of ice that glistened in the sunshine behind them as the waves lapped around the base of the great berg. I wanted to include the sea in the picture, so I framed the shot to place the penguins in the bottom right of the frame. Just at that moment a flock of Cape Petrels flew past the base of the berg. I took the shot and made one of my favourite images from the trip, although I still hope one day to come across that deep blue iceberg full of penguins.

The image on the right shows a Kittiwake sitting on the sea ice at the other end of the world, only a few hundred kilometres from the North Pole. This was quite literally a grab shot – we had just been trying to get close enough to a Polar Bear for photography, but it had wandered off long before we came into range.

In preparation for my hoped-for first encounter with a Polar Bear, I had fitted the longest lens I had with me (400mm f4) with a 2x converter to allow me to shoot from a distance in case we could not get very close.

I still had this set-up over my shoulder as I was talking to two other photographers, all of us disappointed that the bear had not cooperated. We were no longer stalking the bear, so the ship was travelling quite quickly through the ice channel. I suddenly saw the Kittiwake sitting on some mounds of sea ice. I quickly raised the camera, manually dialled in plus two stops to the exposure reading shown by the meter and took the shot over the shoulder of one of the photographers I was talking to, who had her back towards the ice.

Because I had the 2x converter on I was shooting at an effective f8, and at this aperture autofocus only works on the centre spot. I therefore had to place the bird in the middle of the frame, something I would not normally do. Had the camera been set to one-shot autofocus or manual focus I could have repositioned the bird, but it was set to follow focus and there was no time to think, much less change the autofocus method. I got just two shots before the bird was out of range. Ironically, when I processed the image I tried to crop it to take the bird out of the centre, but because of the nice mound of ice on the left and the bird facing right, this detracted from the image.

KITTIWAKE
(*Larus tridactyla*)

Canon 1D Mark II, 400mm lens + 2x converter, 1/1,600th sec @ f10, digital ISO 400

Svalbard, Norway

So far all the bird pictures featured in this chapter were taken from a ship, but once ashore there are many more opportunities for bird images. This is particularly the case in Antarctica, where there are many rookeries – notably those of penguins – during the short breeding season. I have chosen three penguin pictures following the theme of this book, starting with the whole scene, isolating an image from within the scene and finally homing in for a close-up.

The first image, below, shows a huge King Penguin colony on the island of South Georgia, which is spread out over a large and open flat area known as Salisbury Plain, with jagged peaks of snowy mountains in the background. The two birds flying over the colony are Great

Skuas, which are on the lookout for any scraps of food they can find, including penguin eggs and newly hatched chicks. Given the dull light and the white sky, this was never going to be a great work of art. However, the point of the image was to record the scene as well as was possible in the circumstances, to show the sheer number of King Penguins gathered together in the landscape where they breed.

When working among large colonies of birds, the biggest challenge is locating a clear and uncluttered background. With so many birds packed together it is easy to create pictures in which the background is a mess, with bits of other birds intruding on the scene and distracting the viewer's eye. When you find yourself in a large breeding colony of birds such as penguins, a solution is to work around the edges. This is the approach I took when visiting the Emperor Penguin colony at Snow Hill on the Antarctic Peninsula. Emperor Penguins breed on the sea ice, rather than on land. If you want to visit a colony you have to go on a special trip because they breed much earlier in the season than the other penguins. You also have to travel on an icebreaker, because there is a great deal of sea ice at this time of year and only an icebreaker can make the journey through the frozen sea.

The centre of this colony was packed with birds that – from a photographic point of view – were all getting in each other's way. The adults spend a lot of time out at sea catching fish to feed to their young. The colony was a couple of kilometres from the edge of the sea ice, so the adults had to walk backwards and forwards to the sea when they went fishing. They would often do this in small groups. When they came across a nice flat area of ice they

KING PENGUINS
(*Aptenodytes patagonicus*)

Canon 1D Mark II, 28-135mm zoom lens @ 75mm, 1/160th sec @ f16, digital ISO 400

South Georgia

● EMPEROR PENGUIN
(*Aptenodytes forsteri*)

Canon 1Ds Mark II,
100-400mm zoom
lens @ 400mm,
1/1,000th sec @ f11,
digital ISO 400

Antarctic Peninsula

would sometimes flop down on their stomachs and push themselves along with their feet. This is known as 'tobogganing', and on suitable ice can be a quick and easy method of travel. It was something I wanted to photograph.

When I saw a small group approaching I crouched low to give more of a 'bird's eye' view, and used the 400mm end of my zoom lens to narrow the field of view and isolate the single bird shown above. Even in overcast conditions, out on the sea ice it was very bright, because the light was reflected off the snow and ice and lit up the whole scene. I was therefore able to use an aperture of f11 and still shoot at a fast shutter speed to freeze the movement.

When visiting a Chinstrap Penguin colony on Half Moon Island it was nigh impossible to isolate individual penguins or couples at the edge of the colony, because the rocky terrain severely restricted access. It was early in the season and there was a great deal of activity at the colony,

as birds quarrelled over territory and began mating. None of this would have made for good photography because Chinstraps nest very close together, and try as I might I could not make a composition that did not include an extremely messy background full of other penguins.

Rather than take pictures that I would only throw away later, I sat down quietly at the edge of the colony and watched for a while. It was then that I noticed some of the penguins eating snow; presumably at this time of year it was their only source of drinking water. Although I was close to the birds I decided to use a 400mm lens and a 1.4x converter. At close range and with such a long lens, I was able to isolate the heads of the penguins and photograph them as they bent low to take the snow into their beaks. I hand-held the camera because a tripod would have been a hindrance in this situation – I needed the freedom to change the camera angle frequently to

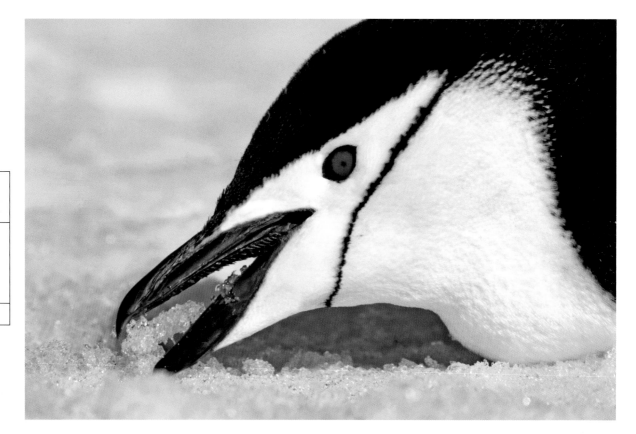

● CHINSTRAP
PENGUIN
(*Pygoscelis antarctica*)

Canon 1D Mark II,
400mm lens + 1.4x
converter,
1/1,250th sec @ f11,
digital ISO 400

Antarctic Peninsula

ensure that I excluded bits of other nearby birds from the image. Other penguins would frequently walk between the camera and my chosen subject as they went about their business, but this was their domain, not mine. With a lot of patience I finally got the picture I was after, shown above.

MAMMALS

Sea mammals dominate the polar regions, and the most noticeable are the seals that breed on the land or frozen seas at either end of the planet. On the Antarctic Peninsula, the most common species you are likely to encounter is the Crabeater Seal, which can often be found hauled out on ice floes, particularly in the more sheltered bays. Although it is possible to photograph these seals from your ship with a long lens, the best opportunities for photography are from Zodiacs, which can take you into much shallower waters and get you far closer to your subject. When working from a Zodiac I carry two cameras, one fitted with a short zoom, the other with a telephoto zoom. It can get quite crowded on a Zodiac full of people wanting to take photographs, so big telephotos are difficult to use and everything needs to be hand-held. IS lenses are perfect in this situation.

The image of the Crabeater Seal, opposite, was taken on one such Zodiac excursion on a beautiful sunny day on the Antarctic Peninsula. With a blue sky, nice white clouds and the snow-covered mountains in the background, I wanted to include the whole landscape in my picture of the seal. I obviously required a wide-angle lens, and used the 28mm end of my 28-135mm zoom lens (this was my 'standard' lens before Canon released the 24-105mm lens that I replaced it with). While in a Zodiac you must either sit or kneel for the sake of the stability of the craft and

your own safety, since the boats have very low sides and it is easy to topple over into the rather chilly water.

The difficulty was that at such a low angle I could not get the composition I was after. The Zodiac driver told us that he was going to drift slowly past the seal, so I asked if it was all right for me to stand up. Fortunately, I had worked with this driver before and he knew he could trust me to be careful, so he agreed. While the other photographers concentrated on taking close-ups, I raised myself to my full height and waited as all the elements came into place while we went slowly by, finally getting one of my favourite Antarctica pictures.

The following Crabeater Seal picture is completely different and shows the animal in close-up. This was taken with the telephoto zoom from the same Zodiac, only this time I was sitting down. The sunny conditions enabled me

⬤ CRABEATER SEAL
(*Lobodon carcinophagus*)

Canon 1Ds Mark II, 28-135mm zoom lens @ 28mm, 1/320th sec @ f14, polarising filter, digital ISO 400

Antarctic Peninsula

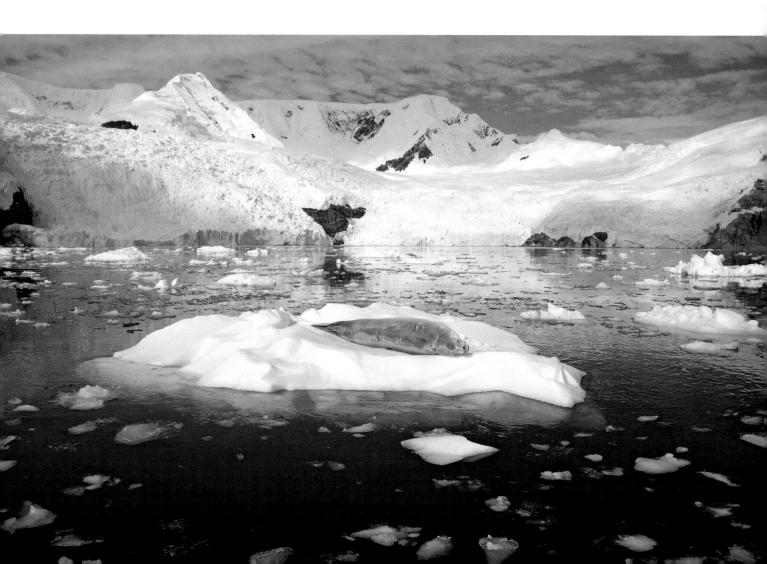

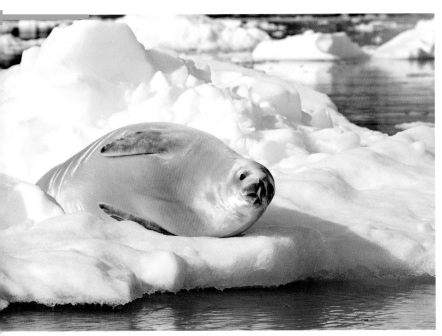

Above:

● CRABEATER SEAL (*Lobodon carcinophagus*)
Canon 1D Mark II, 100-400mm zoom lens @ 190mm, 1/1,600th sec @ f10, digital ISO 400
Antarctic Peninsula

Opposite:

● WALRUS (*Odobenus rosmarus*)
Canon 1D Mark II, 400mm lens, 1/640th sec @ f8, digital ISO 400
Svalbard, Norway

to catch the light in the seal's eye, which always brings an animal picture to life. When working with two cameras and two different lenses, it makes sense to use the full-frame camera for the wide-angle lens and the camera with the smaller sensor for the longer lens, to make the best of the apparent magnification factor on these cameras.

At the other end of the globe, the Walrus is an iconic animal of the far north. The mammals congregate in large haul-outs on beaches, but when on land they are quite nervous and easily disturbed if you get too close. When I visited such a site on Svalbard, I wanted to photograph the haul-out. However, there were quite a number of photographers in the group and we could not get very close, because the large number of people would have spooked the animals. A long lens was thus essential, but as in the case of the first image of the Crabeater Seal, the problem was the angle.

This time, using the long lens, I needed to get as low as possible because I wanted to include the snow-covered mountain in the far distance as a backdrop. I wandered around the beach until I found a slight depression in the sand and lay down flat within it. This enabled me to point

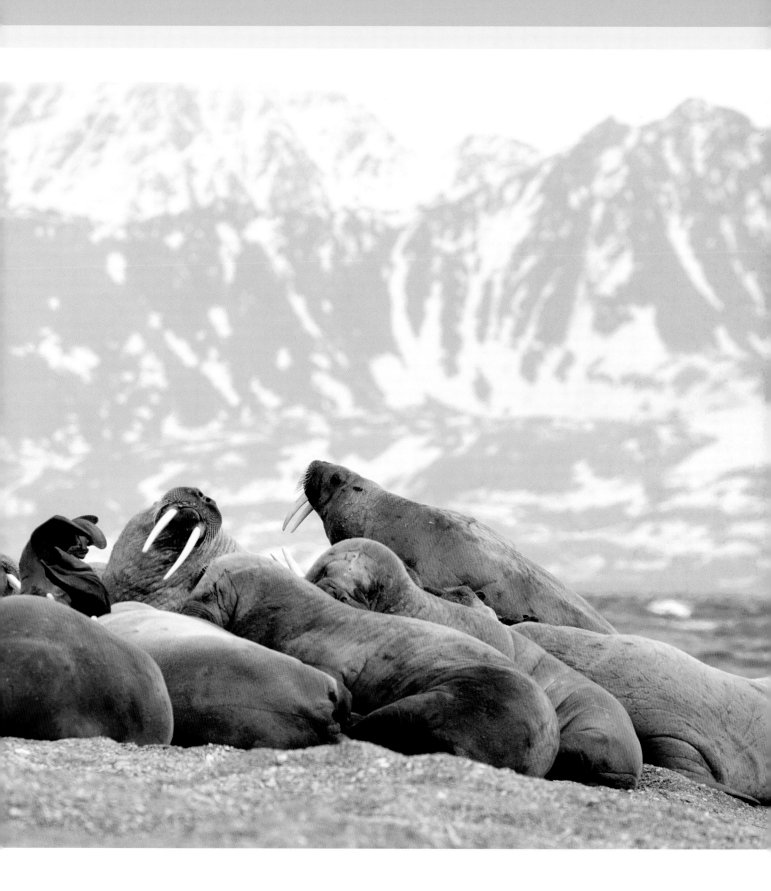

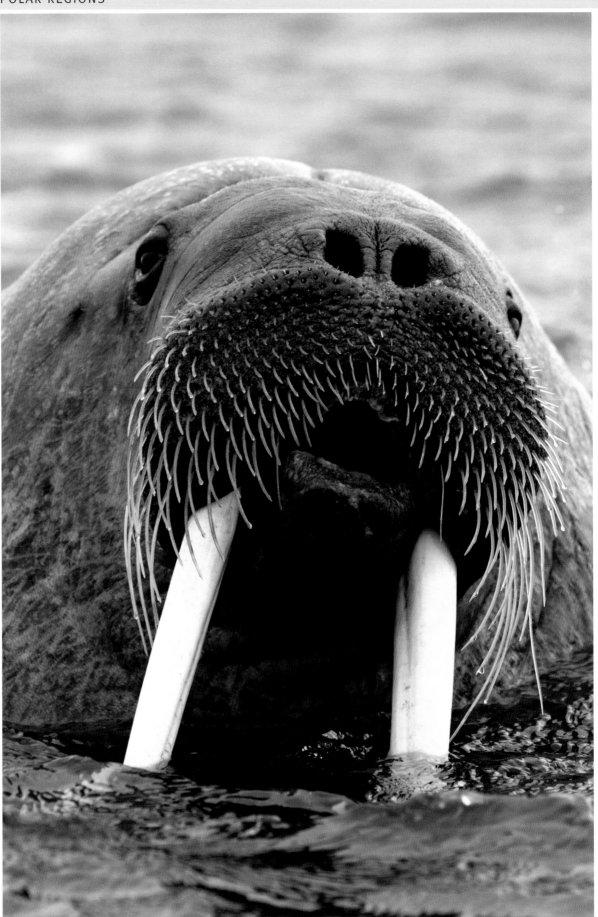

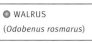 WALRUS
(*Odobenus rosmarus*)

Canon 1D Mark II,
400mm lens,
1/64oth sec @ f8,
digital ISO 400

Svalbard, Norway

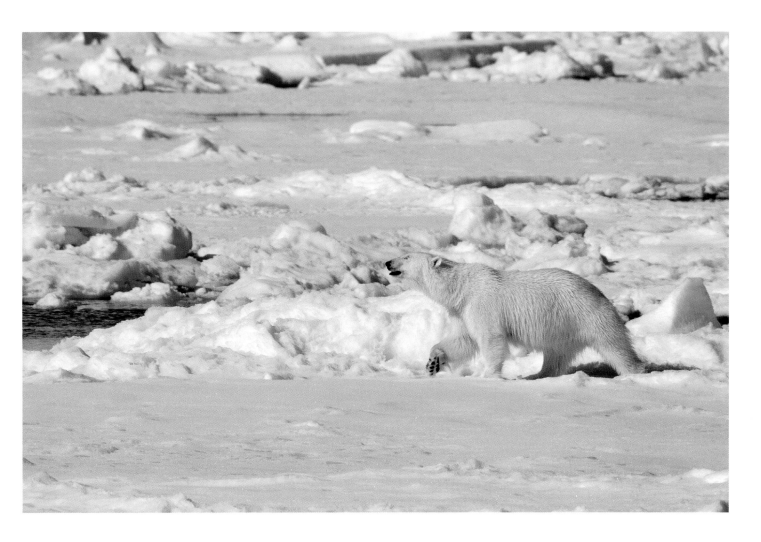

the camera slightly upwards and get the composition I had envisioned. Flat Walruses do not make the most photogenic of sights, so I had to wait until a male raised his head and showed his tusks in a rather lazy challenge to another male before I made the picture.

Once in the water the Walrus is a much more confident animal, and a few that were already in the water when we arrived swam up to our group to give us the once over. I took a close-up (opposite) in portrait mode showing the animal's distinctive shaving brush-like bristles and tusks. It makes for an intimate portrait of this fascinating mammal.

I could not leave this section on polar mammals without including a picture of a Polar Bear. I had always wanted to see and photograph this lovely animal, but when I visited Svalbard in the summer of 2008 there was far more ice around than was usually the case at this time of year. This meant that the ship could not reach many of the best places for the bears.

Disappointingly, we only had a single encounter that was anywhere near photographic range, and even this was quite distant. At least the bear was in pristine condition and the sun was shining when I took the above shot. It is of a large male strolling across the sea ice, and I had to use a 2x converter on my 400mm lens to achieve it. Wonderful animal, though, and one day I hope to return and have better luck.

● POLAR BEAR
(*Ursus maritimus*)

Canon 1D Mark II,
400mm lens +
2x converter,
1/160th sec @ f10,
digital ISO 400

Svalbard, Norway

● BLACK BEAR CUBS
(*Ursus americanus*)

Canon 1D Mark II,
400mm f4 lens,
1/640th sec @ f4,
digital ISO 400

*Rocky Mountains,
Canada*